THE ORIGINS OF THE
ROMANESQUE

THE ORIGINS OF THE
ROMANESQUE

Near Eastern Influences on European Art 4th–12th centuries

V. I. ATROSHENKO AND JUDITH COLLINS
with architectural drawings by Nigel Cox
and other drawings by G. M. Mundy

Lund Humphries · London

Copyright © 1985 Warwick Arts Trust

First edition 1985
Published by
Lund Humphries Publishers Ltd
26 Litchfield Street London WC2H 9NJ

ISBN 0 85331 487 X
ISBN 0 85331 557 4

Designed by Chrissie Charlton and
Marita Lashko
Made and printed in Great Britain by
Balding + Mansell Limited, Wisbech,
Cambridgeshire

Illustration Acknowledgements

Nigel Cox, architectural drawings
1, 2, 3, 4, 6, 8, 9, 10a, 11, 16, 17, 18a&b,
20, 21, 22, 25, 26, 27, 28, 32, 34a&b, 35,
36, 37, 38a&b, 39, 40, 41, 43a, 45b,
46a&b, 47, 49a–e, 50, 51, 52a&b, 76,
103
John Flower, maps on pp. 6–7 and 76
G. M. Mundy, drawings
60, 62, 65, 82, 83, 84, 86, 88, 92
The following photographs have been
reproduced by courtesy of
Architectural Association, London
Plate II; Fig. 15, 54 (Baum, *Romanesque
Architecture in France*)
Biblioteca Medicea Laurenziana, Florence
Plate VIII; Fig. 67
Bibliothèque Nationale, Paris
Fig. 70; 71
The Bodleian Library Oxford, Manuscript
section of
Fig. 63
Bridgeman Picture Library, London
Plates III, VII, IX, X
The British Museum, London, The
Trustees of
Fig. 61, 78
Caisse Nationale des monuments
historiques et des sites, Paris
Fig. 10b, 44 (Photo: Lefevre-Pontalis,
© Arch. Photo. Paris SPADEM 55a (©
Arch. Photo. Paris SPADEM), 55b (©
Arch. Photo. Paris SPADEM)
Ciol, Elio, Casarsa, Italy
Fig. 89
Collins, Judith
Plates IVa&b, V, XIV, XV
Deutsches Archaelogisches Institut, Rome
Fig. 5, 7, 24
Frantz, Alison, Princeton N.J.
Fig. 43b
Giraudon, Photographie, Paris
Plate VI & jacket (Lauros-Giraudon);
Fig. 75
Hinz, Hans, Colorphoto
Plate XI
Hirmer Verlag, Munich
Fig. 79, 91
Holle Bild-Archiv, Baden-Baden
Plate XIII

Hornak, Angelo
Plate XVI
Michael Joseph, London (Gabinetto
Fotografico Nazionale, Rome)
Fig. 90
Loerke, W. C., Washington, D.C.
Fig. 66
Longo, Angelo, Ravenna
Plate XII
Lund Humphries Publishers/Gütersloher
Verlagshaus Gerd Mohn
Fig. 77
Mansell Collection, The, London
Fig. 23 (Anderson, Rome), 48 (Alinari),
64 (Bulloz), 81 (Anderson)
Marburg, Bildarchiv Foto
Fig. 45a
MAS, Arxiu, Barcelona
Fig. 94
Powell, Josephine, Rome
Fig. 14, 33
Rijksuniversiteit, Bibliotheek der, Utrecht
Fig. 72, 73
Royal Commission on Historical
Monuments of England
Fig. 58
Stadt Köln, Der Oberstadtdirektor,
Verkehrsamt Freigabe RPD OP1111
(Skylife, Düsseldorf)
Plate I
Trinity College Dublin, The Board of
Fig. 68
Victoria & Albert Museum Crown
Copyright
Fig. 69, 80
Vogüé, Charles-Melchior de
Fig. 12, 13, 19, 29, 30, 31, 85, 95, 96, 98
Zodiaque, St Léger Vauban
Fig. 42, 53a&b, 56 (Photo: Yan
Zodiaque, Jean Dieuzaide), 57, 59
(Photo: Jean Roubier), 74, 87 (Photo:
Yan Zodiaque, Jean Dieuzaide), 93
(Photo: Franceschi-Zodiaque), 97, 99,
100, 101, 102, 104, (Yan Zodiaque, Jean
Dieuzaide), 105, 106, 107, 108, 109

CONTENTS

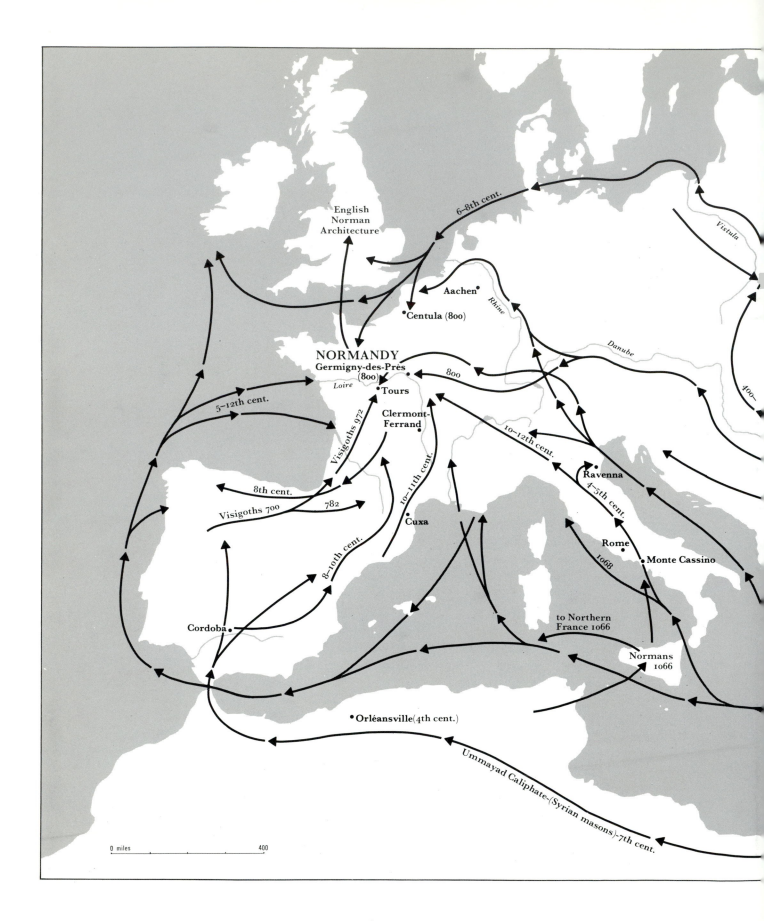

English
Norman
Architecture

6–8th cent.

Aachen•

Rhine

•Centula (800)

NORMANDY
Germigny-des-Prés
(800)

Loire

800

Danube

•Tours

5–12th cent.

Clermont-
Ferrand

Visigoths 972

10–12th cent.

Ravenna
4–5th cent.

Vistula

400

8th cent.

10–11th cent.

Visigoths 700 782

Rome•

•Cuxa

8–10th cent.

•Monte Cassino

1068

Cordoba•

to Northern
France 1066

Normans
1066

•Orléansville(4th cent.)

Ummayad Caliphate-(Syrian masons)-7th cent.

0 miles 400

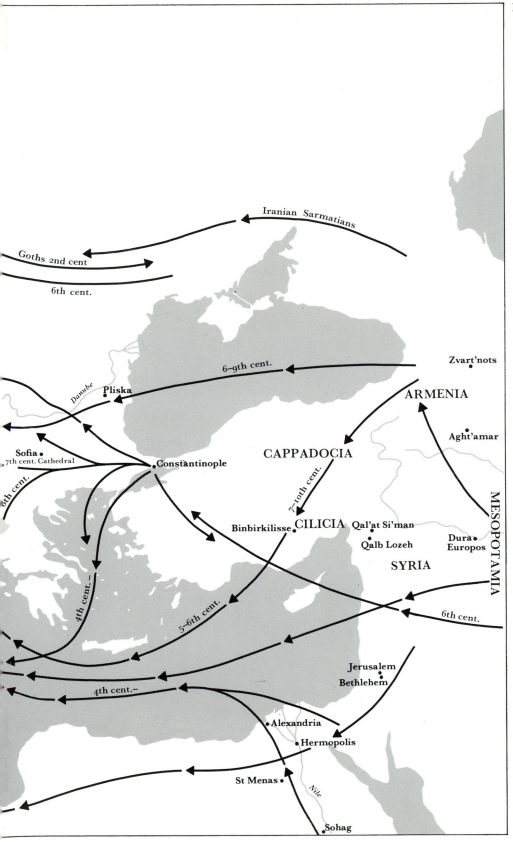

Iranian Sarmatians

Goths 2nd cent

6th cent.

Zvart'nots

ARMENIA

6–9th cent.

Danube

Pliska

Aght'amar

Sofia
7th cent. Cathedral

CAPPADOCIA

MESOPOTAMIA

6th cent.

Constantinople

7–10th cent.

4th cent. –

Binbirkilisse

CILICIA

Qal'at Si'man

Qalb Lozeh

Dura
Europos

SYRIA

5–6th cent.

6th cent.

4th cent.–

Jerusalem

Bethlehem

Alexandria

Hermopolis

St Menas

Nile

Sohag

7

Authors'
Acknowledgements

We should like to express our
thanks to Professor Otto
Demus for his early encourage-
ment of this project; to
Dr Barnashi, Director of the
Damascus Museum; Professor
El Hakim of the University of
Damascus; and to Miss Shari
Taylor, Curator, Research
Collections, Department of Art
and Archaeology, Princeton
University, for their generous
help in obtaining material
relating to Syria; and to the
Marquis de Vogüé for very
kindly allowing us to photo-
graph his copy of *Syrie centrale:
architecture civile et religieuse du Ier
au VIIe siècle*.

 Not least, we should like to
record our indebtedness to
Chrissie Charlton, for her
inspired work on the design of
this book, to Eveline van Rooy
for her patience in assembling
the photographic material from
many sources, to Charlotte
Burri for her meticulous
attention to detail and, most
especially, to John Taylor for
his continuous support and
encouragement.

To Milton Grundy

INTRODUCTION

Christian Europe expected the world to end in the year 1000. The passing of that fateful year was followed by a century and a half of church building, with its attendant painting and sculpture, on a scale and of a sophistication not seen since the disintegration of the Roman Empire. To describe the art of this period, Thomas Rickman in 1814 coined the word 'Romanesque'. The word itself carries the implication that it is 'like the Roman' – just as when one says a thing is 'picturesque', one means it is 'like a picture'; and it may be that this linguistic presumption has conditioned later observers to focus their attention on those aspects of the Romanesque which can be seen to have their antecedents in classical antiquity. Such a view has not been without its supporters, even in recent times. The great empires of the nineteenth century – British, French and Austro-Hungarian – legitimised their aspirations by reference to the Roman Empire, as indeed has been done in more recent times, and one finds a classic expression of the view that the antecedents of European art are to be found in the work of the Romans in Bettini's work (published in Vienna in 1942!).

But, as the reader will see from what follows in this book, the story of Romanesque art is both more complicated and more interesting. Primarily, it is the story of an immense and – even today – not generally recognised debt to Christian art of the fourth to seventh centuries produced on the eastern littoral of the Mediterranean. During that epoch, while the West was suffering the economic and cultural decline which followed the decay of the Empire of Rome, the Eastern Empire, with its capital at Constantinople, enjoyed considerable economic prosperity, and scholarship and the arts continued to flourish. For this culture, even the greatest of our historians of the Empire, Edward Gibbon, had no sympathy; he saw it merely as an appendix to his history of Rome. In the nineteenth century, Finlay saw it as the preface to the story of modern Greece.

A turning point comes with Charles de Vogüé. Between 1865 and 1877, he published the six volumes of his *Syrie centrale: architecture civile et religieuse du Ier au VIIe siècle*. He was the first to draw attention to the superb and original qualities of the architecture and building techniques of the Syria of this period – of the period, that is to say, before Christian Syria was conquered by Moslem armies. The topographical sketches he made during his travels in the Near East recorded much that has since succumbed to earthquakes, looting and decay. These, and his imaginative reconstructions of the buildings

(some of which are reproduced here, pp. 50–52) opened the eyes of later art historians to the striking and at that time unexplained similarities between Early Christian and Romanesque buildings.

H. C. Butler made an expedition to Syria under the auspices of Princeton University in 1889–1900 and published his findings in 1903. He conducted further expeditions in 1904–5 and in 1909. His *Early Churches in Syria, fourth to seventh Centuries*, posthumously published in 1929, elaborated upon the tentative suggestions made by de Vogüé. More specific parallels were drawn by Josef Strzygowski, whose *Origins of Christian Church Art* was published in 1923. His emphasis on the rôle of Armenia raised the question of the antecedents of the Romanesque to the level of strident and often bitter academic controversy. But while many of the insights which resulted from the intellectual battles of that time have percolated into standard works of today, the general reader appears to have been largely untouched by these important discoveries. It is the purpose of this book that the connections between the art of Western Europe of 1000–1150 and that of the Early Christian Near East should be simply and convincingly demonstrated.

Romanesque art was essentially a Christian art; its buildings were mainly churches and monasteries, and it is perhaps hardly surprising that its principal characteristics were not to be found in the pagan and secular buildings of ancient Rome. To enter a Romanesque church is to be conscious of a quality one can best call 'spirituality': the spirit of the worshipper is intended to be – and indeed is – affected by the mystery and the monumentality of the building. The articulation of space and the subtle use of proportion and of lighting, the emphasis on verticality – all the architectural components serve to turn the mind towards contemplation, mysticism and inner vision and away from the physical and exterior world. This is the kind of experience far removed from the rationalism and hedonism of classical antiquity; its sources are in the search for spiritual salvation which Christian teachers brought from the Near East. Low-relief sculpture has a didactic as well as a votive purpose. Biblical stories feature in the *tympana* and on the capitals, often juxtaposed with scenes of everyday activities, so that the unlettered masses could more readily identify themselves with the events in the lives of Jesus, the Apostles and the saints.

A church has also a symbolic function; its ground plan is often in the shape of a cross, and heaven may be indicated by a dome over the centre of the cross (a feat of constructional engineering which, as we shall see, had itself a Near-Eastern origin). Buildings with such features were not inspired by the remnants of Roman barracks, aqueducts, triumphal arches, tenements and so on which littered the landscape of early Mediaeval Europe. Nor can they be seen as derived from Vitruvius, who was in any case very little known in that period. All these features on the other hand are to be found in Near-Eastern churches built during a period which ended four centuries before the beginning of the Romanesque. Several commentators

have doubted the existence or extent of the influence of these early works on others so far separated both geographically and in time. What we describe in this book suggests a continuous artistic connection between Europe and the Near East and a movement of information over the great distances involved.

An important reason for this link lies in the Christian movement which became known as monasticism. It was begun in Egypt by Anthony (264–356). After his death, Athanasius, the Bishop of Alexandria, wrote his biography, and Pachomius began the creation of organised monastic life. The movement was essentially a reaction against what was seen as the materialism, corruption and self-indulgence of secular life in that part of the Roman Empire. It had an immediate and astonishing success. By the end of the fourth century, there were some 7,000 monks in Egypt, living and working in monasteries, and from there they spread to Western Europe, founding monasteries as far away as Ireland. The movement took a somewhat different form in Syria. There, a single holy man would retire to the desert, and Christian followers would make pilgrimages to his place of retreat. Simeon Stylites was one such, and the fifth-century church, built around his pillar, became one of the principal pilgrimage centres of the early Christian world.

Merchants and craftsmen, as well as pilgrims and monks, travelled continuously to and from the West throughout the Dark Ages. The land routes to the holy places in Palestine took travellers through Armenia, Turkey and Syria. Ivories, textiles, manuscripts and other portable artefacts found their way from the still intact and prosperous civilisations of the Near East to the barbarous territories of Western Europe. Many of these artefacts have remained there to the present day, and provide evidence that Europeans were by no means ignorant during this period of the art being produced by the Christian East. There is evidence, too, that master builders and 'travelling journeymen' – masons and other craftsmen – from the Near East were regularly employed in the building of monasteries and churches in Europe. These great architectural achievements can only have been 'built' by abbots and churchmen in the sense that the Pharaohs 'built' the Pyramids. Much Greek knowledge – especially of geometry and mathematics – was lost to Europe in the 'Dark' Ages. But it was preserved in the Near East, and the complexity of much Romanesque building needed a command of mathematical principles which required to be imported from the East.

This knowledge manifested itself in buildings in the West – in Tours (e.g. Saint-Martin 470), in Ravenna (San Vitale, c.530–48), in Centula (Saint-Riquier, c.790), in Germigny-des-Prés (Oratory of St Theodulf, c.806), in Cuxa (Sta Maria de Cuxa, 878), in Aachen (Cathedral, early ninth century). But for the most part, the great upsurge of artistic production in Europe had to await the more settled conditions which prevailed after 1000 – the ending of the invasions of Vikings, Saracens and Huns, and the consequential rise in prosperity of largely agricultural communities.

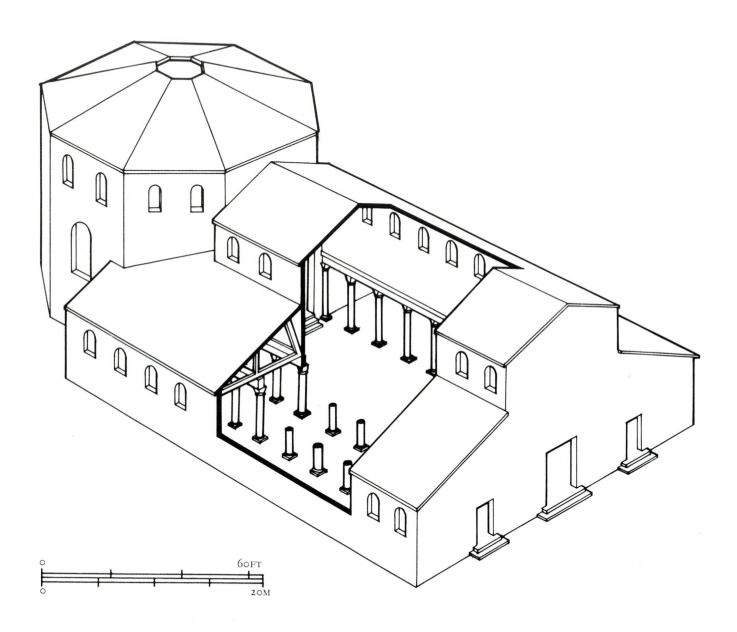

1 Church of the Nativity in Bethlehem (4th century); isometric drawing

CHAPTER 1 EUROPE AND THE NEAR EAST

By the Edict of Milan in 313, Christianity became the official religion of the Roman Empire. In the years following, the Emperor Constantine moved his capital to Constantinople (in 330) and ordered the building of churches commemorating the birth and death of Jesus – the Church of the Nativity in Bethlehem and the Holy Sepulchre in Jerusalem. He also provided the funds for the building of St Peter's in Rome.

All these churches included a *martyrium* – a building covering holy ground, generally the site of the martyrdom, death or burial of a saint. This became a characteristic feature of early Christian churches. The *martyria* of St Peter's and of the Holy Sepulchre were round, that of the Nativity octagonal. The eight-sided plan symbolised regeneration – a new beginning, for in the Old Testament story, God had taken seven days to create the world, and on the eighth day the life of the world began. It is interesting that so early a Christian building utilises symbolism. Such use of symbolism was quite foreign to the tradition of pagan building in classical times; it is characteristic of the tradition of Christian architecture – the church in the shape of a cross, for example, becoming a common feature of ecclesiastical building. It is also interesting that the architect of the Holy Sepulchre, Zenobius, came from Syria – from which, as we shall see, part of the great tradition of Christian architecture was to emerge.

Not all *martyria* were round or octagonal. The *martyrium* at Concordia Sagittaria, between Aqueleia and Altino (near present-day Venice) was cruciform. In the cemetery beside it are headstones whose inscriptions of 409–10 show that those buried there came from Apamea in Coele, in Syria.

The Basilical Plan

Abutting the *martyria* of the Nativity and the Holy Sepulchre, were oblong halls with rows of internal columns. Such a hall is strongly reminiscent of the civic *basilica* of pagan Rome. But closed buildings with internal colonnades were by no means unique to Rome and the basilical hall which became absorbed in the Western tradition of church architecture was different from the *basilica* of Rome in important respects. The feature which from the beginning distinguished the Christian from the secular use of this form was the

4TH CENTURY

11TH CENTURY

12TH CENTURY

2 The Holy Sepulchre in Jerusalem (4th century); plan

absence of columns on the short side. A Roman *basilica* sometimes (though not always) had an apse at one end, but it could not be clearly seen from the other end because the columns formed an entire oblong within the oblong of the hall. The absence in the Christian church of columns on the short side enabled the worshipper to see the apse from the entrance, focusing his view on the altar, and it divided the church into nave and aisles.

The most decisive change, however, which the basilical hall underwent in the East, was the introduction of the apse with a trefoil plan combined with the basilical hall.

Creswell believes that a triple-apsed hall had been developed in Syria for use as a throne room or audience hall and that it was due to Egyptian influence that this feature was combined with the basilical hall. Certainly Egypt played an important part in this development, for out of five earliest examples of this type of building which have survived, three are to be found in Egypt, namely the White Monastery and the Red Monastery at Sohag (c.440) and the basilica at Dendera (end of fifth century). The other two are the basilica of Paulinus at Cimitile-Nola (c.401–3) and the later Church of the Nativity at Bethlehem (before 565). This plan occurred almost exclusively in Egypt, North Africa and the opposite shore of the Mediterranean, and it is thought likely that the architect of Cimitile-Nola took the plan from North Africa.

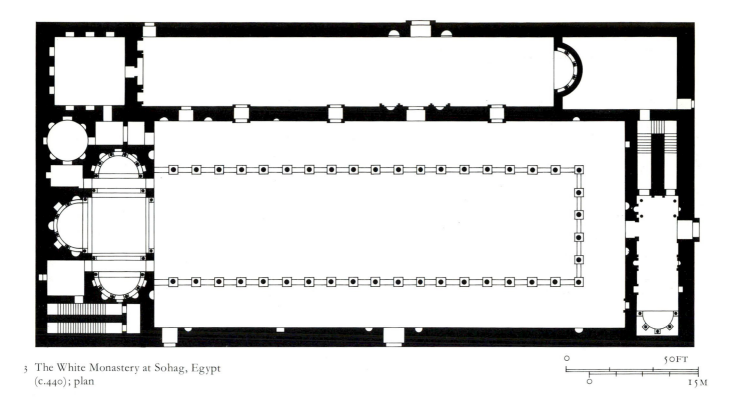

3 The White Monastery at Sohag, Egypt
(c.440); plan

The basilica with nave, aisles and a single apse became the standard
church plan in the Western provinces. Around the Aegean this had
occurred by the middle of the fifth century, and it lasted until about
530, when it was superseded by Justinian's architecture. In North
Africa and the Latin West standardisation had occurred by 420;
the basilical plan remained standard in Italy until 600 and in North
Africa until the Arab conquest of 640. The Arab conquest did not
necessarily lead to the abandonment of indigenous styles of church
building. It did so in Syria, but native styles continued in Asia Minor
and Mesopotamia into the ninth century and in Armenia throughout
the Middle Ages.

Near-Eastern Influences

But it is a mistake to think of this basilical plan as the direct source for
Romanesque churches – or indeed for the styles of church building
adopted in Carolingian or pre-Carolingian times. At the end of the
fifth and the beginning of the sixth centuries, the basilical plan fell
into disuse even in Italy and North Africa, and by the sixth
century – and even more in the two succeeding centuries – we find
throughout the West church types which are native to the East – in
Rome, churches with galleries; in northern Italy, churches with three
apses; at Glanfeuil, in the seventh century, a church in the form of a
4 barrel-vaulted hall, like the churches at Binbirkilisse (south-east
Turkey); at Saint-Pierre in Geneva, apses flanked by pastophories;

15

4 The church at Binbirkilisse, south-east
Turkey (7th century); plan

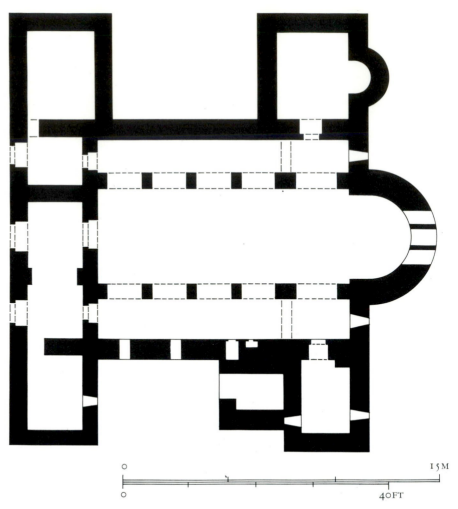

0 15M

0 40FT

and from Switzerland to England, small cross churches, some with
arms the same height as the nave, others with dwarf transepts, very
similar to those which had been built in the highlands of Asia Minor.
There are also examples of twin towers at the west front of the
churches, a feature of Syrian origin. Not until the last decade of the
eighth and the beginning of the ninth centuries do we find the old
Western form of basilica appearing again – a movement evidently
linked to the 'Roman' pretensions of Charlemagne and the popes;
but by now the old style merged with the Oriental features which had
become established in the meanwhile, and this combination was the
heritage on which late Carolingian and Romanesque architecture
subsequently drew.

If we are to look for one place more influential than any other in
establishing the vocabulary of Christian architecture, that place
would undoubtedly be Syria. The buildings sketched and re-
constructed by de Vogüé, some of whose drawings are reproduced
in Chapter 2 (pp. 50–52), illustrate the diversity and inventiveness of
Syrian building from the fourth to the seventh centuries – buildings
which were to have a profound influence on Christian architecture.
We shall come across numerous examples of this influence, but this is

perhaps the place to stress that not only Syria, but the countries of Asia Minor and the eastern Mediterranean littoral generally, were flourishing civilisations at a time when Western Europe was poor and backward.

The history of the fifth century abounds with examples of connections between Europe and the civilisations of the East. In that century one of the bishops of Paris was a Syrian. Theodoric of the Ostrogoths was educated in Constantinople. His banqueting tables were covered with 'cloth from Babylon'. On the other hand, the backward society of fifth-century Europe was not capable of absorbing all the knowledge and technical skill which was thriving in the contemporary East.

Some of the deficiencies in Western technical and artistic skills were made up by importing the artefacts themselves from the East. Some years ago, a sunken ship was raised off the coast of Sicily. It was found to have been loaded with a chancel screen, columns and the entire furnishings of a church; these had been dispatched from Constantinople in the sixth century – at the time of Justinian – to some destination in Italy or further west.

An important part of the Oriental influence of course was what one would nowadays call ideological: the spread of Christianity and in particular the spread of the monastic movement (p.102). Early in the fifth century, this movement established a European base on the Lérins Islands, just off the French Mediterranean coast near Cannes; from there it spread to Ireland, which in turn sent missions to Scotland (563), to France (St Columbanus 615, Luxueil), to Italy (St Columbanus, Bobbio), to Germany (St Kilian, c.690, Würzburg), and to Switzerland (St Gall, 613). St Benedict founded Monte Cassino (near Naples) c.530; this, as we shall see later, proved to be a most important event.

But, above all, the influence of Eastern civilisations on the Europe of the Dark Ages is revealed in its buildings. This can be seen in the galleried basilicas we have already referred to, of which San Lorenzo fuori le mura in Rome (579–590) may stand as an example. The very tradition of stone building died out in Diocletian's palace at Split in Yugoslavia: it reappears in Theodoric's mausoleum in Ravenna (526), but significantly with Eastern features – notably the joggling of the voussoirs which is characteristic of building in Syria and Palestine. In San Paolo fuori le mura and Santa Sabina – both in Rome – the columns were spanned by archivolts: such arcading is believed to have originated in the Eastern provinces. But it is not simply in their detail that these buildings in the West show their enormous debt to Oriental prototypes; it is to be seen in their orientation, their structure and their plan.

The orientation of most Christian buildings of this or any subsequent period shows the church directed towards the East: this appears to have been an Oriental feature – Strzygowski attributing its origin to the religious architecture of the Mazdean cult in Armenia.

5
6

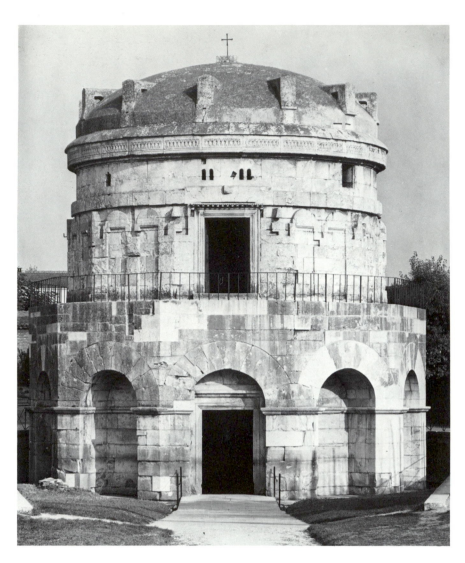

6 Joggling of the voussoirs; a characteristic
of building in Syria and Palestine

The Use of Stone

There was a long tradition in Mesopotamia of the use of stone for roofing. The architects of Syria and Anatolia drew on this tradition, and it was in those provinces of the Byzantine Empire that the barrel-vaulted roof was developed and such churches had to be lit by windows in the side aisles and in the apse. This is another Oriental feature of the church of Santa Sabina in Rome – and one which was to **49a–e** be found later in the pilgrimage churches in France and Spain on the routes to Santiago de Compostela. Another result of stone roofing was the use of the pier to take the place of the column, or sometimes of alternate columns. Slender columns and light walls can support a timber roof: a masonry vault required something altogether sturdier. The arcade followed as a further development, and this called for a new capital. Whereas a stone slab of an architrave can rest on a small surface, a much larger support is required for the base of an arch. At first, this need was met by the use of an impost capital – a

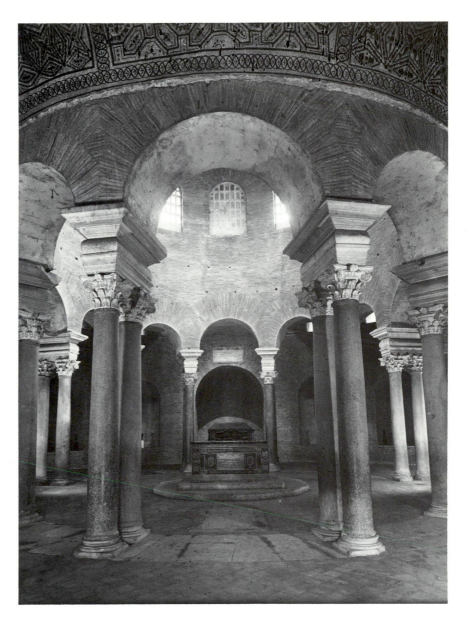

second and wider capital placed above the usual one; later the two were combined into a single capital. A capital carrying an arch could be decorated only with low relief; the deep incision of the Corinthian style would weaken it too much.

The civilisations of the East were responsible for the most revolutionary – and certainly the most conspicuous – feature of Christian church building, and that is, the dome placed on a rectangular base. The art of placing a dome on a *round* base was known in classical times – the Pantheon in Rome stands as an example. And indeed, Eastern architects appear to have been fond of round or octagonal buildings: there was the *Anastasis* – part of the church of the Holy Sepulchre in Jerusalem – from which Santa Constanza in Rome is derived; there is the Baptistry of the Orthodox at Ravenna, which had its prototype in Antioch and its successor at

7

8 & 9 The pendentive and the squinch; two
solutions to placing a dome on a square
base

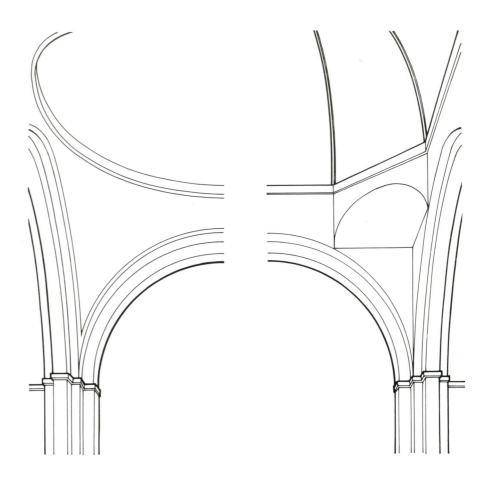

Aachen. But to place a dome on a square base presents an altogether more difficult problem – which was tackled in two ways. One solution was the squinch, of which the earliest surviving example is in the third-century Sassanian palace of Firuzabad in Persia. The **9** squinch converts a square into a circle by first placing beams across the four corners to make an octagon, and so on until a rough circle is **8** formed. The pendentive is a masonry infill between adjacent arches: four of them together make a masonry ring to support a dome, and each of them is of a triangular shape with an inward curve. Examples from the second or early third century survive at Amman, Jerash and Samaria, and the invention travelled from there to Byzantium, Italy and Armenia.

One can find Armenian building ornament, motifs from Armenian miniatures and even the personal seals of Armenian masons in numerous European church buildings. This alone would prompt any student of the events described in this book to acquaint himself with the developments which took place in Armenia during this period: such a study, as we shall see, is rewarding.

Armenia

Armenia has plentiful supplies of building stone. Its mountains have been quarried and a tradition of stone masonry established since time immemorial. The building techniques and the innovations of the Armenians were commented on by Vitruvius in Rome in the first century.

Christianity established itself in Armenia before it became the official religion in the Roman Empire. The Milan Edict on tolerance was issued by Constantine in 313; twenty years before, Tsar Tridates III had made Christianity the official religion of Armenia. When the first dissent in the Church took place in 451, the Armenians – along with the Syrians and the Copts in Egypt – took the Monophysite side and parted from the Byzantines. Behind this difference over dogma, there lay profound economic and political differences. Byzantium was determined that its rule should encompass all the Christian countries of the East. But these countries were struggling to establish their political independence from Byzantium and found in doctrinal independence a natural – not to say useful – correlative to their political ambitions.

In the fifth and sixth centuries, the Armenians were building churches of the kind to be found in Mesopotamia and Syria, but striking out in a new direction. Armenian architects showed a preference for height over length (a feature to be found later in the Romanesque), and gradually they moved away from the elongated basilica towards a cruciform plan with a central cupola.

The creative talent and the originality of Armenian builders became famous: the builders of Ani Cathedral were invited to restore Hagia Sophia in Constantinople, and by the tenth century we find an actual school teaching builders from neighbouring countries, and even from Byzantium. The Crusaders' path to Jerusalem in the eleventh to fourteenth centuries passed through Cilicia, now in south-east Turkey, but then part of Armenia: this gave Europeans from the West a direct link with Armenian culture. The spread of their culture was also a by-product of the mass emigrations of Armenians to other countries, in consequence of the Mongolian (ninth century) and later Turkish (twelfth century) invasions, which brought Armenian masons and architects to the West.

The church of San Satiro in Milan (restored in 1476–1514 by Bramante) was built in 868–881; its plan was inspired by the Armenian church in Bagaran (624–631).

10a,b In 806–811 the Armenian architect Oton Matsaetsi built the church of Germigny-des-Prés in France, and in 806 the belfry of Charlemagne's Palace in Aachen, after the model of the Etchmiadzin monastery as it was in the fifth century. The Armenian architectural style had a distinct influence on the churches in Provence and Languedoc – St Mary's church in Tarascon, the churches in Gard and Chilly and the cathedrals in Cahors and Port-de-Clermente. In Lombardy (and elsewhere) one finds the cubic capitals which were

10a The church at Germigny-des-Prés, France
(806–11); plan

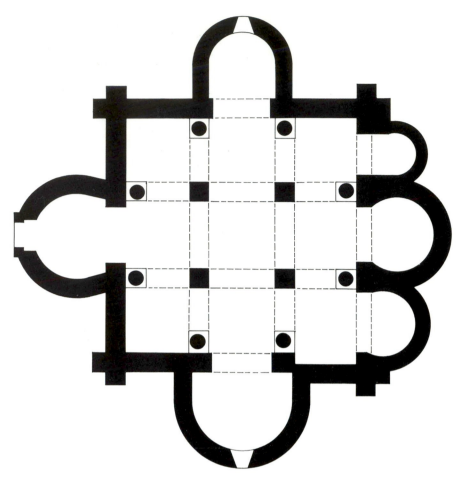

10b Germigny-des-Prés; interior

used in Zvart'nots and other elements typical of Armenian architecture.

According to the French archaeologist François-Auguste Choisy, from Armenia the arcades, conical vaults and cupolas spread to the West. Speaking of the influence of Armenian architecture and decoration on European architecture, Choisy writes that it spread over the Dnieper and the Vistula to the Scandinavian countries, then along the coastline to England, Ireland and northern France.

Armenian architecture was studied in detail by Strzygowski. In his works, he writes that certain architectural elements that have become typical of Romanesque and Gothic architecture, particularly the cruciform vaults, ogival arches and cupolas, the lofty spires and interlaced decoration, were originally adopted from Armenian architecture.

The Cruciform Plan

The ability to place a dome on a square base opened up many possibilities, and in particular it made possible a church in the shape

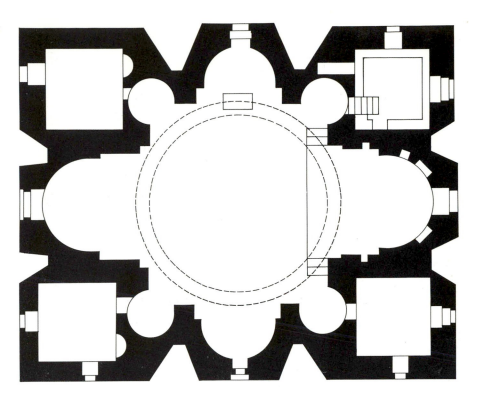

11

12

of a cross, the crossing surmounted by a dome, which symbolically stands for heaven above. A building whose structure carried a symbolic significance of this (or indeed any other) kind would have been inconceivable in the world of classical antiquity, but seems to have arisen quite naturally out of the mysticism and spirituality of the East.

Other variants appear in Armenia. The churches at Mastara (c.641) and Artik take the form of a simple square buttressed by an apse. The church of Hrip'simeh at Etchmiadzin (618) has angle chambers as well as apse buttresses. Earlier, if less well-developed, examples appear in Syria: the Praetorium at Musmiyeh (160, altered c.400) is cruciform in plan, the arms of the cross being vaulted – a plan followed later in the Mausoleum of Galla Placidia at Ravenna (440), which is roofed with a domical vault.

The remoteness from all Hellenistic models, to which Oriental features of these kinds led, is well illustrated by the transverse basilica at Mar Yakub in the Hauran district of Syria. This fifth-century church had a narthex at one end and an apse and flanking pastophories at the other, but 'the nave' between them was a barrel-vaulted rectangular room whose axis lay at right angles to the main axis and extended to the full width of the building.

But the plan which attained decisive importance in the West was the cruciform domed church. Examples in Italy are the church of Santa Fosca in Torcello and a chapel, San Teuteria, in Verona. Santa Comba de Bande was an example in Spain. A most startling example – of enormous size and complexity – was the church of St Simeon at Qal'at Si'man near Aleppo in Syria (450–480), a further

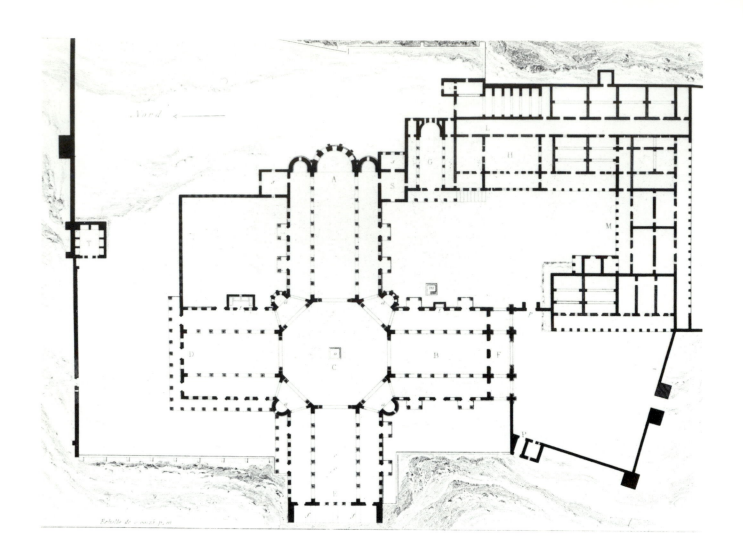

12 St Simeon at Qal'at Si'man near Aleppo,
Syria (480–90); plan

instance of the use of stone in Syria at a time when the technique of
stone building was unknown in the Latin Empire and barbarian
kingdoms. In the Sion church of Anteni the cruciform plan was
enlarged to a square with annexed apses. In Aght'amar, polygonal
stair-turrets were added to the central polygon. Triple apses were
used in Tiflis in Georgia. In all these developments of the cruciform
in the East, the exteriors were richly articulated and the buildings
surmounted by a rich tambour of polygonal or round shape. Oriental
articulation was also a feature of the sixth-century church of
13 Turmanin in Syria. It is in this church that we see for the first time the
twin-tower façade: this becomes a commonplace of European
ecclesiastical building centuries later, and it seems probable that
Turmanin in Syria was the prototype which influenced the use of this
feature in Romanesque times.

In the sixth century, galleries were introduced from the Near East
into the Frankish Empire, in the church of Saint-Pierre in Vienne,
and other churches – the older church at Hildesheim for example –
probably took their galleries from the Near East also.

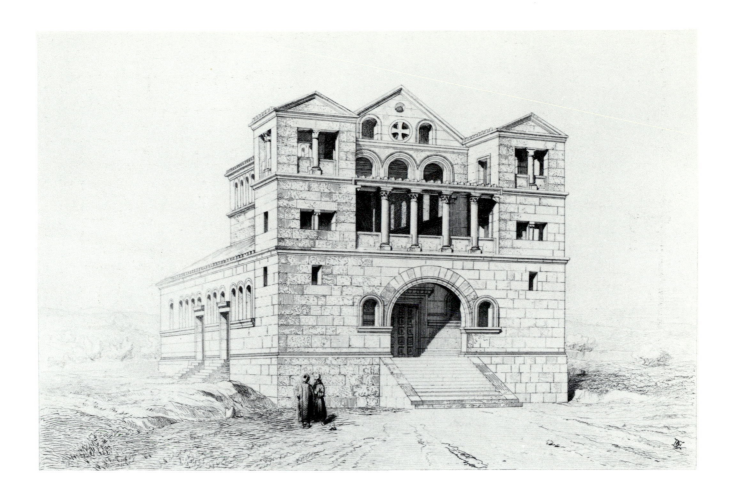

13 The church of Turmanin, Syria (6th century); reconstruction

14,15

There are two outstanding examples of more or less conscious imitation of entire churches. The influence of Byzantium's SS. Sergios and Bakchos on San Vitale in Ravenna can still be seen today, since both these outstandingly elegant buildings have happily survived. The Ravenna church in turn influenced the Carolingian church at Aachen in Germany. The other well-known use of an Oriental prototype was in the building of San Marco in Venice. This was deliberately modelled on the church of the Holy Apostles in Constantinople – and for political as much as aesthetic reasons – for like many *nouveaux-riches*, the Venetians believed (no doubt rightly) that there was a good deal of prestige to be derived from a building in an antique style – particularly if the style had imperial connotations.

The Near East and the Roman World

By the time we come to the fourth century, we find the new religious art which developed in Syria being gradually diffused throughout the Empire. But in the meanwhile other influences were being felt.

The year 226 marked the beginning of a new era in the Middle East, for it was then that the Sassanian kingdom was founded in

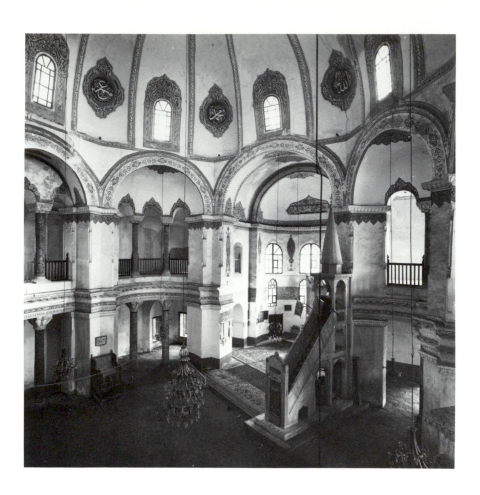

14 SS. Sergios and Bakchos in Constantinople
(prior to 536); interior

Persia, and with the rise of Persian power came a resurgence of
Persian culture, challenging the long-established dominance of
Hellenic culture. It happened that at the same time the economic and
cultural life of Rome was losing its vitality, so that this new wave of
cultural activity from the East was able to sweep into the new
empires of Diocletian and Constantine, to the point that they had a
much stronger resemblance to the Persian monarchy than to the
Roman republic.

There were undoubtedly, as several scholars have argued,
influences on the development of the Romanesque which can be
traced back to Rome of the classical period – notably those which
came via the court of Charlemagne. But in saying this, one must bear
in mind that Rome itself, over a long period, absorbed many cultural
influences from the Eastern Mediterranean.

Most of the people ruled by Rome when the Empire was at its
height lived in what later became the Eastern Empire, and many of
the inhabitants of these Eastern provinces went to live in the Western
part of the Empire, or at least travelled there; it is not surprising
that Eastern influences can be detected even before the move
to Constantinople. There were influences in the field of ideas.
Christianity and other cults stressing spiritual rather than material

values occurred in a world which saw many attempts at proletarian rebellion – in 135 BC, 104–100 BC and, with Spartacus as their leader, in 73–71 BC. The intellectual establishment reacted predictably to this cultural invasion. Juvenal was stimulated to fierce opposition. Cicero suavely perverted the utopian dreams of the Graeco-Syrian author Posidonius. Posidonius wanted to see a world state – the Cosmopolis – where all men would be brothers. Cicero saw this being achieved within the structure of the Roman Empire: in his version, the natural relationship between men became the rule of the superior over the inferior – an arrangement which (as conquerors are fond of believing) he saw as equally advantageous to ruler and ruled.

Eastern influences were by no means confined to the world of ideas. Much of the physical appearance of Roman buildings demonstrated their debt to the East. Greek colonies introduced the structural adhesive of sand, lime and water. It seems likely that foreign architects were imported to construct the domes and vaults which could be built from concrete. Glass-making came from Syria, glass from the Phoenician coast. The Roman taste for gardens can be traced back to Syrians, Babylonians and ancient Egyptians. In Ovid's 'Metamorphoses', and similar collections of myths, the influence of Syria and Babylon can easily be seen. For five hundred years, beginning with the time of Alexander the Great, Greek writers in Syria based their romances on the legends of Mesopotamia and nearby countries, and in Egypt ancient stories were translated and new ones written in the same manner.

Under Roman occupation, the Near East was far from being a poverty-stricken backwater. Cicero found Asia Minor '. . . so rich and fertile that it easily surpasses all lands in the fruitfulness of its soil, the variety of its products, the dimensions of its pastures and the number of things to export'. One of its most notable exports was religion. Eastern cults were numerous and diverse: Mithraism enjoyed a wide popularity in the West, and of course it was in Asia Minor that Christianity first took hold. Asia Minor was also known for its educational centres.

Syria was almost as prosperous as Asia Minor. Despite the frequent involvement in military operations against the Parthians (Persians) on the frontier at the Euphrates, people and goods continued to pass through Aleppo and Palmyra and other caravan centres, and brought with them into the later Roman world many features of Oriental art.

Pilgrims and students came to Syria: there were sun-cults at Emesa and Heliopolis (Baalbek); there was an excellent university at Antioch. In Sidon astronomy was taught, and medicine at Laodicea and Apamea. From Apamea came Numenius, the philosopher who influenced the third-century Egyptian neo-Platonist Plotinus. Perhaps the most notable testament to the vigour of Syrian intellectual life is the fact that Papinian and Ulpian – whose names are familiar to every student of Roman law – were both Syrians. Every port in the Mediterranean had its branch of a Syrian merchants'

guild: they enjoyed what was almost a monopoly of the business of carriage of goods by sea. Rome itself absorbed vast numbers of slaves from the Near East. While, as we have seen, the Easterners and their descendants met with strong antipathy from Juvenal and others, they tended to occupy important posts – and indeed Julia Donna, a powerful and cultivated woman who was the daughter of the high priest at Emesa, became the empress of Septimus Severus, and shortly afterwards her Syrian relatives occupied the imperial throne (218–235).

With the people from the East came ideas from the East – cultural as well as economic borrowings, the religious along with the technological and artistic. The influx from the East was an established phenomenon of Mediterranean life long before the Western Empire began to decline, and, as we shall see, the movement of people and ideas continued down the succeeding centuries, when the Roman schools of sculpture had shut, the Roman villas had been abandoned (and not, as was once believed, burnt down), when government had fallen into the hands of small dictators constantly at war with one another.

Already in the second century the Goths, then in the Ukraine and South Russia, had come into contact with Iranian Sarmatians and when they returned in their sixth-century migration to northern Europe, they carried with them Eastern and especially Persian influences.

The Monasteries

Early in the fourth century in Egypt there arose an institution which was destined to have the most profound effect on the pagan world: the institution of monasticism. It spread with quite unexpected speed to countries in the East as well as to the West, even though – or perhaps precisely because – the monks in the desert were the most extreme manifestation of the Oriental religious spirit, and the very antithesis of classical civilisation. In the West, the most influential of the monasteries was that established by St Benedict at Monte Cassino in 529. It became an intellectual gateway to Europe. As civil government broke down, it maintained intellectual and artistic links with Egypt, Syria and Byzantium. The spread of the order was encouraged by Charlemagne, and by the ninth century monasteries and priories had been built as far away as Languedoc and Aachen. In its most brilliant period, under the Abbot Desiderius, in the eleventh century, artefacts and artists were imported from Constantinople, and it was through Monte Cassino that for example the pointed arch found its way from North Africa to Cluny and thence to the early Gothic style in Europe.

Romanesque architecture in Europe was affected also by the spread of the Mohammedan religion. One of the first and most immediate effects of the Arab invasions was the emigrations they caused: Greek-speaking monks and clerics fleeing into Italy and southern France brought with them the ivories and illuminated manuscripts from which the sculptors of *tympana* and capitals drew so freely. One should say straight away that this was not the only source of Greek culture available to the West: there were sacred objects which had and continued to come from the East, in the ordinary course of commerce; there were missionaries from Ireland, where Egyptian monasticism took root; and later there were refugees from the prohibitions against images in the Byzantine Empire. Generally, there was a good deal more movement – both of people and goods – during the Dark Ages than is generally supposed. From Gregory of Tours we learn that there were Syrians at the fair near Troyes in the ninth century; we know that gifts from Alexandria and Syria were highly prized in the Rome of that period. Syrian manuscripts provided the model for the Utrecht Psalter (Rheims school c.832). In 668, the Archbishop of Canterbury was Theodore of Tarsus (Cilicia, in what is now south-east Turkey). Between 686 and 731, there were no fewer than five Syrian popes in Rome.

72,73

The Moslem World

But the flight of refugees from the lands conquered by Islam should not lead one to suppose that the conquered territories became some kind of cultural desert, inhospitable to art and learning. The very opposite was the case. Nothing could have been more sophisticated than the eighth-century court of Harun ar- Rashid in Baghdad. Baghdad was widely respected as a centre of learning for two hundred years. And it was the Umayyad Caliphs who left Syria after the bitter struggles with the Abbasid dynasty and established themselves as rulers of Spain. They took with them thousands of Syrian masons and workmen. In Cordoba, they had a library said to contain 400,000 volumes, which attracted scholars from all over the known world, and a high level of learning prevailed not only in Cordoba but in all the capitals of the principalities of Moslem Spain.

Although contemporary Europe was not ready to absorb the algebra, trigonometry and astronomy, the knowledge of chess, paper, medicine and numerals, and all the scientific and philosophical knowledge of the Islamic world, it did not remain entirely cut off from the ideas and artefacts of this vigorous and sophisticated civilisation. We know that Pépin le Bref received gifts from the Caliph of Baghdad in 741; he sent an embassy there in 765, and he donated a Persian shroud to the abbey of Mozar (Puy-de-Dôme). The Mozarabs – the Christians living in Moslem Spain – also participated in the intellectual life of the Caliphate, and many

Mozarab monks were to be found in the monasteries of the Christian states to the north. Indeed, it was not unknown for Christian princes to be sent to be educated among the Saracens. There was much for them to learn. The story of Ziryab is characteristic. He trained as a musician at the court of Harun ar- Rashid, but incurred the jealousy of his master and had to flee the country. He arrived in Spain in 822, and for thirty years he played the part of a kind of Beau Brummel, introducing new fashions in dress, new recipes in cooking, and such sophistications as the use of toothpaste and the standard order of courses – from soup to dessert – in a meal.

The learning and the fashions of Islam gradually penetrated Western societies, at first via Spain, later through the Normans after their conquest of Sicily, and later again with the returning Crusaders. There were Carolingian deputations to Cordoba, which returned from the Umayyad Caliph laden with gifts. The Moslem influence extended over a long period and was of the greatest importance, but it has been a fashion among Western writers – until very recently at least – to deny or minimise the importance of this, whereas the derivation of ideas from the civilisations of China seems to have been readily – not to say enthusiastically – acknowledged. It may be that this scar on Western intellectual life remains from the many centuries of ideological and political confrontation between the Christian states of Europe and the church on the one hand and the Arab, and later Turkish, Moslem Empires on the other; but these events are long past, and it should be possible now to look at the influence of the Near East on the development of European civilisation in an objective and dispassionate fashion.

Western Europe

Western Europe appears to have been particularly subject in the ninth century to anti-cultural forces. There were squadrons of mounted Hungarians sweeping through the West, spreading terror and devastation. Earlier than this, the Normans had burned the library and archives of Tours, believed to have been among the richest in Europe.

A force in the opposite direction was the continued growth of monasticism: the Irish in particular, with their Egyptian heritage, were endowed with strong missionary zeal. They read the pagan writers and wrote as well as read Greek; their prose style was full of Hellenistic mannerisms. They and their protégés were to be found in the new monasteries of Fulda and Reichenau in Germany and St Gall in Switzerland.

The ninth century also saw the building of the Palatine Chapel in Aachen and the church of Germigny-des-Prés, but it seems likely that these churches did not have native architects. They are both buildings of Eastern types: it has been suggested that a Syrian was responsible for the Palatine Chapel at Aachen, modelled (as we have

15 San Vitale in Ravenna (completed 546–8);
apse, exterior

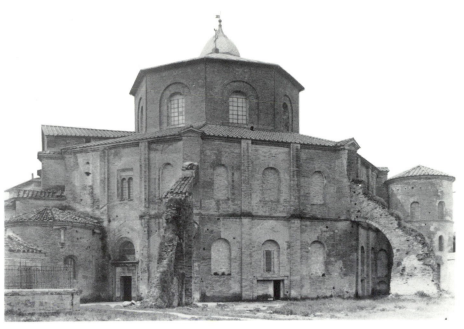

16 Saint-Philibert at Tournus in Burgundy
(c.950–1120); analytical perspective

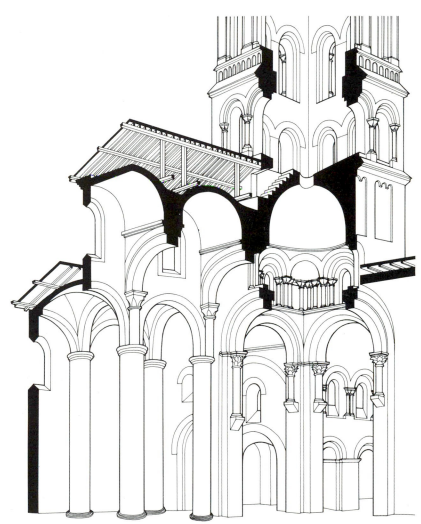

15 said) on San Vitale at Ravenna; and an Armenian architect has been suggested for Germigny-des-Prés, which had a dome supported on pendentives over the intersection of the nave and transept. Then came the churches of San Vincente in Cardona (in Catalonia), Saint-

16 Philibert at Tournus (in Burgundy) and San Paregorio at Noli (in Liguria) – buildings owing nothing to the Carolingian or Ottonian renaissance but redolent of Coptic, Arabic and Syrian styles. Here were the terracing of the masonry round the towers over the crossing, the walls with blind arcading, the vaulting between thick walls or pillars creating narrow internal spaces – foreshadowing the structural systems, massive masonry and plastic effects of the Romanesque style.

But in the main, the ninth century was an era of invasions and destructions: Vikings, Normans and Danes, Hungarians and Saracens burned libraries and sacked monasteries, and such progress as had been achieved in the Carolingian renaissance was lost. Further advances were made under Otto I and his successors: from the tenth century onwards we can discern an increasing awareness of the civilisations of the East. The abbey church of St Cyriakus at Gernrode (founded 961) has galleries and alternating supports in the

17 nave of plainly Byzantine origin. The churches of St Maria im Kapitol in Cologne, San Salvatore at Spoleto and Santa Sofia at Bénévent are derived from Near-Eastern prototypes. The rotunda at Saint-Bénigne at Dijon has its evident prototype in the Church of the Holy Sepulchre in Jerusalem.

The second half of the ninth century saw the end of the iconoclastic controversy in Byzantium: the capital of the Eastern Empire became once again a meeting-point for Slavs, Italians and Syrians. Visitors from the underdeveloped West could only gasp in awe at its architectural marvels. By the tenth century, both the Eastern Empire and the Muslim world were enjoying an era of great brilliance. So it comes as no surprise that after the visit of the Count of Barcelona to the monastery of Saint-Géraud in southern France, the scholar Gerbert (later Pope Sylvester II) went with him to Spain, where he got to know Islamic schools of learning, and then on, first to Rheims, Germany and Italy, and then to the Near East: in Constantinople he found a great intellectual centre which had renewed its ties with ancient Greece.

At the same time, the Byzantine Empire was reconquering Cilicia (south-east Turkey), Syria and Armenia. The cultural influence of the revived Byzantium was felt with particular force in Italy: monks and hermits in Calabria decorated their cells with paintings in the style of Cappadocia (central Turkey); Constantinople had close ties with Bari, Gaeta, Amalfi and Venice. The mosaics at Torcello of c.1008 are Byzantine.

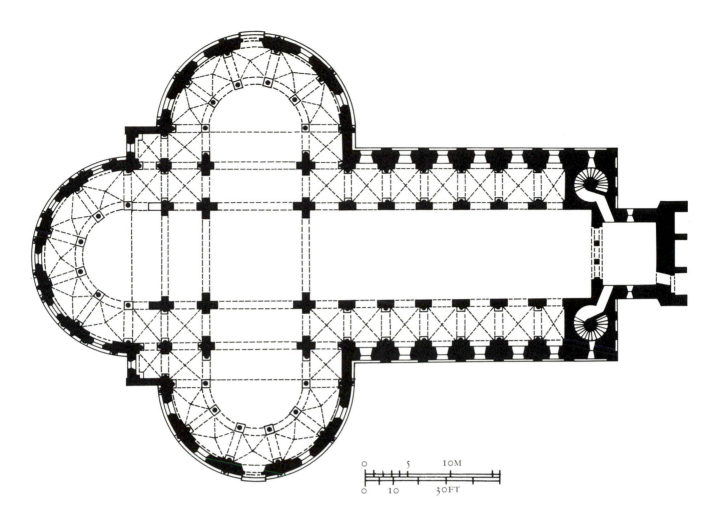

```
O        5        10M
├┼┼┼┼┼┤──────┼──────┤
O    10      30FT
```

17 St Maria im Kapitol in Cologne
(9th century); plan

The Eve of the Romanesque

A survey of Western Europe on the eve of the great era of Romanesque does not show a world continuing a cultural heritage left by the Western Empire. Even the Ottonian dynasty, which followed Charlemagne, had continuous political and cultural ties with Byzantine and Moslem civilisations. The Empress herself was a Byzantine princess. There were envoys from Cordoba, visits from Mozarabs, journeys to Constantinople. The school at Liège taught Greek and geometry. Gerbert had a great interest in Greek learning: he studied mathematics in Catalonia, where a large number of Arabic works had been translated and collected; his abacus – quite different from the Roman counting frame – was introduced to the West (very probably by Gerbert himself) from the Arabs, who in turn had it from India; he taught mathematics to Otto III, with whom he was very friendly. Of all the aspects of Greek culture penetrating the West at this time, mathematics played perhaps the most important part in preparing the way for the Romanesque, for, without a knowledge of mathematics, construction of large buildings is impossible. The new knowledge was not always welcomed: when

33

Gerbert reproached the Romans for their ignorance, he was told by the papal legate that God had always chosen, not orators and philosophers, but peasants and illiterates. But the Eastern influence spread nevertheless.

Though artistic and learned, the Byzantine Empire was cruel and intolerant in a way which the world came to associate with the spread of Christian dogma. Condemned heretics and expelled philosophers found refuge in the tolerant Moslem world, where the Arabs themselves were, as such, a tiny minority, and Jewish, Zoroastrian and Christian minorities flourished. Nothing in Western Europe could remotely equal the sophistication of Byzantium and Baghdad, and it was, one may suppose, inevitable that when the West embarked upon the building programme of the eleventh century, it should look eastwards for its artistic inspiration and for all the advanced technical skills – from the mathematics and geometry to the fashioning of ashlar – which those vast and unprecedented structures required.

The Romanesque

The world did not (as we know) come to an end with the year 1000. This turn of events – or, more precisely, this lack of turn of events – not merely surprised the Christian world, but seems to have galvanised it into a new life and vigour. But there were other occurrences, of a more positive nature, which left their mark on this epoch.

In 1009, the Fatimid Caliph Al-Hakim ordered the destruction of the Church of the Holy Sepulchre in Jerusalem. This signalled an end to a long era during which Christian pilgrims had had – after the early zeal of the Moslem conquerors had faded – free access to the holy sites of Palestine. There followed a period of crusades, culminating in the official and murderous 'First Crusade' of 1095.

The other great event was the conquest of Sicily in 1066 by the Normans. Here they came into direct contact with the Arabs. Normans also took part in the reconquest of the Iberian peninsula from the Moors: in 1064, Barbastro was captured – an event in itself responsible for a considerable diffusion to Western Europe of knowledge of Islamic art and culture.

Meanwhile, the travels of civilians to the East and the artistic influence of its goods continued as in earlier centuries: we read of Greeks and 'Arabs' at the monastery of Bec and of Abbot Wino of Helmarshausen returning in 1033 from the Near East, where he had been sent expressly to study its architectural traditions; a gold *antependium* bearing the old Oriental motif of the Tree of Life was given by Henry II to an abbey in 1020; Byzantine and Islamic textiles, intaglios, cameos, crystals and objects in precious metals continued to be imported and imitated by local craftsmen. But the most direct exposure of Westerners to the art and culture of the East in the

eleventh century resulted from the military exploits of the Normans and the Crusaders. During the siege of Antioch in 1095, ambassadors of the Crusaders were held in Cairo, where Bab al Futah had been built between 1087 and 1091; it is not without significance that the inner jamb of the Cluniac priory Le West at Boulogne (dated 1100) has a stepped serrated entrados exactly similar to that of the gate in Cairo.

Nothing even faintly comparable was occurring in Rome: as far as architecture was concerned, there were a few additions to earlier buildings, mainly earlier Christian basilicas (the campanile and portico of San Giorgio in Vilebra, for instance) but no work of consequence.

The Bayeux Tapestry was made in southern England, but much of its iconography is Eastern – the birds with their necks wound around each other, for instance, and the opposing winged horses, confronted camels, the griffins and the series of beasts in the borders. The date of the tapestry is 1077 – five years after the conquest of Palermo. Other aspects of Arab artistic and intellectual life were spread throughout Europe by Benedectines – whose great monastery at Monte Cassino played a crucial part in this dissemination.

Another gateway for Eastern culture to enter Europe was Spain. The Seljuk Turks captured Baghdad in 1055 and the great Arab intellectual and cultural achievement spread westwards; it came to Spain last, and remained there longest. What flowered in Cluny, Vézelay, Autun and Fontenay came to Burgundy from Tours, and to Tours from Provence and Toulouse, which received along the pilgrim and trade routes the methods and techniques of the 'Islamic'

18a,b architects via the abbeys of Cuxa, Canigou and Ripoll in Catalonia – a province in the north-east of Spain, strongly influenced by Mozarabic culture.

The kind of pointed arch which became familiar in Western Europe was already known in the Moslem world – not in those parts generally accessible to the West, but in parts of the Near East which became known to Westerners in the course of the First Crusade.

The first seven known examples of the pointed arch occur in Syria: the church at Qasr Ibn Wardan (561–4); the mosque at Damascus (705–15); the audience hall at Qsayr'Amra (712–15); the calidarium at Hamman as-Sarkh (725–30); the mosque at Qasr al-Hair (728–9); and vaults at M'shatta and Qasr al-Tuba (744).

Exactly how knowledge of this feature travelled back to Europe can only be a matter of speculation – whether through the observation of clerics and knights or by the experience of trained masons able to bring back the vital elements of the design, or whether Moslem masons themselves brought the pointed arch to the West; but what the pointed arch called for – as did the elaborate and often symbolic structures erected in the next centuries in the Gothic style – was a more sophisticated use of geometry, and this could only have come from the East, for knowledge of Euclid was preserved in the Moslem East and lost in the Dark Ages of the Christian West.

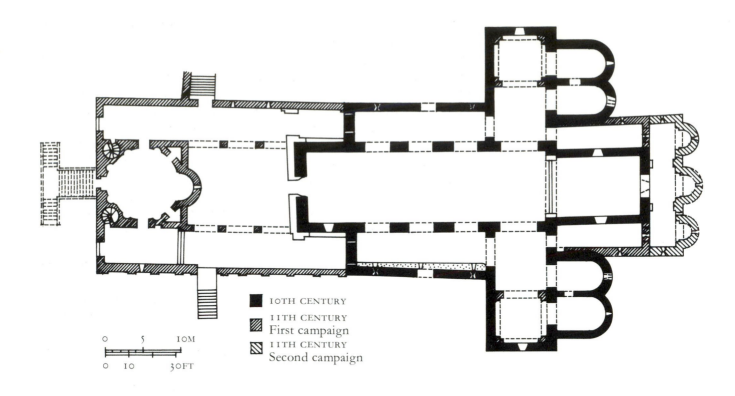

■ 10TH CENTURY

▨ 11TH CENTURY
First campaign

▨ 11TH CENTURY
Second campaign

0 5 10M

0 10 30FT

18 a & b The abbey church of Cuxa, Spain
 (10th–11th centuries); plan and elevation

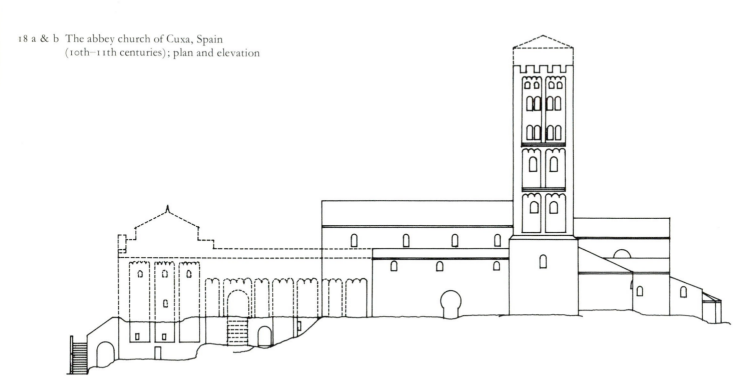

The great cultural heritage we have described, stemming from Syria and from Palestine, Asia Minor, Egypt, Armenia and Byzantium itself, was the basis for the astonishing cultural upsurge witnessed by Western Europe in the 150 years following the passing of the dreaded year 1000. No doubt the release from the pessimism of the doom-laden previous century generated more spiritual and intellectual energy, and the freedom from the devastation and uncertainty of the invasions of Vikings, Saracens and Huns turned men's minds to the creation of buildings and objects of permanence. But perhaps above all it was the gradual but persistent improvement achieved by the monasteries in agriculture and husbandry which created out of what was still a preponderantly agricultural economy the truly amazing economic surplus, which not only supported a priesthood of considerable size, and the courts and military units of innumerable feudal lords, but built at an unbelievable rate churches and monasteries in a unique and sophisticated manner – many of these edifices being of a size which relative to any other building of the period can only be described as gigantic. It is our good fortune that this confluence of artistic heritage, political peace and economic prosperity produced – most notably in France – some of the finest creations of the human spirit.

It is the high quality of these ecclesiastical buildings – their structure, their sculpture, their capitals and their low reliefs, and of the artefacts associated with them, which has inspired us to seek out their origins, and we hope that the reader, armed with the information contained in these pages, will appreciate the value and distinction of these works with an insight he would not otherwise have had.

CHAPTER 2 ARCHITECTURE

In Dura Europos (Qalat es Salihiye), a provincial town on the easternmost frontier of Syria, facing the Sassanian kingdom across the Euphrates – have been found the remains of the first securely datable building devoted to Christian worship. Christianity was still a minority cult in Dura Europos, though it was accepted as the state religion in Nisibis, in northern Syria, and was to attain that status in Armenia in the early third century and later to be adopted by Constantine as the official religion of the Empire. So it is perhaps hardly surprising that the meeting house in Dura Europos (c.230) was established in a dwelling like any other, facing into a small courtyard and having no exterior windows. It is interesting not so much for its architecture as for its interior decorations: these New Testament scenes, and the similar Old Testament scenes in an essentially similar building nearby, which served as a Jewish synagogue, set the iconographical pattern for frescoes and mosaics which were to adorn Christian churches for the next thousand years.

PLATE IV

Splendid as were to be the great basilicas of Constantinople, it is not in the capital city that we find the very beginnings of the kind of ecclesiastical structure which so strongly influenced the subsequent development of Christian building, but in the provinces of the Byzantine Empire.

By the middle of the third century, sixty per cent of the population of Asia Minor professed Christianity. But the Byzantine provinces consistently opposed the centralising ambitions of the Imperial government and the established church, and were marked by doctrinal differences, retention of local languages, the institution of monasticism and a tradition of art and architecture which owed more to their Mesopotamian neighbours than to the Hellenising influence of the capital. Nisibis was an important spiritual centre, and Alexandria the leading centre of Christian thought. Of the Christian churches of this epoch there is no detailed evidence, and even remains of later buildings present unsurmountable dating problems, but it seems that in Mesopotamia there developed the church in the shape of a longitudinal hall, resembling the halls of the Sassanian kings and having many features sharply distinguishing them from pagan temples of the Graeco-Roman tradition – narrow doors at the end of the nave giving access to a tripartite sanctuary (one leading to a rectangular central room and the other two leading to similar rooms on either side), the sides lined with projecting piers or columns supporting transverse barrel vaults over the intervening

niches, and a longitudinal barrel vault over the nave.

The kind of rectangular building known by the general name of 'basilica', often extended in length by an apse and in width by the addition of aisles on either side – the aisles having monopitch roofs and being divided from the central nave by columns, was used in Roman and pre-Roman times for a variety of civil purposes. It was a practical – and no doubt at its best a lucid and elegant – form of building, but an atmosphere of spirituality and religious awe was far from its purpose. Christian communities adopted the name, but not the buildings themselves. The Christian basilica developed many new features – sanctuaries for example; square piers (as opposed to round columns) were often used to support the clerestory. Most importantly, the columns of the Christian basilica did not continue along the short side of the hall in front of the apse.

The Fourth Century

In 313, Constantine declared Christianity the official religion of the Empire, and in 330 he moved its capital to Constantinople (Byzantium). The court rituals of Byzantium soon began to resemble those of the Persian monarchs, and a faith of the humble and meek was rapidly transformed into an integral part of the Imperial power-structure. The modest domestic meeting-places of Christian believers were superseded by large and conspicuous churches, built by Imperial command. These were new buildings. Temples of earlier cults were not utilised: they were not designed to accommodate congregations of the faithful, and their pagan association made them in any case unsuitable.

An absence of monuments and paucity of literary evidence means that we know virtually nothing of the churches built in the great centres of Alexandria and Nicomedia (near Constantinople). There is some indirect evidence of the Golden Octagon in Antioch (now in Turkey, near the border with Syria) and of the cathedral at Tyre (now in Lebanon) and some remains, and considerably more literary evidence, of the churches of Constantinople, Jerusalem, Bethlehem and Orléansville (now El-Asnam in Algeria). The churches of Trier (Germany), Milan and Rome, however, are better documented and to some extent remain standing. From the evidence we have, it is plain that (as may be expected), the impetus for this vast building programme came from Constantinople: the churches were by no means uniform in style, but they were replete with features which were to become the hallmarks of Christian architecture.

The cathedral in Tyre (316–17) is known from a contemporary description. It was a lavish building. The three portals of the entrance impressed the worshipper with awe and reverence. The *diwan* – the impressive gateway – had a long tradition in the Near and Middle East, and it was to be a feature of Christian churches from Qal'at Sim'an in Syria (480–490) through Saint-Riquier at Centula to

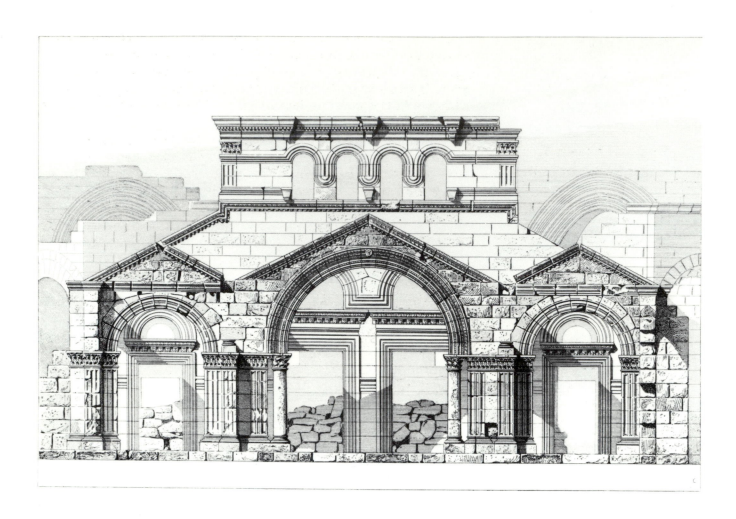

19 The church at Qal'at Si'man, Syria
(480–90); main portal

the great monuments of the Romanesque: The nave is described as
'towering' above the aisles: here we may discern the use of vertical
stress – the sense of height of the building turning the eye upward
and lifting the soul to heaven; this was to be much adopted in
Europe (though it was never to be a predominant feature of
Byzantine churches, which characteristically present a low, not to say
squat, silhouette).

20 The cathedral (c.324) at Orléansville, then a remote bishopric of
the Byzantine Empire and now El-Asnam in Algeria, was an isolated
rectangular building, some 85 feet long and 53 feet wide (c.28m ×
18m); it was divided into a nave and four (not two) aisles, the
division being effected by piers (rather than columns) – a feature
found in Qalb Lozeh (c.500) in Syria and, later, in many European
churches. Under the main apse was a crypt; a second apse – on the
short side opposite the main apse – was added in the fifth century,
and galleries over the aisles may have been added in the sixth century.

The famous Golden Octagon in Antioch (327) is known only from
literary sources and a representation in mosaic, but it appears to have
been the first example of a church plan of which there were to be
many later variants; around a central space were columns supporting

a gallery, beneath which lay an ambulatory. Its antecedents may be traced in earlier centralised buildings of the eastern Mediterranean (e.g. the Hypostyle at Delos) and its successors in Justinian's churches of the sixth century (Hagia Sophia and SS. Sergios and Bakchos in Constantinople) and later in San Vitale in Ravenna (546) and the Palatine Chapel in Aachen (792).

The tradition of Christian architecture may be seen as stemming from the ways in which the longitudinal hall and the centralised space were varied and combined in the churches of Palestine, Syria and elsewhere in the Byzantine Empire. In the first Church of the Nativity in Bethlehem (333) the nave terminated in an octagonal *martyrium*, built over the holy spot where Jesus was believed to have been born. A more elaborate rotunda, with an internal colonnade supporting a baldacchino, and niches projecting from the external walls (the *Anastasis* Rotunda) terminated the nave of the Church of the Holy Sepulchre in Jerusalem (325). The architects were Zenobius, a Syrian and Eustathios, from Constantinople.

20 The cathedral at Orléansville (now El Asnam), Algeria (c.324); plan

0 40FT

0 15M

BEFORE 475 (WEST APSE) AND 6TH CENTURY (STAIRS)

The experiment was not pursued in Rome, which remained conservative and made no contribution to the development of the Romanesque. Here the first churches followed the pattern of the civil *basilica* – notably the Lateran Basilica (313), and St Peter's (319). A round church (still standing, and now called Santa Constanza) was built in 350 as a mausoleum for Constantine's daughter. As in the *Anastasis* Rotunda, an ambulatory surrounds the central space, here separated not by single but by double columns.

A church in the shape of a cross has an obvious symbolic function. This plan was employed in St Babylas, outside Antioch (379), and in the Santi Apostoli in Milan (382). Both may be traced from the fourth-century Church of the Holy Apostles in Constantinople: over its crossing rose a drum, surmounted by a conical roof. At the central crossing of these churches the *martyrium* is no longer a separate space but becomes integrated into the structure. A similar combination occurs in San Simpliciano in Milan (late fourth century), whereas in San Lorenzo, also in Milan (before 378), the central space is more predominant and joins the nave not to other longitudinal spaces but to three smaller chapels, each of a centralised plan. Bishop Auxentius, a native of Cappadocia (central Turkey) is believed to have been the founder of San Lorenzo, and an Eastern architect has been suggested, at least for the southernmost part of the building. Indeed, all these churches in Milan (still standing today) are profoundly Byzantine in feeling; they depart radically from the

21 Santi Apostoli in Milan (382); isometric drawing

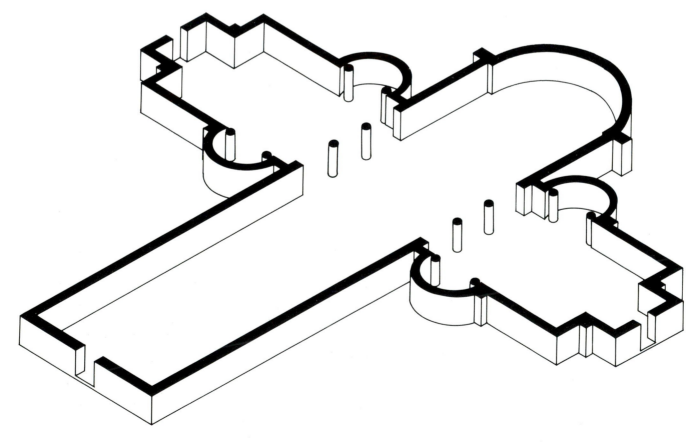

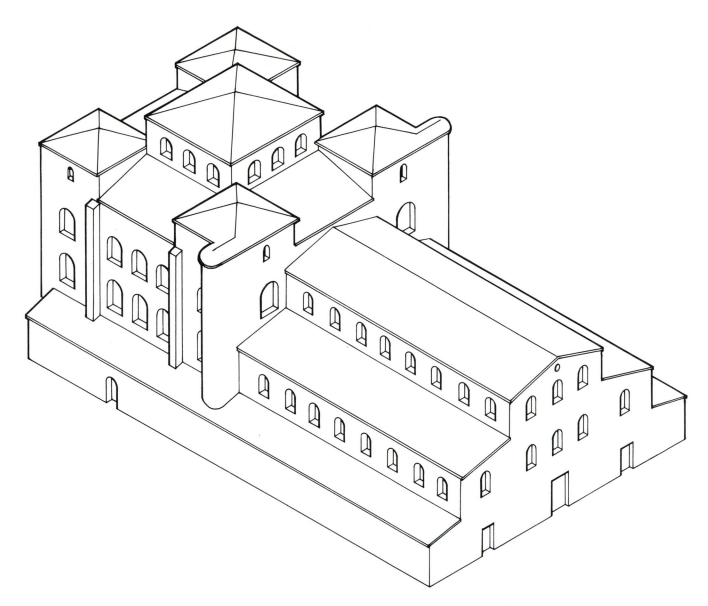

22 The first cathedral at Trier (after 326);
 isometric reconstruction

architecture of pagan times, and manifest a number of the 'Eastern fingerprints' which were to feature in later European church building down to the great Romanesque monuments of France. Characteristically, the silhouette is rich and varied, the internal volumes reflected in the block units of the exterior. Their walls are articulated with dwarf galleries, pilaster strips and blind arcading.

22 The first cathedral at Trier (after 326) was rebuilt in 380. Trier had strong links with Milan, and masons and foreign architects seem to have travelled between them. The new chancel (still standing, and incorporated into the Romanesque church) was made up of rectilinear units, with strong vertical emphasis, harmoniously put together. The resulting silhouette was not dissimilar to that of San Lorenzo. A large central square bay had four smaller and lower square bays at the corners, joined by four rectangular bays, the whole forming a centralised structure adjoining, here again, a basilical nave.

The Fifth Century

23 Dark and mysterious inside, the Mausoleum of Galla Placidia in Ravenna (425) has a strongly Eastern feeling. Its plan is in the shape of a cross, the arms slightly shorter than the nave, and barrel-vaulted, the centre rising to a pendentive dome. Mosaic, attributed to Syrian workmanship on stylistic grounds, covers the interior; on the outside surrounding the windows are blind arcades – a feature common in many Romanesque churches, especially those in Italy.

24 The exterior walls of San Giovanni Evangelista, also in Ravenna (425–34), are articulated with pilaster strips – pilasters without base or capital, which occur again in Anglo-Saxon and early Romanesque churches. Also presaging Romanesque building practice, the capitals are surmounted by impost blocks. In the plan of this church we can discern a feature which was characteristic of much Christian building in Asia Minor and was to become commonplace in Europe: this is the tendency of the building to, so to speak, explode – to have

23 Mausoleum of Galla Placidia in Ravenna (425)

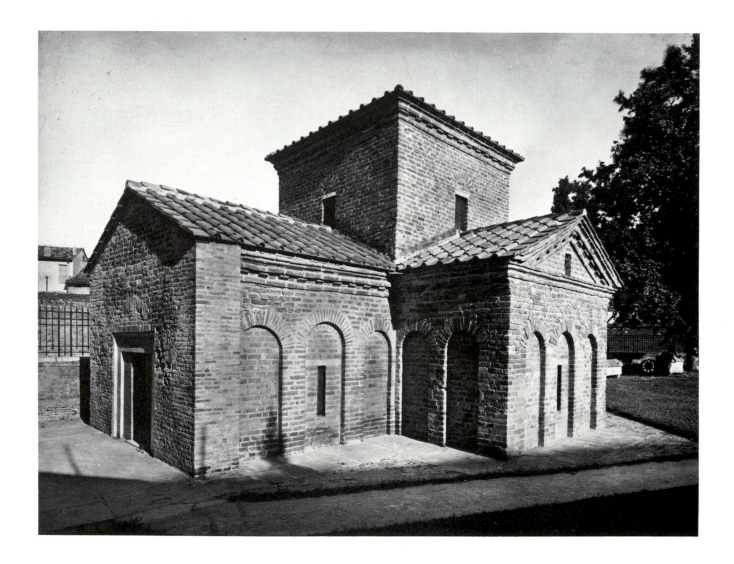

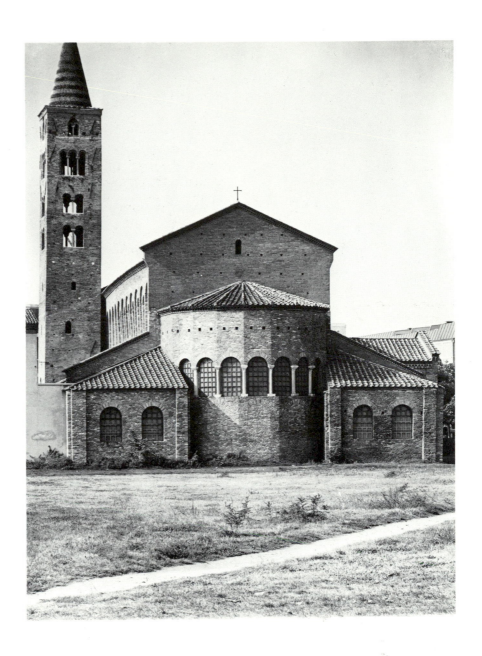

24 San Giovanni Evangelista in Ravenna
 (425–34)

elements lying outside its main contour. Here the 'exploded' elements were low towers on either side of the narthex; in other buildings, we find transepts, absidioles and other elements placed outside the principal space.

By the middle of the fifth century, a new way of terminating the nave had developed in Egypt, by the use of three apses at right angles to each other. Sometimes they were encased in the rectangular outer **3** wall of the church – as at the White Monastery (Deir-el-Abiad) near Sohag (c.440), but the ultimately more influential form was that of the triconch transept, where the side apses protruded beyond the exterior wall of the nave, as at the cathedral in Hermopolis – now **25** Ashmunein (c.430–40). It appears that this new plan had been developing for some time in North Africa, and an early, though not

45

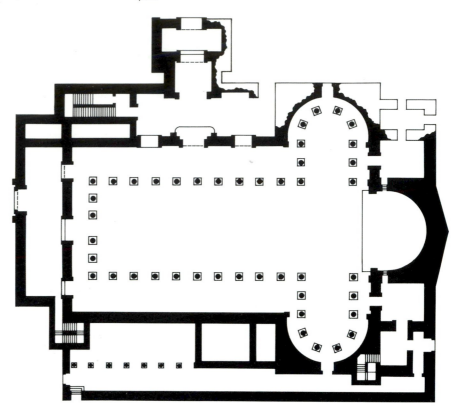

25 The cathedral in Hermopolis (now
Ashmunein), Egypt (c.430–40); plan

well-constructed, example occurred at Cimitile-Nola, near Naples,
(c.401–3). In a modified form, it was utilised in the influential Church
26 of the Nativity in Bethlehem, which was constructed between 560
and 603–4, and the influence on later church building is hard
to exaggerate – see, for example, St Maria im Kapitol in Cologne
(1040).

The fourth century saw the beginning of monasticism in Syria and
Egypt. This important movement was to bring to Western Europe
missionaries, artefacts and ideas from the Near East on an
increasingly large scale. Pilgrims in great numbers were already
travelling from the West to the holy places of Palestine, as well as to
the shrines of saints in Syria and Egypt, where churches and
accommodation had been built for them. An important pilgrimage
27 church was that of St Menas (Abu Mina) in Egypt, built in 412,
and rebuilt in 490. It was a cross-shaped *martyrium*; it is known to
have been modelled on the Church of the Holy Apostles in
Constantinople – the source of innumerable later cross-shaped
churches. The pilgrims' journals recorded plans, decoration and
architecture; the images of the manuscripts, icons, *ampullae* (vessels
holding holy oil or water) and other artefacts with which they
returned had a profound effect on the development of Christian art.

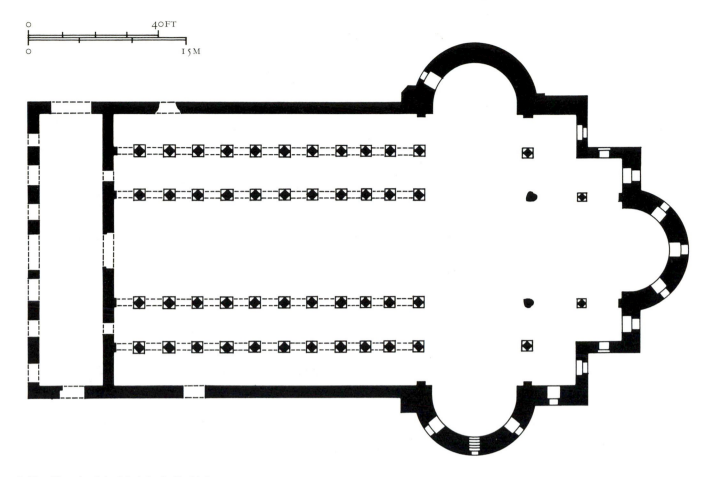

40FT

0

0

15M

26 The Church of the Nativity in Bethlehem
(560 and 603–04); plan

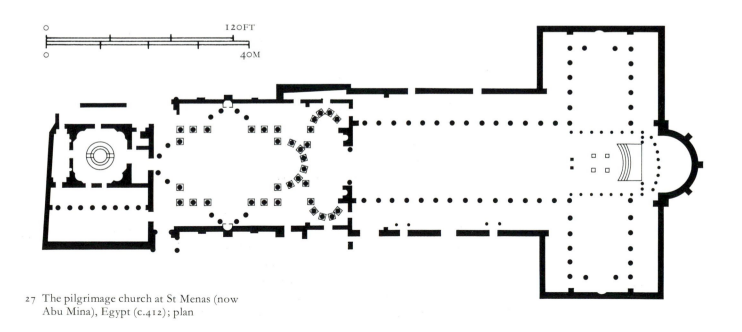

120FT

0

0

40M

27 The pilgrimage church at St Menas (now
Abu Mina), Egypt (c.412); plan

47

28 The monastic church of Saint-Martin at Tours was built in 470 (but replaced in the sixth century); it had the essential features whose development in the Near East we have already traced. In marked contrast to the horizontal, inward-looking and self-contained compositions of classical building, Saint-Martin displayed the vertical emphasis, and the combination of block units forming a complex internal space and the correspondingly rich external silhouette, which were to be the hallmarks of the Romanesque.

Syria

To this day, large areas of northern and central Syria present a truly astonishing sight: ruined churches, some with cloisters, dot the landscape, and remnants of columns and arches lie abandoned in profusion. The authors have seen fifth-century mosaic beneath the carpets in a peasant's house, and horses drinking from a sixth-century sarcophagus.

The largest and most monumental of these churches, the remains of which were seen by de Vogüé (and still, to a great extent, exist), was the monastery and pilgrimage centre built at the end of the fifth century around the pillar on which St Simeon Stylites spent the last **29** years of his life. The *martyrium* at Qal'at Si'man (c.480–90) had a central octagon surmounted by a pyramidal roof, from which radiated four longitudinal halls flanked by aisles. Three arms had seven bays; the eastern arm extended to 20 bays, and terminated in a triple apse, the central apse being twice as wide, and consequentially higher, than the two on either side. The elegance and sensitivity of the building is striking, even in its present state; the semi-circular arch over each apse, emphasised by finely executed mouldings, forms a particularly harmonious unit.

The church was large – 260 ft by 295 ft (80m × 90m); with its outbuildings it covered many acres. Drawing on a long tradition of fine masonry, in a region rich in quarriable stone (but comparatively poor in timber) it was constructed in ashlar – large blocks of finely dressed stone. The exterior walls were strongly articulated – on the side walls, a string course rising over the windows and arches, and the wall of the apse featuring a corbel table – projecting blocks beneath a continuous lintel. The impressive entrance had three portals; within, elegant bases supported columns surmounted not by conventional Corinthian capitals – still less by capitals taken from earlier buildings – but by the so-called 'windblown' capitals, deeply incised and portraying in a stylised fashion acanthus leaves blown from one side, giving an asymmetrical effect. But the distinguishing feature of the entire building was its extreme lucidity. Here, in a manner utterly remote from the habit of Roman building, the block units of the exterior clearly indicated the interior spaces they contained.

28 The monastic church of Saint-Martin at
Tours (470); reconstruction drawing

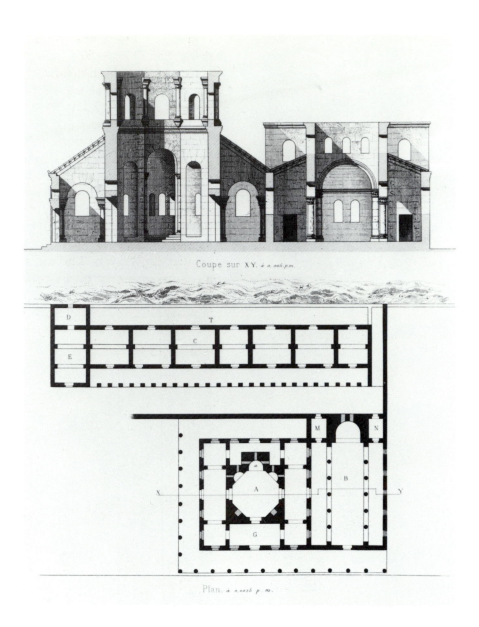

29 The *martyrium* of the church at Qal'at Si'man, Syria (c.480–90); plan and elevation

In the hinterland of Syria there developed a school of church building destined to be of the utmost importance to the vocabulary of Christian architecture, first in Asia Minor and Armenia, and later in Europe. In addition to the features noted in Qal'at Si'man, we should note those which may be seen in another comparatively well-preserved church not far away – that at Qalb Lozeh: the apse had three windows, a feature which, we are told by a contemporary Syrian poet, symbolised the Trinity, and was flanked, in the Mesopotamian tradition, by two chambers; piers were used to support the clerestory; on the south side, gabled porches were supported by and projected over the entrances; and – perhaps most importantly – the deep entrance porch at the west end flanked by two

30

towers, as at Turmanin. Syrian westwork was the precursor of many a later twin-tower façade, notably that at Saint-Riquier (790) in Centula in northern France. In other Syrian churches, the side chambers of the apse were topped by domes or low towers – e.g. at Turmanin and R'safah (where the squinches survive). Here we may see the germ of the profusion of towers which characterised the silhouette of Pliska, Bulgaria (sixth to ninth centuries) and of Saint-Riquier itself. Much of the interior detail of Syrian churches of this period is explicable not in functional terms, but in terms of the effect

31 it produced on the worshipper. At Qalb Lozeh itself, and also at Ruweha and R'safah the rows of short columns supported by brackets along the clerestory were there to produce an effect of monumentality, as were the wide arches opening on to the side-chambers at R'safah. The walls at R'safah were articulated with half piers supporting an upper order: the effect was at the same time to divide and unify the interior space. At Qalb Lozeh the nave is divided from the aisles by low piers and arches almost as wide as that of the apse: the effect is to give an impression of space larger than is there in reality.

30 The church at Qalb Lozeh, Syria (before 500); façade

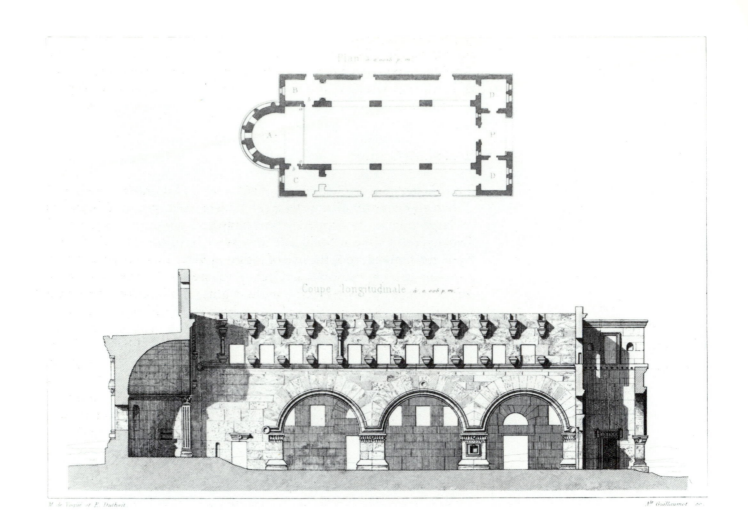

Plan à o,oo8 p.m.

Coupe longitudinale à o,oo8 p.m.

M. de Vogüé et E. Duthoit *M^{lle} Guillaumot sc.*

31 The church at Qalb Lozeh, Syria (before
500); plan and elevation

The church at Qasr Ibn Wardan was built in eastern Syria in 564.
The nave was roofed with short barrel vaults, and from its centre
rose a dome on squinches. An inner narthex, and a gallery over it,
were formed by a continuation of the aisles and galleries across the
west end. Interestingly, the lateral arches beneath the dome are
slightly pointed, hinting at the later development of the Gothic or
Moslem arch. There were galleries over the aisles, one above the
other, both divided from the central space by triple arches, one above
the other. It is thought that it was from the hinterland of Syria, rather
than from Constantinople, that the use of galleries over aisles spread
to other areas. Two notable examples remain standing in Rome.

Of the church of Sant' Apollinare Nuovo in Rome (c.490)
Krautheimer observes that it incorporates countless Eastern
features. Most immediately striking are the large and splendid
Eastern mosaics. They are not only beautifully executed but
beautifully lit. The lighting follows the custom of church builders in
the Aegean coastlands: windows illuminate both the nave and the
aisles, distributing light and shadow evenly throughout. The nave is
broad and high, and the span of the arcades wide, giving an

impression of great space. The arches supporting the clerestory rest on impost capitals. One particular detail evidences the debt of Sant' Apollinare Nuovo to the great churches of Syria: a continuous band of brick on the outer wall crosses the pilasters and arches over the windows.

The Sixth Century

5 The Mausoleum of Theodoric (c.526) takes up a number of themes of Syrian architecture. The walls are of ashlar: the technique of building in large blocks of dressed stone had died out in the West with Diocletian's palace at Split, but was, as we have seen, usual in Syria. Syria maintained, too, the use of joggling voussoirs – tapered stones forming an arch, the lower half set off to one side (to the right on the left of the arch, to the left on the right), the interlocking of the protrusion and indentation giving added strength to the structure. The arches around the base of the Mausoleum are joggled in this fashion. A gallery around the upper storey (no longer there) was roofed with short transverse barrel vaults of the kind found at Mar Yakub. These techniques in the masonry of the building are strong evidence to support the suggestion that Theodoric brought Syrian masons over to build it, and it is significant that an Ostrogoth ruler of what remained of the Western Roman Empire should have looked to the flourishing Eastern lands for the means to perpetuate his memory.

Another feature which we have noted in Syria is the use of galleries over the side aisles. In the course of the sixth century, this feature begins to occur in the West – galleries were added to earlier churches at Orléansville (North Africa) and nearby Tipasa, and were utilised in San Lorenzo fuori le mura in Rome (579–90) and later in Sant' Agnese, also in Rome (625–38).

The great church of Hagia Sophia in Constantinople (532–7) is undoubtedly the most astounding and impressive monument of the sixth century. Its cost, in present-day terms, was something over two hundred million pounds – a remarkable testimony, in itself, to the prosperity of the Byzantine Empire. Its architects – Anthemios of Tralles and Isidorus of Miletus – were not master-builders, but experts in physics and geometry, and inheritors of the long tradition of scientific knowledge in the Greek-speaking world; their daring building depended on nicely calculated stress and support, and they eschewed the massive volumes much used by Roman builders in the West. It is true that the result, while visually breathtaking, was not altogether a practical success – rebuilding was required in 558–63, in 869, in 989 and again in 1346, but it remained for centuries the most famous building in the most prosperous town in the known world, and its structural ambition and the complex interplay of space it made possible, was a constant source of inspiration to later architects.

14 The church of SS. Sergios and Bakchos was completed before 536.

53

The interior of this beautiful and sadly neglected building (a priest with a key must be found to open it, and chickens in the narthex flutter aside at his approach) strikes a curiously Baroque note: an octagonal central area is surrounded by an ambulatory and upper gallery, and surmounted by a 16-sided pumpkin dome of alternating scooped and straight segments, the whole producing a spatial ambiguity reminiscent of the Baroque masterpieces of southern Germany. Its antecedents may be traced in the dematerialised wall decorations of Parthian and Sassanian (i.e. Persian) architecture, in the centralised plans of churches in Armenia and in the techniques of light vaulting of Mesopotamia and Egypt. The tradition of building to a centralised plan was continued to some extent in the West – e.g. in San Vitale at Ravenna (completed 546–8) and in the Palatine Chapel at Aachen (792–805); but this does not lie in the mainstream of later European church building, until it was rediscovered in the Renaissance. Indeed in telling the story of the Romanesque, Byzantine church building, with its absence of verticality, its reliance on the centralised plan and into what ultimately became a stifling conservatism, lies somewhat at the margin of our history; the more influential events occurred in the provinces of the Byzantine Empire – in Egypt, Asia Minor, Syria and Armenia.

4 　　 From the early sixth century onward, churches with Syrian features were built in very large numbers in what is now southern Turkey – notably at Binbirkilisse and Kayseri. Pilasters articulated the outer walls; string courses rose in arches over the windows, aisles had galleries; capitals were decorated with patterns resembling vertical tongues; some façades appear to have had twin towers. In Binbirkilisse, a basilical plan was standard: the nave and aisles were barrel-vaulted, the clerestory – supported by horseshoe-shaped arches on low pillars – was pierced with small windows. In Kayseri and the surrounding parts of Cappadocia, the cross-church plan was adopted: the nave was short, and the apse, polygonal outside, was horseshoe-shaped inside; the exterior of the crossing was a tower, the interior a dome; all the elements were of equal height, and barrel-vaulted. In these remote uplands, features originating in Syria in the fifth and sixth centuries were continued into the seventh, eighth and ninth centuries and had a profound and continuing influence on the development of an architectural vocabulary for Western Europe.

32 　　 The church at Meriamlik in southern Turkey, (471–94) is the first known example of a church type which became common in the Eastern Empire and had a lasting influence on church building in Europe – the domed basilica. This, in essence, is a basilica, with a nave, aisles and galleries, and a tower or dome above the centre bay of the nave. It occurred elsewhere in southern Turkey in the late fifth century, and the church at Qasr Ibn Wardan, in Syria, was of this type. The type was represented in Constantinople, before the time of Justinian, by St Polyenktos (524–7), and was much used by
33 　　 Justinian's architects (e.g. in St Irene in Constantinople, begun in 532 and still standing – though considerably modified in the eighth

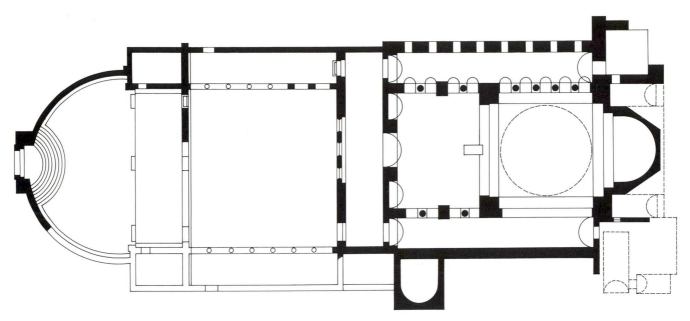

32 The church at Meriamlik, southern Turkey
(471–94); plan

33 St Irene in Constantinople (begun 532);
interior

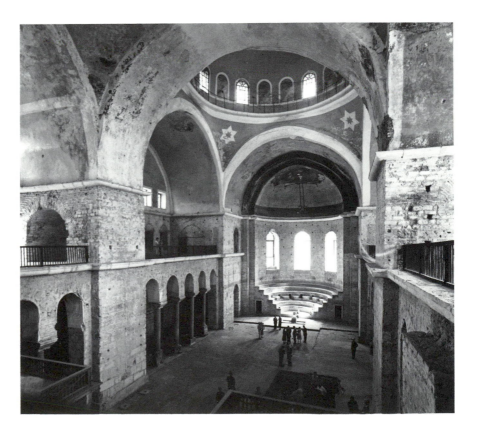

34a,b

36

century, and in the church of St John at Ephesus, completed by 565). The great step towards a recognisably mediaeval church plan came when a transept was added to the domed basilica: this occurred in a tentative form at Philippi, in Macedonia (Basilica B, before 450), at Paros, in the Greek Islands (after 550), at Gortyna in Crete (late sixth century), and in a mature form in the cathedral at Sofia, Bulgaria (sixth to seventh centuries).

Sant' Apollinare in Classe, in Ravenna (532–6), has a number of elements already seen in San Giovanni Evangelista – the blind arcading framing the windows, the narthex flanked by low towers, the use of impost blocks above the capitals. Its interior has the spacious and luminous quality of the churches of the Aegean – like that of Sant' Apollinare Nuovo, and much of the marble used in the building was imported from the East – the columns, 'wind-blown' capitals, pedestals and veneers. The apsidioles of the side chambers have their prototype in Asia Minor – for example in St Thecla at Meriamlik.

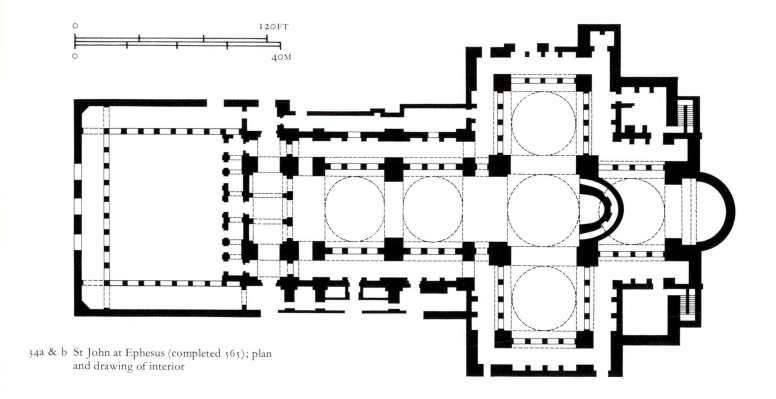

o 120FT

o 40M

34a & b St John at Ephesus (completed 565); plan and drawing of interior

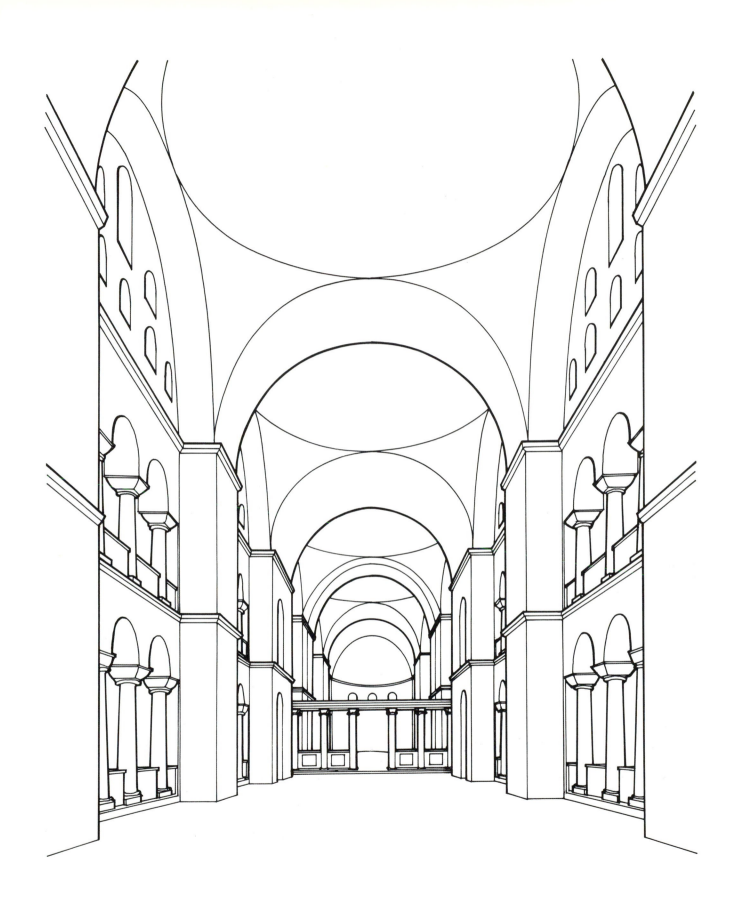

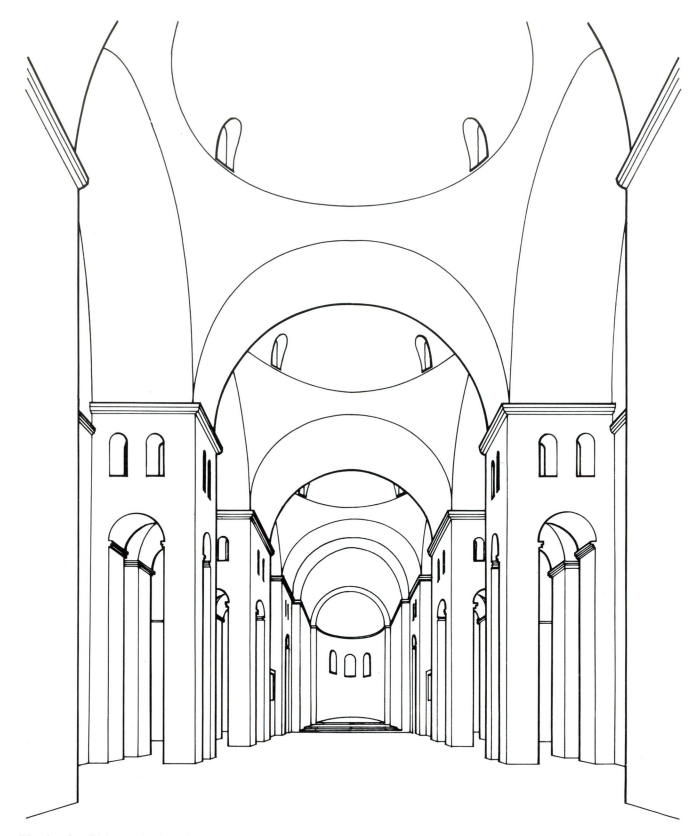

35 The church at Périgueux (11th–12th centuries);
drawing of interior (compare with Fig.34)

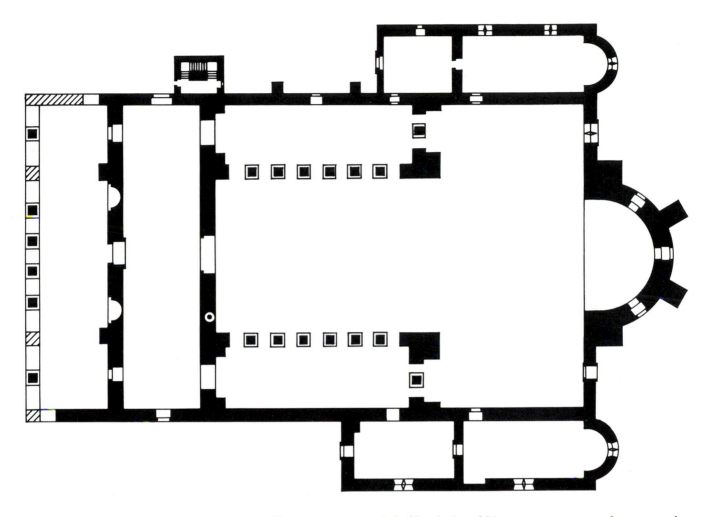

36 Basilica B at Philippi in Macedonia (before 450); plan

From the second half of the fifth century onwards, strongly Byzantine churches appear in Ravenna and Istria – e.g. at Poreč, Pula and Grado. In the cathedral at Poreč, we find a triconch chapel – similar to one at R'safah, imported capitals, and exterior stucco decoration (a rare survival); there were aisles ending with absidioles – as at Qal'at Si'man. The *martyria* at Pula recall pastophories found at R'safah. The exterior of the apse of the cathedral at Grado was enclosed by a straight wall, following the Aegean custom. The construction of these buildings was an important factor in carrying Eastern elements into what was to become the Romanesque architecture of Western Europe.

The Seventh Century

St Hrip'sime, in Vagharshapat, was built in 618. Four semi-circular apses in a slightly elongated square give it a cruciform plan. On the outside, deep niches rise up the building, emphasising its vertical tendency, lightening the otherwise massive appearance of the thick walls and outlining the cross of the plan, and at the same time reducing the actual weight of the structure.

The other famous seventh-century cathedral in Armenia was at Zvart'nots. This was an entirely new and original building, both in plan and elevation. The plan was cruciform, but the cross was inscribed within a circle. The building rose in three tiers – three cylinders on top of each other, each narrower than the one below. A more elongated version of this tetraconch silhouette appeared in the eighth century in the turrets of Centula, northern France.

Inside the Zvart'nots cathedral were numerous pillars, and 32 semi-pylons supported the arcades around the outside. Some scholars consider the cathedral at Bosra in Syria (512) its prototype and find it in one way or another reminiscent of churches elsewhere in Syria. Other scholars regard its origin as wholly Armenian –

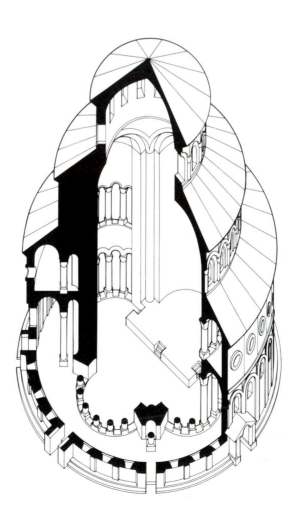

37 The cathedral at Zvart'nots, Armenia (7th century)

pointing to the remaining four or five monuments of the same type in the Transcaucasus, to the absence of churches of this type in other countries and to the testimony of the historian Kalankathustsi who wrote that Constantine III was invited to the opening ceremony and, astonished by the edifice, ordered the builders to follow him to Byzantium. But whatever their views about the derivations of this remarkable building, writers have generally agreed that its size and technique puts it into a category above anything achieved at that time.

Constantine's Church of the Nativity in Bethlehem was remodelled in the late sixth and early seventh centuries (560 to 603–4). The nave and aisles remained much as before; what was new was the combination of a transept and a triconch, the rectangular and semi-circular elements combining to produce a more sophisticated ground-plan and a more subtle relationship of interior spaces. The birthplace of Jesus being an important pilgrimage centre, the Church of the Nativity became well known throughout the Christian world, and the early trefoil transept and chancel had a conspicuous influence on later church building.

38a The cathedral in Sofia (7th century); plan

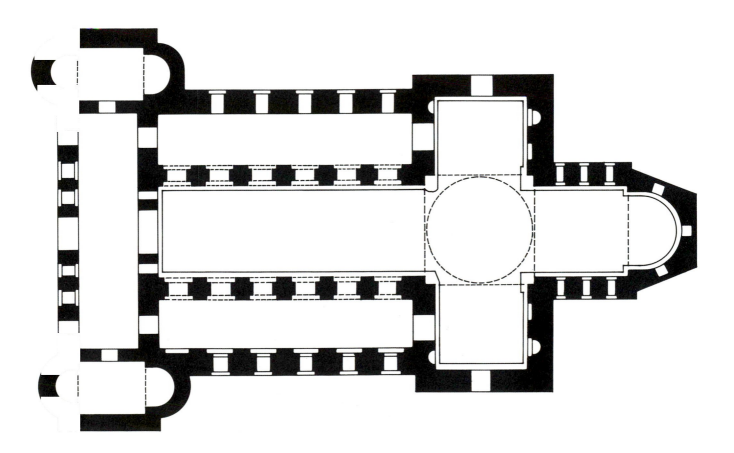

38a,b The beautiful cathedral in Sofia, Bulgaria, much of which, happily, is still standing (and carefully restored over many years) is the first building in our history which strikes the visitor as belonging unmistakably to the tradition which culminated in the Romanesque churches of Western Europe. Here the dome over the crossing is fully and satisfyingly integrated into the basilical plan. It dates from the sixth or early seventh century: it is known to have had a narthex of three storeys, flanked by towers (echoing its prototype in Syria), and blind arcading in the walls of the chapel and transept. What is now Bulgaria was at that time a part of the Byzantine Empire, but

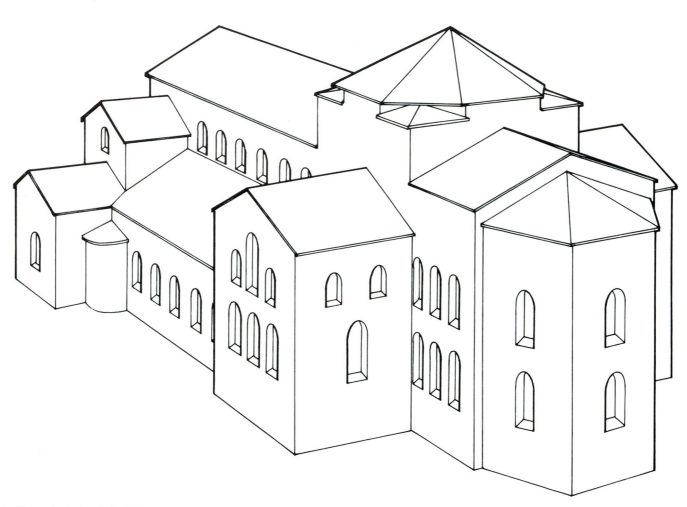

38b The cathedral in Sofia (7th century)

this very 'Romanesque' building departs strongly from the centralised churches of the capital, and illustrates once again the vitality of provincial architecture in the disparate territories governed by Constantinople – a vitality which proved to be crucial to the development of Christian architecture in Europe. In the course of the sixth, and more importantly in the next two centuries, church types of Eastern origin. began to appear in the West: the small church at Glanfeuil, in France, was barrel-vaulted, resembling those at Binbirkilisse (Turkey), and, like Saint-Pierre in Geneva, had pastopheries on either side of the apse; churches with galleries were built in Rome; churches with triple apses became common in northern Italy.

The centre of architectural vitality in the seventh century was in Armenia (now partly in the Soviet Union and partly in Turkey).

The Eighth Century

Outside Armenia, the seventh and eighth centuries produced little which carries our story further, but there were some distinguished buildings. The church at Nicaea, near Constantinople (now Iznik), was built in the early eighth century but destroyed in 1920. Like the church of Hagia Sophia (before 726) at Salonica in Greece, it was a cross-domed church; the façade was, for the first time, decorated with sculpture; both its plan and its façade resemble those of the cathedral at Angoulême in France (1105–28). The Palace of the Exarchs in Ravenna (after 712) survives from this epoch. The articulation of its façade – with paired openings, buttresses and arched niches and arcading with columns – prefigure the Lombard Romanesque of succeeding centuries. A second church was built at Saint-Denis (north of Paris) between 754 and 775, replacing a fifth-century church: this was a basilical church, with pillars, narthex, transept and apse, in the manner with which we have already become familiar. But the two remarkable churches built in Western Europe in the eighth century were Saint-Riquier, in Centula (northern France) and the Palatine Chapel in Aachen (Germany).

The Palatine Chapel in Aachen (792–805) is the less interesting of the two. It is essentially a coarsened and simplified version of San Vitale in Ravenna. What is interesting about it is not the building itself, but the fact that an architect of the Carolingian Empire, which saw itself as the heir of Rome and looked to classical Rome as its political and cultural inspiration, should have taken a Byzantine building as the model for the Imperial chapel. The belfry (806) was designed by the Armenian architect, Oton Matsaetsi, on the model of Hrip'sime. These borrowings from the East manifest the cultural influence which the flourishing Eastern Empire exerted throughout the Dark Ages on the barbarian kingdoms of the West. Another example of this influence may be seen in the little Oratory at Germigny-des-Prés, near Saint-Benoît-sur-Loire. Built in 806 (but

PLATE II

39

10a

63

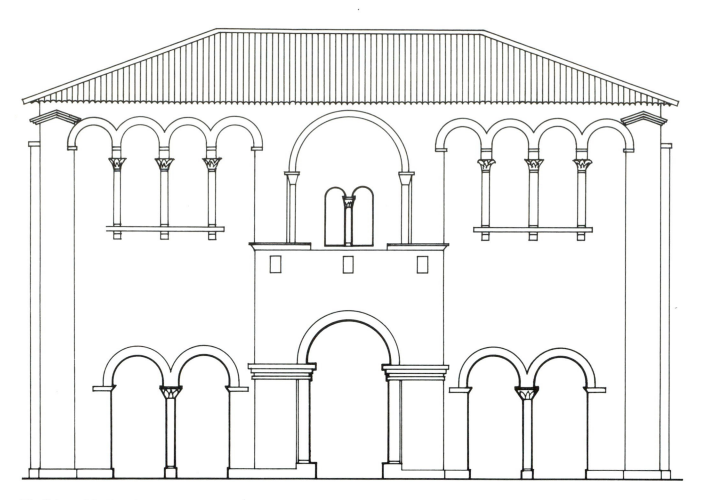

39 The Palace of the Exarchs in Ravenna
(after 712); façade

rather brutally restored in the nineteenth century), it seems like a displaced Eastern church – with its Byzantine centralised plan of nine compartments and its tower over the central space giving a vertical emphasis to the building (a feature developed in Armenia).

The centralised plan was not, as we have already said, ultimately of great importance in the development of the Romanesque. The most important church of this epoch was undoubtedly that of Saint-Riquier, at Centula in northern France (790). It was a large, impressive church, some 250 feet (83m) long, its towers rising 180 feet (60m). It astonished its contemporaries: nothing had prepared them for this foreign-looking building, though readers of this book will perceive an affinity between the placing of its axial towers and the position of those at Saint-Martin in Tours. The towers themselves, with their telescope silhouette, recall that of Zvart'nots; an earlier example occurred at R'safah, in Syria. The vestibule entrance, flanked by towers, shows its debt to Syrian westwork, of which Turmanin is an early example.

This motif was to occur again in the abbey at Fécamp in Normandy, whence it travelled to England; via Reims it went to

40

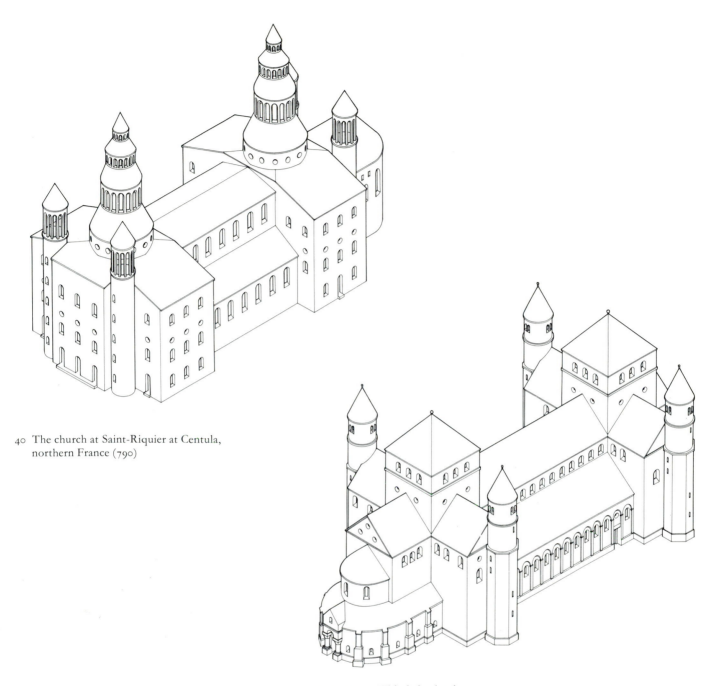

40 The church at Saint-Riquier at Centula,
northern France (790)

41 Cathedral at Hildesheim (872)

41 Hildesheim (872 and later) and via Corbie, in Picardy, to Corvey on
the Weser (873–85). The influence of Saint-Riquier may be seen
again and again in Germany, notably in the cathedral of Mainz (978
and later).

The outer vestibule of Saint-Riquier was decorated with stucco
reliefs – an Eastern feature we have already noted; reliefs in stone
(more durable in a northern climate) became a regular feature of the
portals of Romanesque churches. Another Eastern feature was the

baldacchino which surmounted the altar. The large assemblage of towers of Saint-Riquier may well owe its origin to the palace complex at Pliska, in Bulgaria (fifth century onwards).

People – and, consequently, ideas – travelled via the Danube and the Vistula rivers to the Baltic and thence to the Western European coastline. The towers of Saint-Riquier spawned examples at Saint-Bénigne, Dijon (1001–17), with nine towers, Santiago de Compostela (late eleventh century), intended to have nine towers and the third abbey at Cluny – Cluny III – (late eleventh century), with seven towers.

The whole of Spain, apart from the north-west corner, was conquered by Moslem forces between 711 and 732. In the Christian state which remained (and which was enlarged by conquest of territory in the north-east) this contact with Arab civilisation stimulated the building of many new churches which made a

42 Santa Maria de Naranco, Spain (848); interior

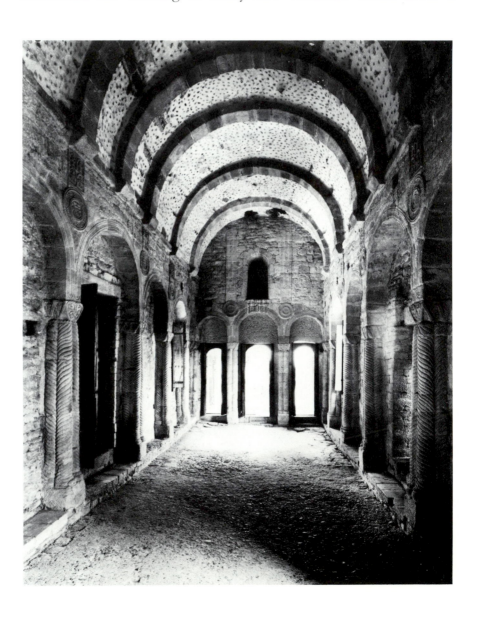

significant contribution to the development of the Romanesque. A continuation of the Syrian tradition of church building is evident at **42** Santa Maria de Naranco (848): it is built in ashlar and shows a sophisticated grasp of stone construction; transverse arches vault the crypt and the nave; slender buttresses articulate the exterior walls. Tentative use of sculptural decoration may be discerned in the tiny figures in the medallions at Naranco and in the enlarged ivory bookcover reproduced on the jambs of the main portal of San Miguel de Linio nearby.

Spain continued to be a gateway for Eastern ideas to penetrate Europe via southern France. There are grouped piers in the church at Val de Dios (893, additions of tenth century), which look forward to the compositions of piers in later Romanesque building. The Mozarabs – Christians living in the Moslem part of Spain – brought the horseshoe arch, zebra striping, cusped arches and other Moorish features into the Christian part of Spain, whence they travelled northwards into France, and are conspicuous in the cathedral of Le **97** Puy, on the borders of the Auvergne, in southern France.

The Ninth Century

43a,b The tributaries which flow into the Romanesque rise in many countries. The Panaghia at Skripou, north-west of Athens (873–4) has a central dome on pendentives, in characteristic Byzantine fashion, but it has a strong 'Romanesque' feeling – with its blocked masses externalising its interior spaces, its nave terminating in a triple apse and its continuous horizontal mouldings on the external walls rising, as in Syria, over the windows. The Lombards, who by this time had established themselves in the Po valley in northern Italy, had many contacts with the Byzantines of Ravenna: the church of San Satiro in Milan (876) has the Byzantine centralised plan of nine compartments, which we have noted at Germigny-des-Prés.

The Lombard masons are remembered for their building skills, especially in vaulting, in brick wall-work and in stucco, but were more transmitters than originators of architectural forms. Essentially, they developed a simplified version of the style of building prevalent in Ravenna, which had, as we have seen, close links with Syria. This has been sometimes called the First Romanesque style. Professional designers, having something of the function of the modern architect, began to appear, and their designs were executed by travelling bands of craftsmen, originally from Lombardy, but later from local workshops trained by Lombards. Thus, Lombard craftsmen are believed to have worked on the abbey church in Dijon (begun 1001) and are known to have been summoned to work on the abbey church at Fécamp. Typical of the Lombard style are the arch recesses at the top of the exterior walls of the main apse of San Vincenzo in Prato (814–33, rebuilt in the

43a The Panaghia at Skripou, north-west of
Athens (873–74); plan

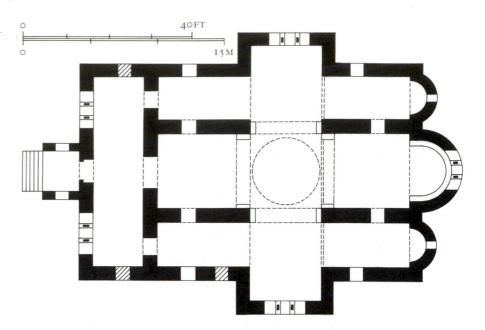

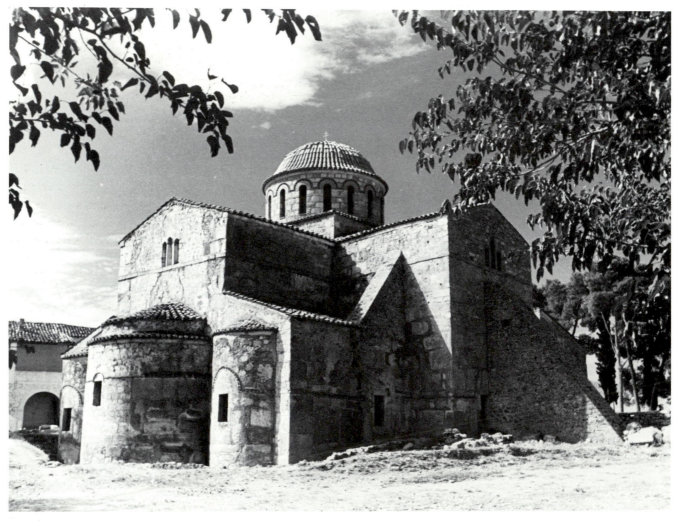

43b The Panaghia at Skripou; view of apses

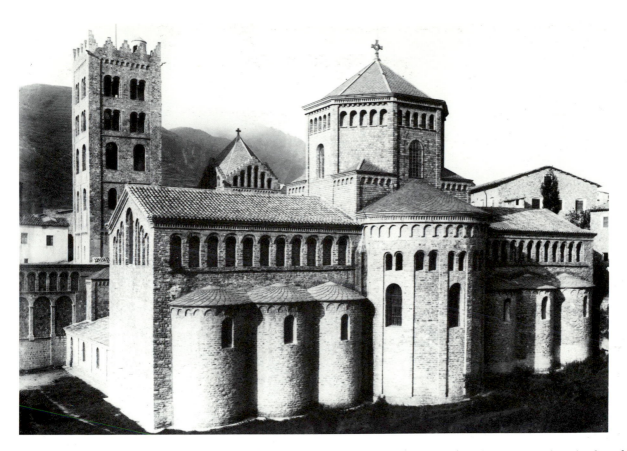

44 The monastic church of Santa Maria at Ripoll, Spain (c.1020–32)

eleventh century), as well as its pilaster strips and arched corbel tables beneath the eaves.

The Lombards carried their style eastwards to Yugoslavia (St Donat, Zara, 812–76) and, more importantly, across southern France and by sea to the Pyrenees (Catalonia). There its influence, mixed at first with the Mozarabic style, gave rise to innumerable small churches and several major monuments of the early Romanesque, notably the monasteries of Saint-Martin-du-Canigou (built in 1001–9 and 1026 and recently well restored) and of Santa Maria at Ripoll **44** (c.1020–32, and less faithfully restored in the nineteenth century). The tower of Saint-Martin has arched corbel tables and pilaster strips, its crypt has tunnel vaulting and transverse arches supported by grouped piers, and the entire complex has an undoubted Romanesque appearance. The mosaic pavements of Ripoll, with their sea-monsters and animals, as well as its jewel-studded altar, its many frescoes, and its remarkable library, with books on mathematics, music, history, poetry and astronomy, have all disappeared, (though there remain some interesting capitals showing Moorish influence), but it is known that Ripoll functioned as a great artistic and intellectual centre. Catalonia contributed a highly influential innovation to the development of the Romanesque – the use of figure sculpture, with doctrinal purpose, on church exteriors. The influence on low relief of the 'Commentary' of Beatus (780) is discussed in Chapter 4, pp. 158–60. Its earliest preserved mani-

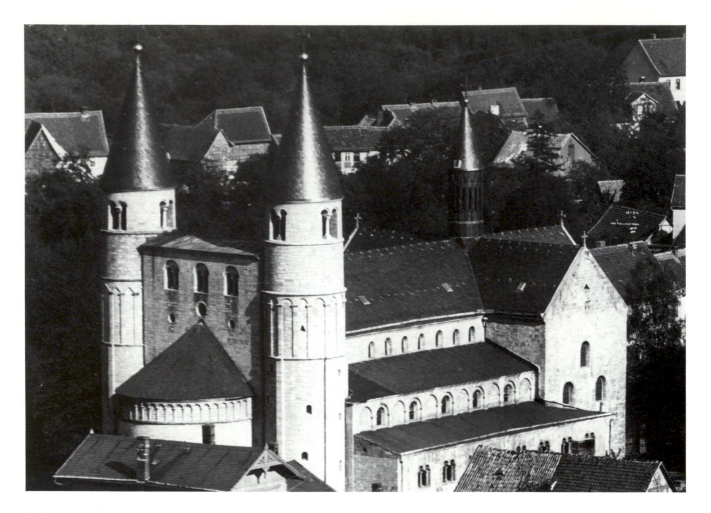

45a St Cyriakus at Gernrode, Germany (961)

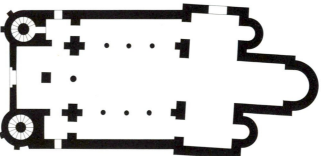

45b St Cyriakus at Gernrode; plan

festation is the beautiful marble lintel over the main door to the church of Saint-Genis-des-Fontaines (1020–1), with two angels and six apostles flanking Christ in Glory within a mandorla. Other examples, sometimes showing Moslem influence, occur in Catalonia; many were exported, and examples are to be found at Cluny (1095) and Toulouse (1096).

Lombardic influence manifested itself also in Germany. We can see the characteristic arched corbel tables and pilaster strips on the churches of St Pantaleon in Cologne (966–80) and of St Cyriakus at Gernrode (961). St Cyriakus is a handsome church in fine ashlar.

45a,b

The aisles are divided from the nave by columns alternating with piers, there are galleries over the aisles, and its towered silhouette is reminiscent of that of Saint-Riquier.

The Tenth Century

Just before the dawn of the Romanesque in Germany, the lands east of the Rhine were exposed to a number of influences from Byzantium. Otto II (973–83) married a Byzantine princess, who brought not only artefacts but artists and courtiers from her native city, and their son Otto III (983–1002) modelled his court on Eastern patterns. The influence of San Vitale, Ravenna – via the Palatine Chapel at Aachen – was to be seen in the hexagonal church of Wimpfen im Tal (979–98).

An important influence in the spread of Eastern ideas to Western Europe was the abbey of Monte Cassino, in southern Italy. Founded in 529, it was destroyed by Lombards in 581 and by Saracens in 883, but by the tenth century it was flourishing again. During the eleventh century, the region came under the rule of the Normans, and under the leadership of its distinguished abbot Desiderius artists and artefacts were brought from Constantinople to the abbey and students of the various arts came, not only from other parts of Italy but also from other countries, to study there. The abbey itself was rebuilt in 1058–75, many of the builders coming from Amalfi, south of Naples, which at that time was a powerful trading republic with stations in Northern Africa, Egypt, Palestine, Cyprus and Byzantium. Virtually all of this work was destroyed in the Second World War, but some impression of its nature can be gathered from the still extant priory at Fornis. This has a portico modelled on the two porticoes at Monte Cassino; it is remarkable for its pointed arches, and its resemblance to the inner portico of the Great Mosque at Mahdia, in Tunisia. The church at Monte Cassino had many Eastern features, which astonished its visitors: there was plasterwork decoration (believed to have been, like the arches, of Moslem origin) on the porch and lunettes over the doorways. The Byzantine-style frescoes covering the interior (of which an impression can be gathered from those in the Fornis priory) recurs – and can still be seen – in the delightful Cluniac chapel of Berzé-la-Ville, in France.

74

The influence of the rich and powerful abbey at Cluny on the development of the Romanesque is well-known. In 1015 a narthex façade was completed at Cluny, with two towers and a porch in between. It can hardly be a coincidence that the same year saw the beginning of the building of a similar façade for the cathedral at Strassburg (now Strasbourg, in France); the type was adopted in many churches in neighbouring regions, and became the standard cathedral frontispiece. In the eleventh century, Cluniac monks

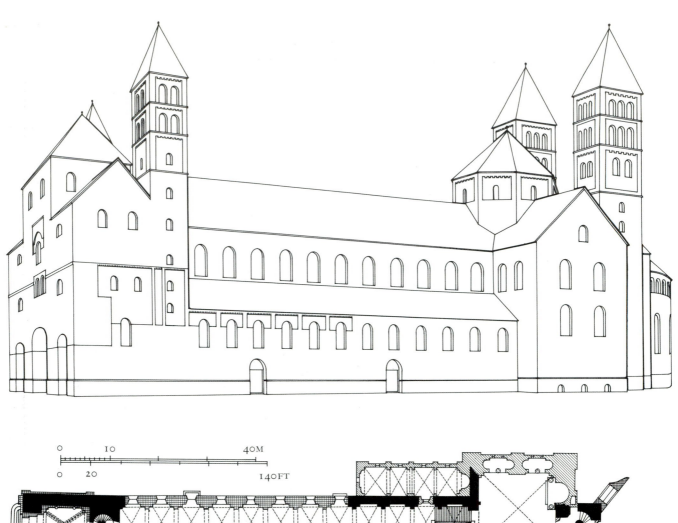

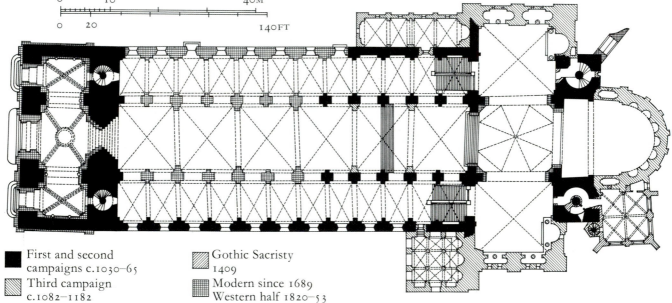

First and second campaigns c.1030–65

Third campaign c.1082–1182

Gothic Sacristy 1409

Modern since 1689 Western half 1820–53

46a & b The cathedral at Speyer (begun c.1030); drawing of exterior and plan

penetrated Germany extensively, bringing Eastern influences with them. The interior of the chapel of St Bartholomew, near the cathedral of Paderborn (1017), has a distinctly Moorish look; it is thought to have been built by workmen from southern Italy, and the capitals have a vigour unusual for the period. The cathedral

at Hildesheim (1001–33), following Saint-Riquier and its Syrian antecedents, had entrances opening into the south aisle, and towers on either side of the entrance porch. Much of the early Romanesque **46a,b** in Germany has not survived, but the cathedral at Speyer (begun c.1030), though much altered in later centuries, is still standing. The crypt is divided into compartments by piers, each roofed by groin vaulting, supported by columns surmounted by plain, cubical capitals of Near-Eastern origin. The silhouette, with the slender stair tower flanking the entrance, and the tall crossing vault surmounted by a great octagonal tower on squinches, has the verticality of Saint-Riquier, and later alterations imported the Lombardic decorative arcading, pilaster strips and corbel tables.

The Eleventh and Twelfth Centuries

The tenth century brings us to the threshold of the Romanesque, which can conveniently be regarded as beginning with the eleventh century. No Romanesque church was built in Rome in the eleventh century; northern Italy continued its Lombardic tradition of the First Romanesque style during the tenth and eleventh centuries. The true Romanesque had its origin in France – not in Provence, which essentially continued a tradition derived from Rome, nor in the Île de France, which was to be the cradle of the Gothic, but principally in Normandy, Burgundy, Aquitaine and Languedoc.

47 The former cathedral at Dijon, in Burgundy (1001–18), illustrates the transition between the Early Romanesque and the mature masterpieces. From the Holy Sepulchre in Jerusalem (via Saint-Pierre, in Geneva) it took the rotunda at its eastern end. To the Moslem use of columnar shafts at the corners of piers it owed the design of the triforium piers, and Moorish detail appears in the rotunda. In its strong and bold silhouette it followed the example of Saint-Riquier. Its pilasters and corbel tables were Lombard.

The principal Romanesque churches of the eleventh and twelfth centuries in northern and central Italy – the cathedrals at Modena, Parma and Pisa, San Zeno Maggiore in Verona, San Michele in Pavia **48** and Sant' Ambrogio in Milan – are handsome examples of the Lombard tradition of fine masonry and elegant design, but contributed little to the development of the mature Romanesque in France. The Byzantine orientation of Venice manifested itself notably in the church of San Marco, begun in 1063 and modelled (with some variations) on the church of the Holy Apostles in Constantinople: but it was not significantly via Venice that influences from the far side of the Mediterranean came into Western Europe, but rather via Sicily and the pilgrimage routes to northern Spain.

In 1066, the Normans conquered not only England but Sicily; both events proved to be of great importance in the development of

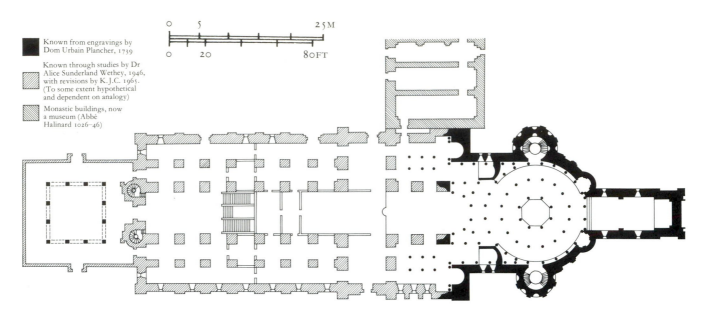

0 5 25M

0 20 80FT

47 The former cathedral at Dijon, Burgundy 48 Sant' Ambrogio in Milan (11th century);
 (1001–18); plan interior

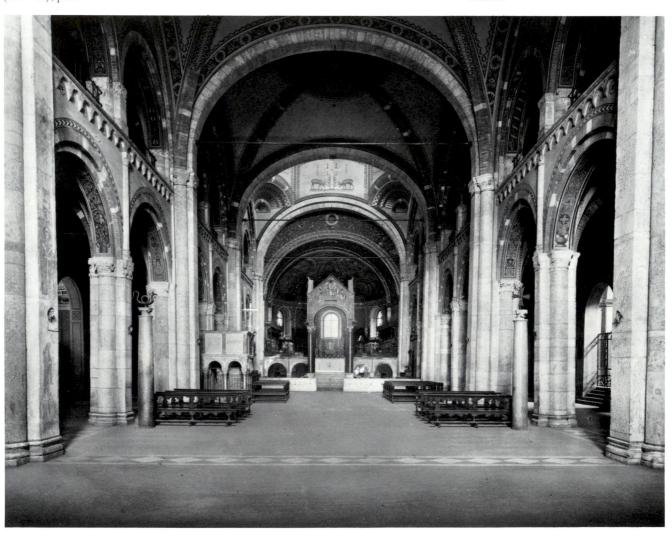

European architecture. Sicily and southern Italy largely cut off from northern Italy by the stagnant Papal State and the Abruzzi and Apennine mountains, was culturally and, to a large-extent politically, part of the Byzantine Empire; these areas had continuous economic ties with Moslem countries and for a time Sicily had Moslem rulers. For a time, Norman rule extended to parts of North Africa, and in Sicily itself the Norman rulers modelled their palaces on those of their Moslem predecessors. Norman architects in Sicily and southern Italy gracefully assimilated the Moorish pointed arch – in, for example, the enchanting cloister of Monreale; it was taken up at Monte Cassino and appears in profusion at Cluny. Byzantine and Syrian features were absorbed with equal grace: the exterior of the apse of the cathedral at Troia (begun 1093) is remarkably similar to that of Qal'at Si'man, the pattern of the Byzantine four-column church was followed in the Martorana in Palermo and the well-known mosaic of Christ in Cefalù cathedral is purely Byzantine in character.

The great French art historian, Emile Mâle, in his *L'art religieux du XIIe siècle en France* (Paris, 1922) meticulously documented the Near Eastern influence on the art and artefacts of Romanesque France, influences which travelled along the pilgrimage routes, from their destination at Santiago de Compostela, in north-west Spain, to their sources in the main regions of France (see map, p. 76). Along these routes, a group of five great churches was built in the eleventh century: Saint-Martial in Limoges (dedicated 1095) and Saint-Martin in Tours (c.1050 ff, replacing the earlier church, referred to on p. 48) no longer exist, but Sainte-Foi at Conques (c.1050–1130). Saint-Sernin at Toulouse (c.1080) and Santiago de Compostela (1075 ff) remain. There were four principal routes: the three most northerly joined together north of the Pyrenees – one beginning in Paris and Chartres and passing through Tours, Poitiers and Bordeaux; another starting at Vézelay and going via Limoges and Périgueux; and a more southerly route commencing in Le Puy and striking south-west through Cahors and Moissac. A fourth route from Provence began in Arles, and, after Saint-Gilles and Toulouse crossed the Pyrenees separately.

The *mihrab* of the mosque of Cordoba (961) inspired similar vaults in Christian Spain and the pattern spread along the pilgrimage route to, for example, the church of Saint-Martin in Tours, through which passed the route from Paris. This route continued through the town of Poitiers, and there two notable churches were built in the Romanesque period – Saint-Hilaire and Notre-Dame-la-Grande. The Mozarabic influence on Saint-Hilaire (started 1025–49, vaulted in the twelfth century and much rebuilt) is evident in the vaulting of the nave and aisles – the nave roofed with octagonal vaults, the curved surface separated by groins, and the aisles having two rows of groin vaults supported by a central column, as in the Mozarabic hermitage of San Baudelio de Berlanga, near Burgos, where the pilgrimage route continued westwards across Spain. A Byzantine, rather

49a–e

50

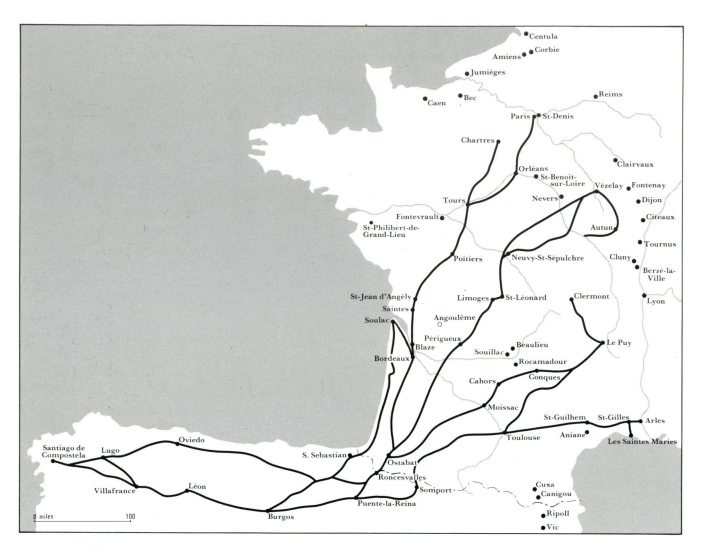

Centula
Corbie
Amiens
Jumièges
Caen · Bec
Reims
Paris · St-Denis
Chartres
Clairvaux
Orléans
St-Benoît-
sur-Loire
Vézelay · Fontenay
Tours
Nevers
Dijon
Cîteaux
Autun
Tournus
Fontevrault
St-Philibert-de-
Grand-Lieu
Poitiers
Neuvy-St-Sépulchre
Cluny
Berzé-la-
Ville
St-Jean d'Angély
Limoges · St-Léonard
Clermont
Lyon
Saintes
Soulac
Angoulême
Périgueux
Blaze
Beaulieu
Souillac
Bordeaux
Rocamadour
Le Puy
Cahors
Conques
Moissac
St-Guilhem · St-Gilles · Arles
Oviedo
Toulouse · Aniane
Les Saintes Maries
Santiago de
Compostela
Lugo
S. Sebastian
Ostabat
Roncesvalles
Cuxa
Canigou
Villafrance
Léon
Somport
Puente-la-Reina
Ripoll
Burgos
Vic

0 miles 100

Churches on the Pilgrimage Routes to
Santiago de Compostela

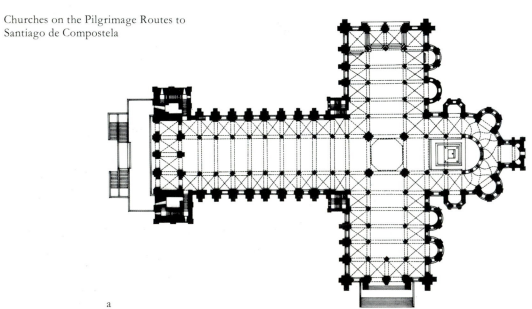

a

76

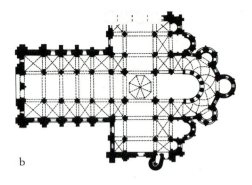

b

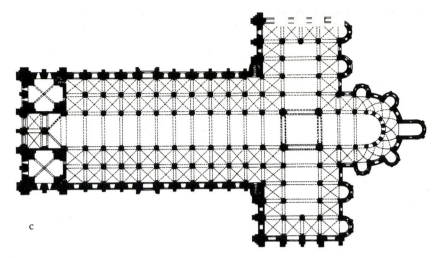

c

49a–e Plans of five great churches built in the
11th–12th centuries along the pilgrimage
routes to Santiago de Compostela:
a) Santiago de Compostela (1075 ff)
b) Sainte-Foi at Conques (c.1050–1130);
c) Saint-Sernin at Toulouse (c.1080);
d) Saint-Martin in Tour (c.1050ff);
e) Saint-Martial in Limoges (dedicated 1095).

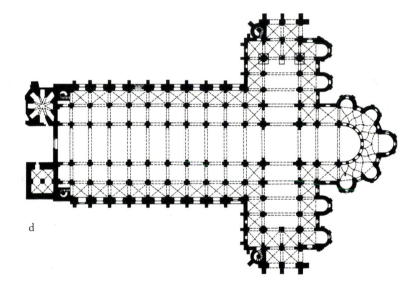

d

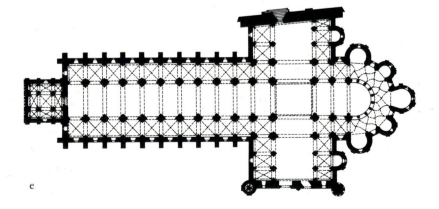

e

0 30M

0 100FT

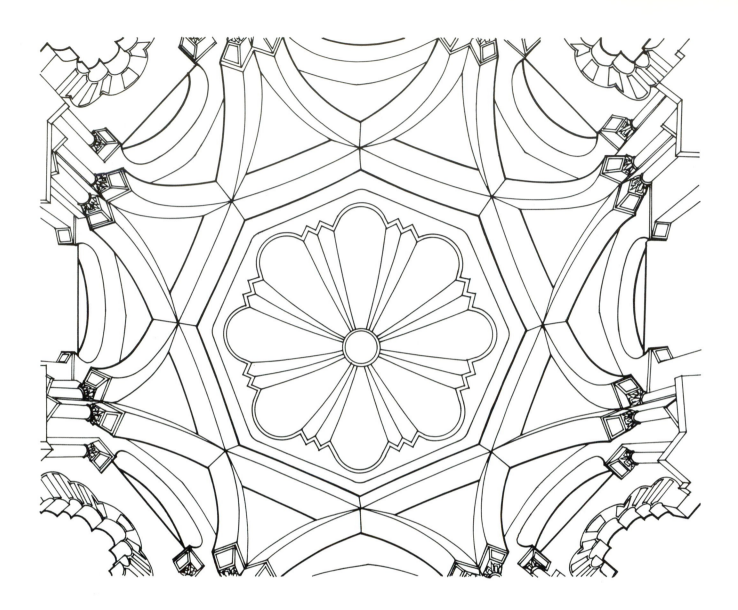

50 The *mihrab* of the mosque
of Cordoba (961); drawing PLATE XIII

35,51

than Moslem, effect is produced by the façade of the church of Notre-Dame-la-Grande (c.1130–45), with its richly articulated façade.

This route continued south through the town of Limoges and the region of Aquitaine, to join with the route from Paris across the Pyrenees. Saint-Martial in Limoges (dedicated 1095) was destroyed, but the spectacular domed church at Périgueux (eleventh and twelfth centuries), though heavily restored in recent years, is still to be seen today. It is one of a group of 77 domed churches, of which 30 are still standing in Aquitaine, and another 30 at more distant sites, of startlingly Byzantine character, perhaps influenced by similar churches which Crusaders had seen in Cyprus. The domes (five of them at Périgueux) rest on pendentives, but are supported on pointed arches, this geometrically complex structure being a new and original contribution of the architects of the period. Domes surmounting the four bays of the nave, and smaller domes over the

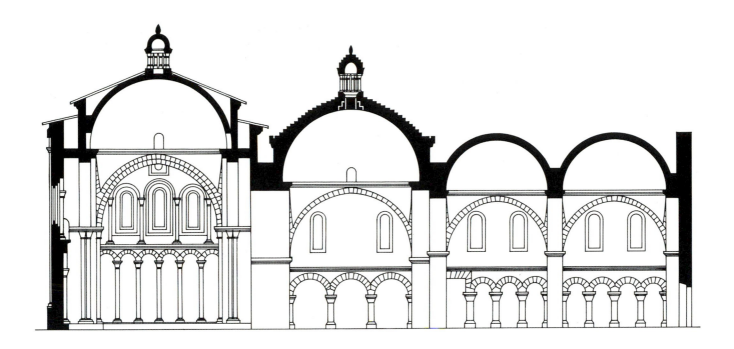

51 The church at Périgueux (11th–12th centuries); elevation

transept, roof the cathedral at Angoulême (1105–28 and later), some 70 kilometres to the north: here the domes (except one) are constructed in ashlar, whereas those of Périgueux had been built in rubble.

The route from Burgundy began at Vézelay, a small hill town dominated by the pilgrimage church of the Madeleine (1104–32). Its famous low reliefs are discussed on page 161. The church is famous for its large and handsome nave, divided into bays by transverse arches in alternate red and white stone, recalling the stonework at Cordoba. The use of rib vaulting is characteristic. As a method of constructing a vault, its origin may be traced to Byzantium. It was used for the first time on an ambitious scale in the dome of Hagia Sophia. This was repaired in 975 by an Armenian architect, and indeed from the seventh century onwards the method was in common use in Armenia. The method was adopted by the Moslems, and from the mid eleventh century onwards, it became a commonplace of European church building. The abbey church at Fontenay (1139–47) has cubic capitals, the transverse arches of its nave are of the pointed, Moslem shape.

Moorish influence (via Monte Cassino) was also discernible in the **52a,b** abbey church at Cluny (c.1093–1100) – Cluny III, with its large-scale use of pointed arches and horseshoe lobes on the arches of the triforium. This vast, and hugely influential monastery complex was sold after the Revolution to a builder's merchant, and little of it now remains, but some impression of its interior at least can be gained **53a,b** from the priory church at Paray-le-Monial (c.1100) and from the cathedral of Autun (c.1120–30). Cluny, and the Cluniac order generally, has its place in the history of architecture not for any

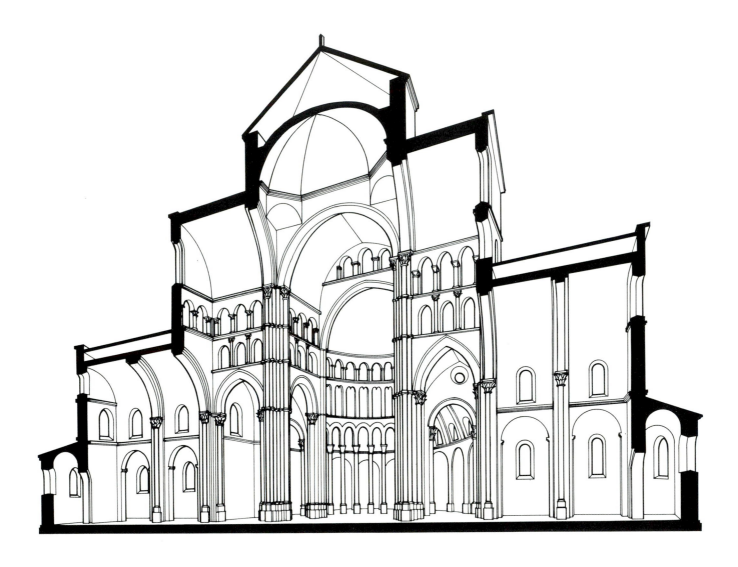

52a & b The abbey church at Cluny (Cluny III,
 11th century); cutaway perspective and
 front elevation

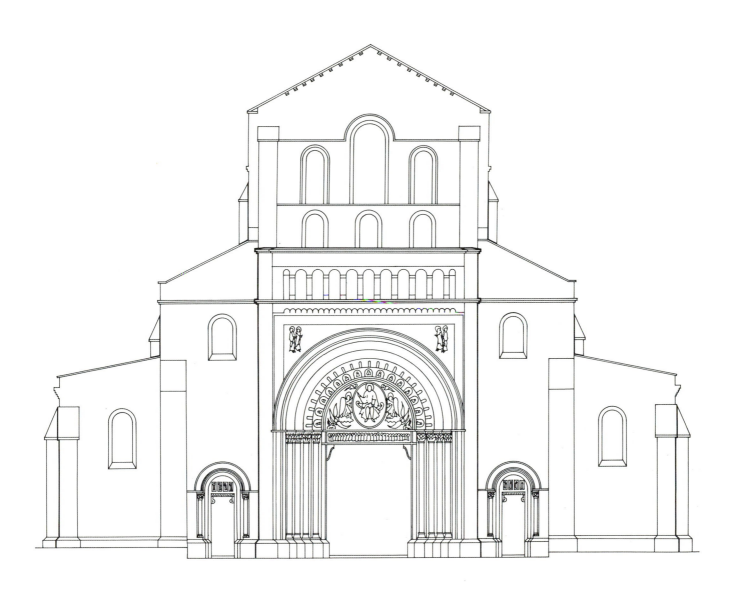

originality of invention but for its strong organisation and rich patrons (half of Cluny III was paid for by the Spanish King Alfonso VI) which enabled it to disseminate architectural conventions originating elsewhere.

The third of the principal pilgrimage routes ran from Le Puy, some 100 kilometres to the south-west of Lyons, passing through Conques, Cahors and Moissac in Languedoc, to join with the two **54** more northerly routes to cross the Pyrenees. The cathedral at Le Puy (twelfth century), on a stunning site in what was continuously an important city, displays an astonishing wealth of Moslem detail: painted and cusped arches abound; stone walling has horizontal stripes, corresponding to the alternate voussoirs in contrasting stone over the doorways and blind arcading; there are masonry panels in

53a The priory church at Paray-le-Monial, France (c.1100); interior

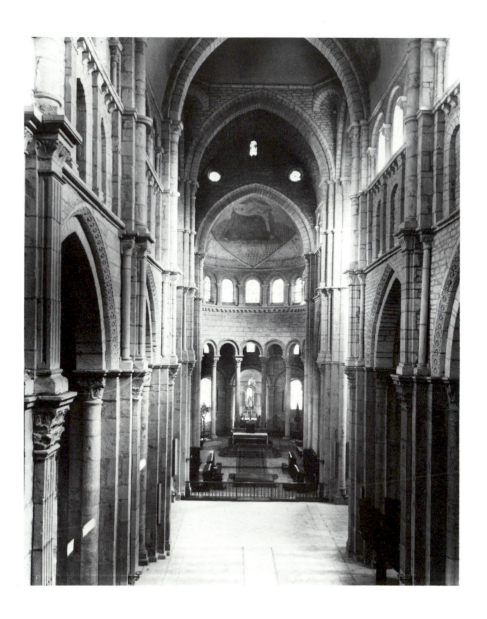

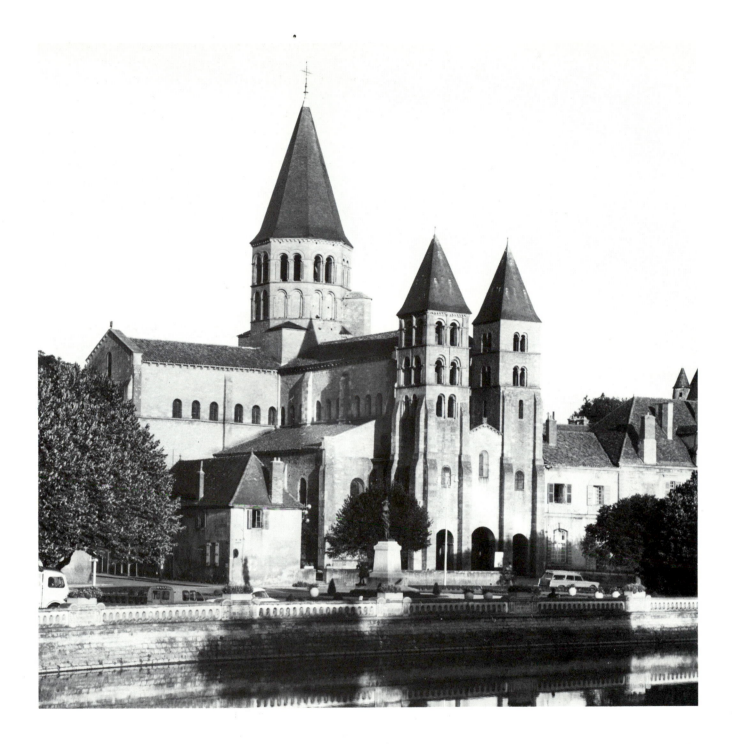

53b The priory church at Paray-le-Monial;
view from the north-west

pattern-work; wooden doors are carved in low relief with Cufic inscriptions; there are nearly one hundred capitals of Moslem pattern.

55a,b

56

Moorish, Byzantine and Lombardic influences mingle delightfully in the (relatively) small church of Sainte-Foi at Conques (c. 1050–1130), and, again, further down the route in the cathedral at Cahors (dedicated, incomplete, in 1119). The priory church of Moissac (c. 1100) was much altered in the Gothic period, but the

83

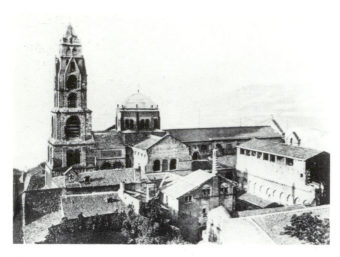

54 The cathedral at Le Puy (12th century)

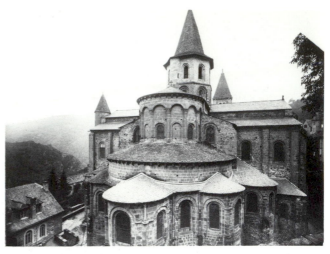

55a Sainte-Foi at Conques, France
(c.1050–1130)

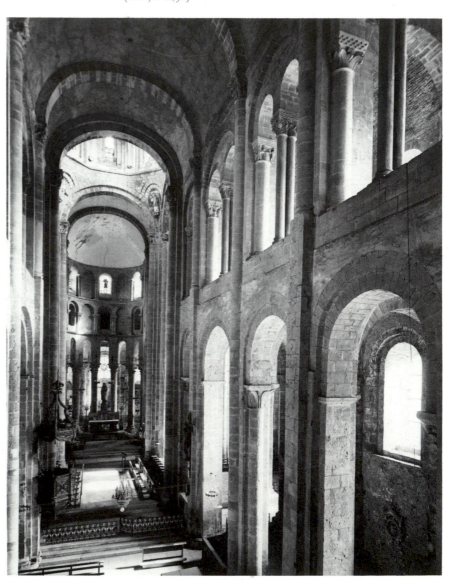

55b Sainte-Foi at Conques; interior

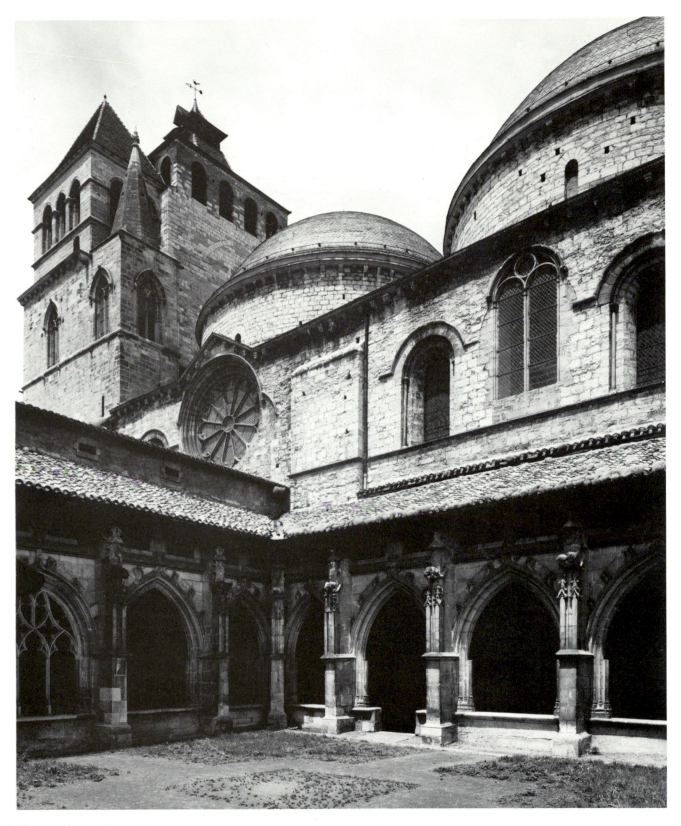

56 The cathedral at Cahors, France
(dedicated, incomplete 1119)

104 carvings of its portal and the columns and capitals of its cloister remain as masterpieces of this epoch.

The southernmost pilgrimage route began at Arles, in Provence; it passed through Toulouse, made a separate crossing of the Pyrenees, and joined up with the other routes at Puente la Reina, in Spain. Toulouse is the site of another handsome Languedoc church – Saint-Sernin (c.1080), which has some particularly fine carving. Architecture in Provence, by contrast, continued to live on the remains of the tradition of classical antiquity, and, while Romanesque features were utilised there in eleventh and twelfth century building, often with charming effect – e.g. in the cloister of the former cathedral of Saint-Trophime at Arles – the churches of this region show a lack of the essential spirituality of the neighbouring region of Limousin, and no Romanesque masterpiece was constructed there.

The destination of the pilgrims was Santiago de Compostela, in the north-western corner of Spain. The cathedral there (c.1075 and later) houses the relics of St James, brought from the Near East. Its long nave and ample transepts, roofed by ribbed tunnel vaults, and its apse with radiating chapels are similar to those the pilgrims would have encountered at Tours, Limoges, Conques or Toulouse.

The other region of France in which the Romanesque style took root was the new and vigorous Dukedom of Normandy. Feudal principals gave it effective government; the Normans enjoyed a long maritime tradition and displayed a singular openness to outside influence; and the region was blessed with a source of extremely fine limestone at Caen. Of the many handsome Norman buildings, few have survived, but their character is amply demonstrated by the three extant and deservedly famous masterpieces – the abbey at Mont-Saint-Michel (1024–1228 and later), and the two abbeys at Caen:

57 Sainte-Trinité (begun 1062) and Saint-Étienne (begun c.1068).

The Norman Romanesque influenced Edward the Confessor's large church at Westminster (c.1045–50, dedicated 1065); it established itself in England, after the Conquest in 1066, as the official style of the conquerors, and is known, simply, as 'Norman'. Abbeys, cathedrals and parish churches in astonishing number manifested the power of the new régime, and its ability to generate and muster human and physical resources on an unprecedented scale. Huge and splendid cathedrals, mostly extant (though often altered in later centuries), were begun in Canterbury (1070), Lincoln (1072),

58 St Albans (1077), Winchester (1079), Worcester (1084), Gloucester
59 (1087), Norwich (1090), Ely (c.1090), Durham (1093), Peterborough (1118) and elsewhere.

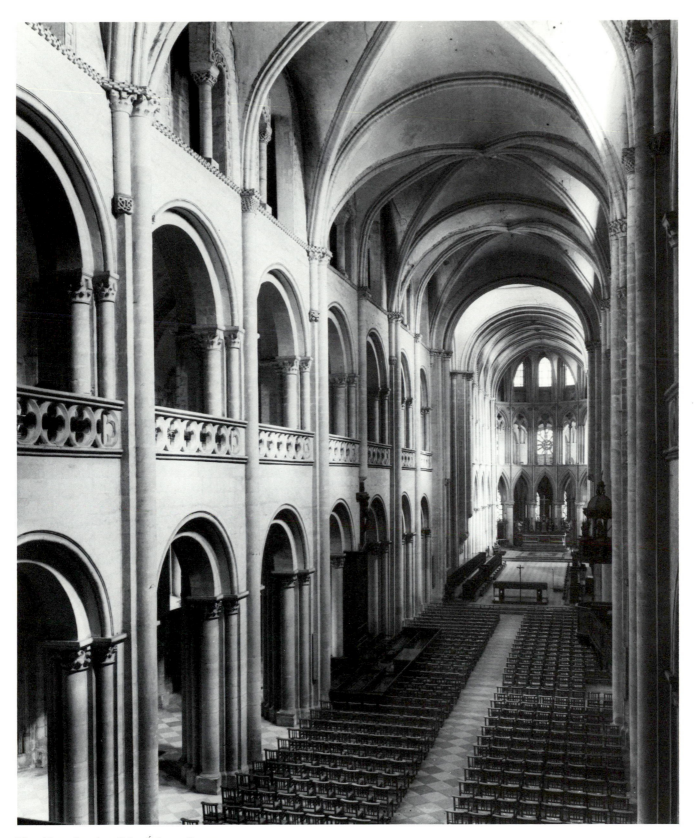

57 The abbey church at Saint-Étienne (begun
c.1068); interior

58 St Albans Cathedral (1077); crossing, north transept

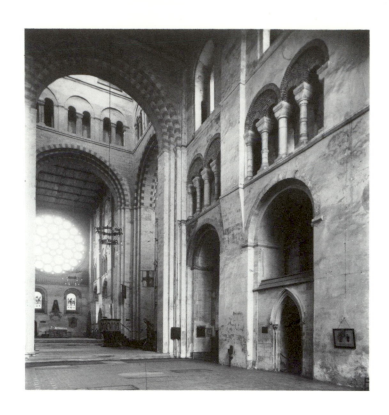

59 Durham Cathedral (1093); nave

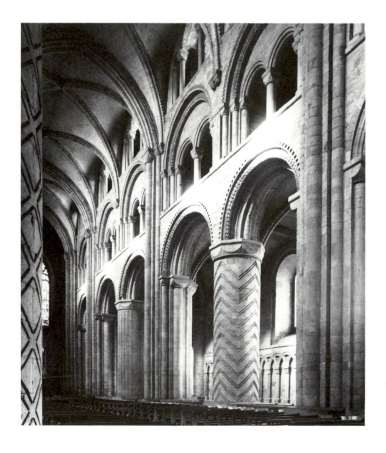

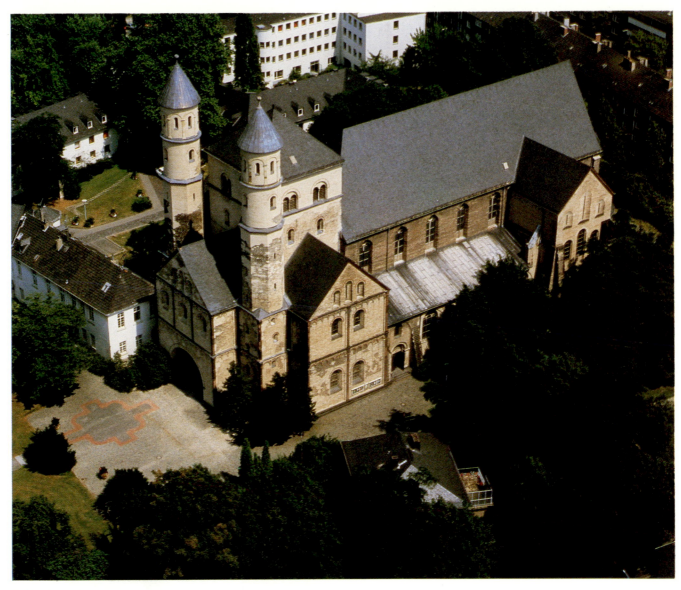

St Pantaleon, Cologne (966–80)

PLATE I

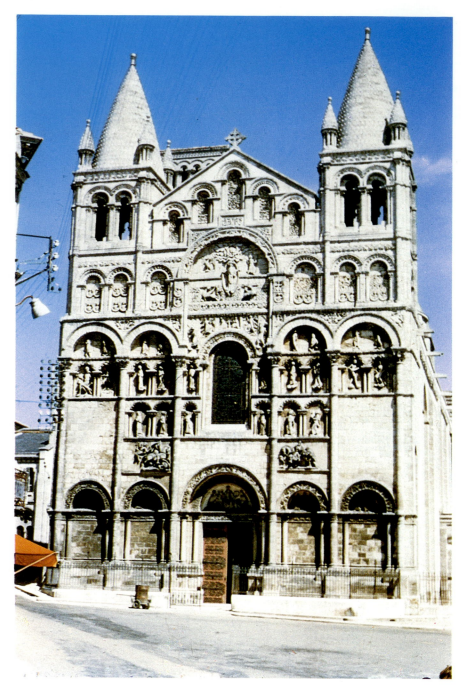

Cathedral of Saint-Pierre, Angoulême
(1110–28); west front

PLATE II

Evangeliary with the Four Gospels (late
8th century); Canon Tables page

PLATE III

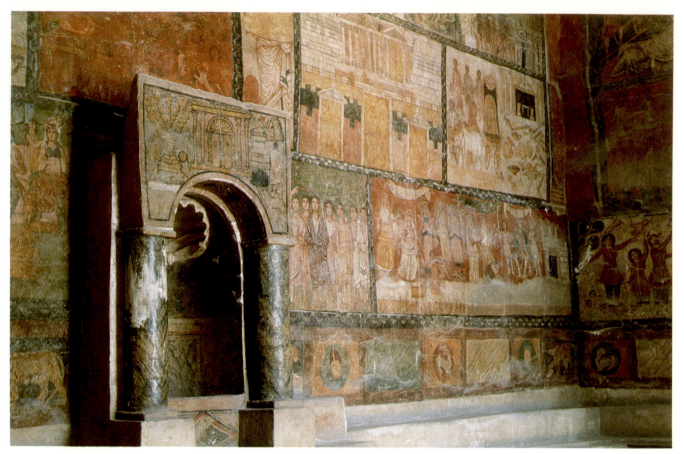

The Synagogue of Dura Europos (c.245);
view of interior

The Synagogue of Dura Europos (c.245);
patterned band between registers

PLATE IV

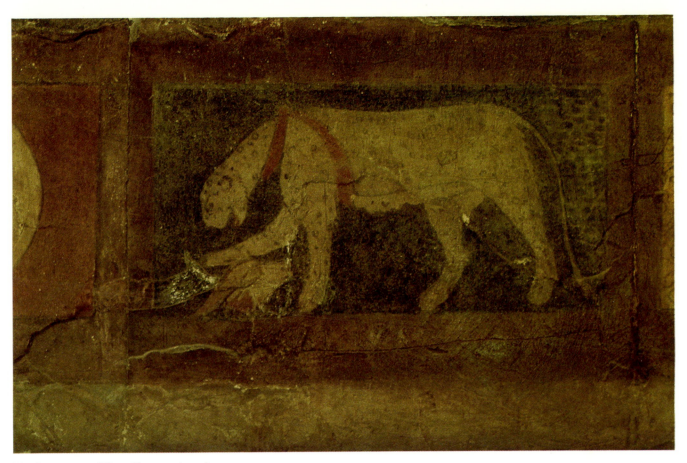

The Synagogue of Dura Europos (c.245);
wild animal from bottom register of mural

PLATE V

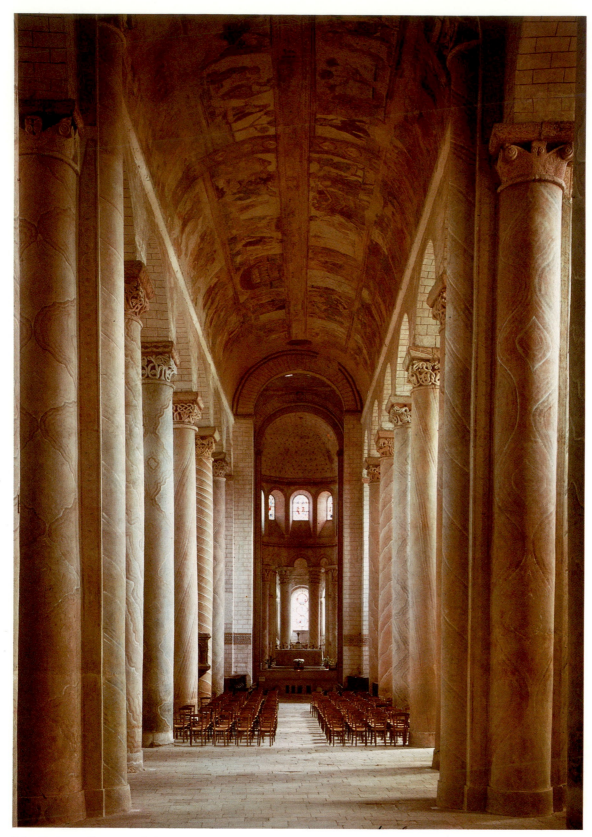

Saint-Savin sur Gartempe, Poitou
(c.1100); the nave

PLATE VI

The Book of Durrow (c.680); page with
symbol of St Matthew

PLATE VII

Persian version of the *Diatessaron* of Tatian
(16th century); ornamental page

PLATE VIII

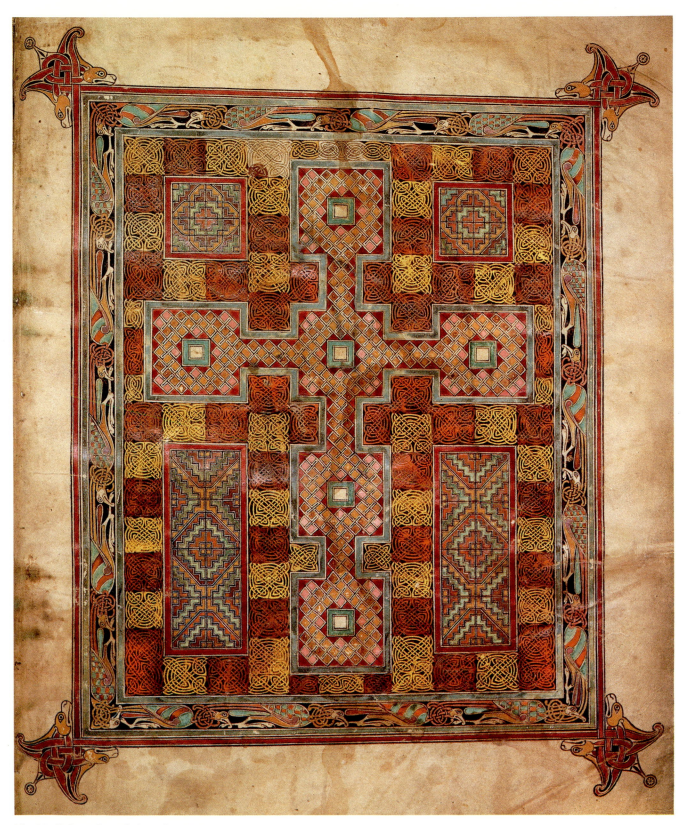

The Lindisfarne Gospels (c. 700); carpet-
pattern page with cross

PLATE IX

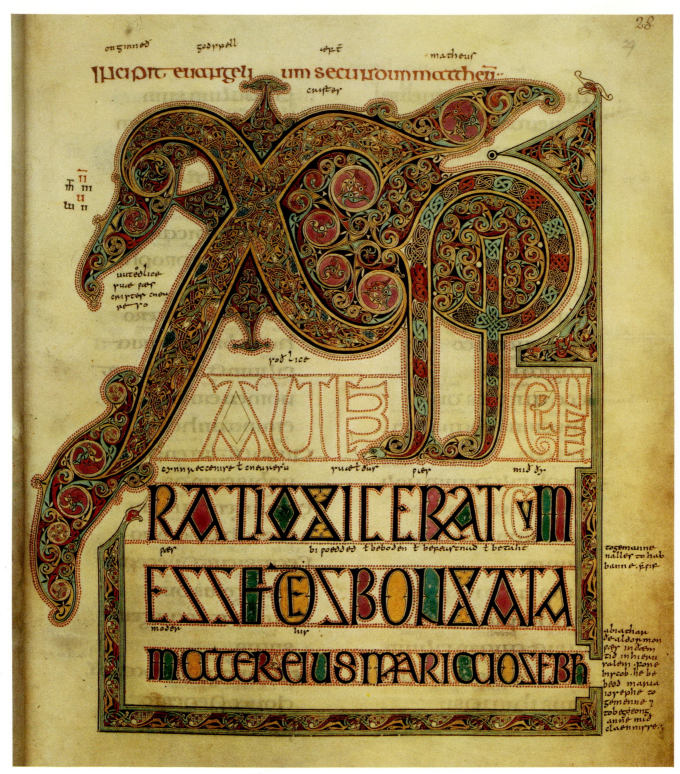

The Lindisfarne Gospels (c. 700);
decorated initial from St Matthew's
Gospel

PLATE X

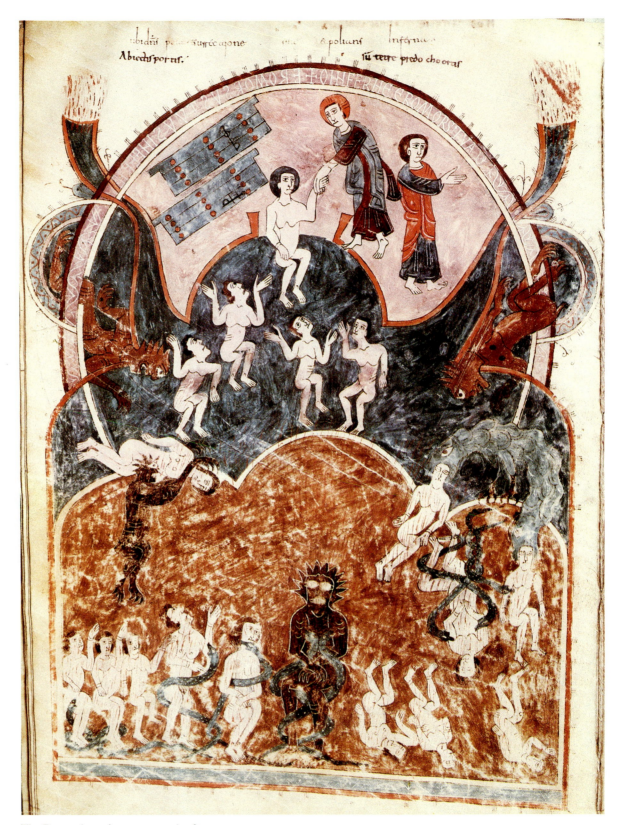

The Beatus Apocalypse manuscript from
Gerona Cathedral (dated 975); page with
scene of Hell

PLATE XI

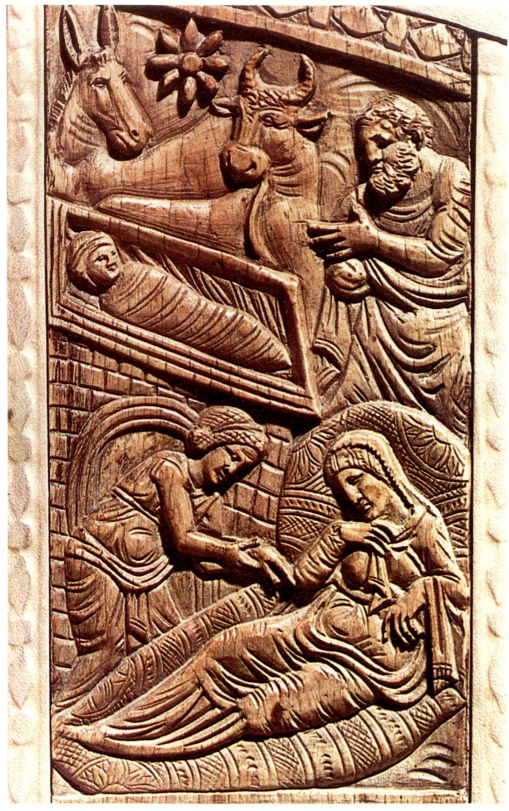

Ivory throne of Archbishop Maximian
(6th century); scene of the Nativity

PLATE XII

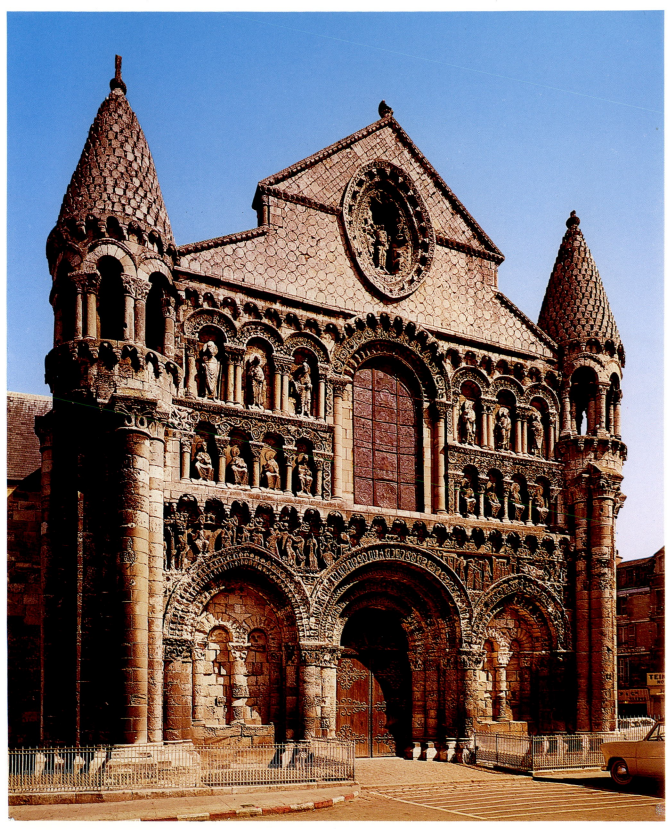

Notre-Dame-la-Grande, Poitiers (1st half
of 12th century); west front

PLATE XIII

The Ruthwell Cross (c.700); scene of
Christ with Mary Magdalene

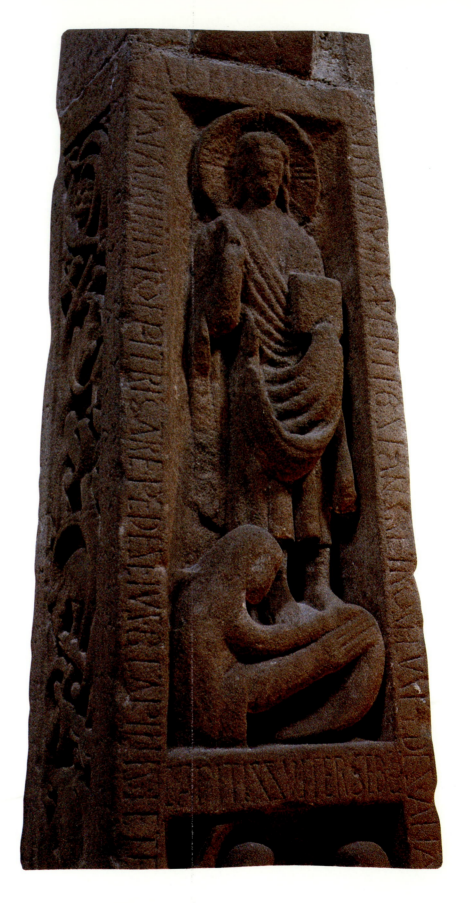

PLATE XIV

The Ruthwell Cross (c. 700); side face with
vine foliage, grapes and birds

PLATE XV

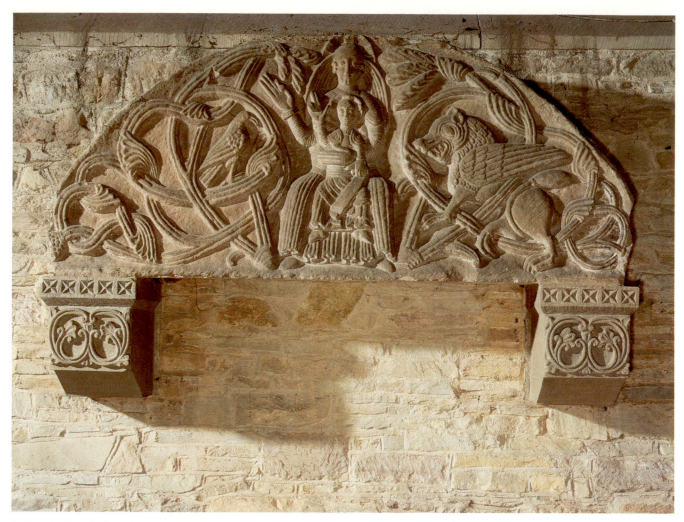

St Mary's Church, Fownhope (c.1140);
tympanum, scene of the Virgin and Child

PLATE XVI

CHAPTER 3 TWO-DIMENSIONAL ART: FRESCOES, MOSAICS, ILLUMINATED MANUSCRIPTS AND TEXTILES

The Development of Christian Iconography

Before the birth and death of Jesus there was a tradition of Old Testament Biblical illustrations in Egypt, drawn on papyrus rolls. With the spread of his doctrine, the first Christian states came into existence in Armenia and Syria, and the first extant Biblical frescoes, dated c.245 have been discovered in two rooms of a house in Dura Europos, a Syrian frontier town on the Euphrates. The tradition PLATE IV which informs the appearance of the Dura frescoes has its origins in the hieratic style of Mesopotamia at least as far back as the end of the first and the beginning of the second centuries AD, and probably much earlier. It is a style in which artists displayed a lack of awareness of the figures one to another, a lack of interest in portraying the body in three dimensions and in the illusionistic manipulation of the picture space, but an interest in spiritual intensity. Contemporary with Egyptian and Syrian Biblical illustrations, Christian art of a less monumental nature was emerging in the catacombs of Rome. There its growth was based on the pagan secular art of the classical world, and sacred symbols were either transmuted from or hidden among commonplace decorative motifs. It is accepted that there is no single centre which provided the origins of Christian art, and thus no single source for the Christian iconographic tradition. Christianity began among a race which did not have a tradition of figurative art, and thus it had to absorb and adapt the visual language of the regions to which it spread. The first holy places were in Palestine. They were the sites of events in the life of Jesus or the Apostles, and each became a pilgrimage centre. A church there would be adorned with scenes depicting the event which caused the site to be venerated. The iconography of scenes from Christ's life would most probably have been created specifically for these pilgrimage centres. It seems that Palestine was the first region to be developed in order to glorify these very events. Since Christianity was an Eastern religion, it would be correct to assume that the East led the West in the development of its iconography. Christianity was a religion of holy things. It quickly produced books, frescoes, mosaics, carved ivories, relics, *martyria* and churches to commemorate holy men, who performed miracles and acts of salvation or stood fast in adversity, becoming martyrs.

In the early centuries of Christianity, pilgrimages to the Holy Land became very popular, and people were prepared to travel vast distances as an act of veneration. The churches they visited at

Bethlehem, Nazareth and Jerusalem were very fully decorated with monumental compositions in fresco and mosaic of scenes from the life of Christ. These are no longer extant, but souvenirs brought back to the West by devout pilgrims have helped to reconstruct what was there. Twenty-six sixth-century Syro-Palestinian silver oil containers (*ampullae*) decorated with miniatures, have been preserved, 16 in the cathedral treasury of Monza and 10 in the church of St Columban at Bobbio. Their value is beyond measure in the knowledge they provide of fourth- and fifth-century Syro-Palestinian iconography, but they must equally have been highly prized in their own time, since the 16 *ampullae* at Monza were part of a gift which Pope Gregory the Great sent to Theodelinda, Queen of the Lombards at the beginning of the seventh century.

The church at Nazareth probably had a mosaic portraying events from the life of the Virgin – for example, her Annunciation and the **60** Visitation. A Monza *ampulla* records an Annunciation which is positive in mood: when the angel appears with the divine message, the Virgin, who had been seated, rises to stand and accept her task. The Visitation, seen again through the Monza souvenir, is even more powerful in mood. The Virgin and her cousin, Elizabeth, throw themselves into each other's arms visibly expressing their deep emotion. The grandeur and passion of the scenes at Nazareth can be contrasted with the homely realism and love of detail found at Bethlehem. There, the church was decorated with the Nativity and the Adoration of the Magi. A Monza *ampulla* records the Syrio-Palestinian scene of the Nativity – on the left Joseph sits lost in thought, his head resting in his hand; on the right the Virgin, overcome with the effort of the birth, lies on a pallet on the ground; and between them the Christ child lies in a crib with two attendant adoring animals. At some point early on in the codifying of this scene, Syrio-Palestinian artists added the domestic detail of two midwives bathing the child and set the whole Nativity scene within a cave. Until 354 both the feast of the Nativity and the feast of the **61** Adoration of the Magi were celebrated on the same day, 6th January. Only after that date was the feast of the Nativity altered to 25th

60 An *ampulla* from Monza (6th century); scenes of the Annunciation and Visitation, top register

61 Near-Eastern ivory panel (6th century);
the Adoration of the Magi and the
Nativity

December. Thus if a scene of the Nativity also contains the Adoration of the Magi, it is likely to date not later than the first half of the fourth century. The Council of Ephesus dominated by Cyril of Alexandria, was held in 431 to decide the status of Mary, and proclaimed her divine motherhood. She attained the title of Mother of God, Theotokos, and from that date began to be portrayed as a figure of great grandeur, like a queen or empress. The façade of the church at Bethlehem showed her thus seated full face, holding the Christ child on her knee. The scene of Christ as a majestic figure, seated or standing in glory, adorned the churches of the Transfiguration and of the Ascension at Jerusalem. The Eastern Church, in the first four centuries of Christianity, preferred to represent Christ in Majesty as a symbol of man's redemption, rather than to show him suffering and dying, in human form on the cross. The scenes of the Transfiguration and the Ascension were given deeper symbolical significance by being composed as if inspired by an Old Testament prophet. The vision of Ezekiel, who saw God in glory surrounded by attendant angels, is wedded to the New Testament version of Christ in glory. Often a four-wheeled chariot under Christ's feet betrays the Old Testament source. In the Jerusalem Transfiguration, Christ appeared in a mandorla, standing in glory, surrounded by cherubim and attended by Apostles and the Old Testament figures of Moses and Elias, Ezekiel and Habbakuk. The Jerusalem Ascension showed Christ seated on a throne and surrounded by an aureole supported by four angels. Seated in glory as the Master and Judge he raises his right hand and holds a book in his left. The Apostles are grouped symmetrically below him, and at their centre, the Virgin, with a halo, stretches out her arms in the attitude of an orant. Since the Virgin is given a halo, the Jerusalem Ascension is probably datable to after the Council of Ephesus.

62 An *ampulla* from Monza (6th century); the Adoration of the Magi

63 English manuscript of St Augustine's Commentary on the Psalms (c.1150); the Virgin and Child enthroned

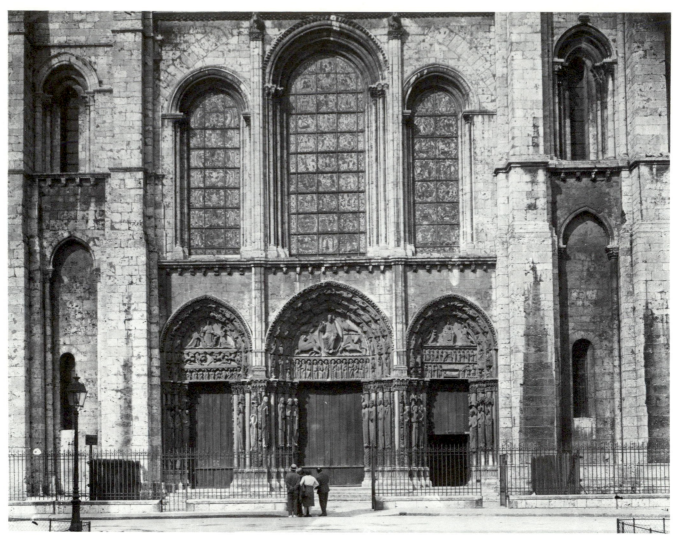

64 The Royal Portal of Chartres (c.1150–55);
the right-hand *tympanum* shows the Virgin
and Child enthroned and the central
tympanum shows Christ in Majesty with the
four symbols of The Evangelists

65 An *ampulla* from Monza (6th century);
Ascension of Christ

The way in which the Transfiguration and Ascension scenes in Jerusalem were enriched in significance by the addition of an Old Testament context is paralleled by the emergence of a school of Christian figurative art in northern Mesopotamia which seems to have initiated and developed the parallel arrangement of Old Testament and New Testament scenes on the opposite walls of churches. A famous fifth-century letter from St Nilus of Sinai is preserved, which recommended for the decoration of a church a sequence of such scenes ranged in chronological order down opposite sides of the nave. An example of the antithetical arrangement of Old and New Testament scenes which was popular in early Christian centuries was the Sacrifice of Isaac and the Crucifixion. Isaac was made by his father to bear a bundle of faggots for his own sacrifice, prefiguring the way Jesus was made to bear his cross along the Via Dolorosa. Many churches of the fourth to seventh centuries must have used this didactic system of decoration; we know, for example, that the nave of the sixth-century church of St John at Ephesus had mosaics of Old and New Testament scenes, and Benedict Biscop's late seventh-century church at Monkwearmouth in Northumberland had frescoes following the same arrangement.

81 The wooden doors of the church of Santa Sabina in Rome, c.430, are made up of carved figurative panels of Biblical scenes. The reconstruction of the complete iconographical scheme is impossible. However, it does seem that the episodes on the panels were taken equally from the Old and New Testaments and originally arranged to point analogies. The style of the Santa Sabina panels points to the Near East as its centre of origin or source of influence.

PLATE III Eusebius, Bishop of Caesarea in Palestine (265–340) and a celebrated theologian, devised in about 330 numerical tables for drawing up concordances between the Four Gospels, and these became known as the *Canones Evangeliorum* or Canon Tables. Parallel passages in the gospels are arranged opposite each other, set in painted and decorated arcading designed to frame and support the tables. The systems of parallel arrangements of Old and New Testament scenes and parallel passages from the Gospels reveal the serious and thoughtful ordering of Biblical subject-matter which was undertaken in the Near East in the fourth and fifth centuries, and which very quickly found its way into the West. The first decorated Canon Tables are found in Italian manuscripts by the last quarter of the fourth century.

Illustrative art forms had existed before Christian times. The Jews lived under the guidance of the Ten Commandments, of which the second was 'Thou shalt not make unto thee any graven image'. But the next verse in Exodus (10,4–5) exorted them not to bow down to them or serve images, thus allowing the interpretation that some forms of imagery were allowed and indeed expected. The existence of a Jewish narrative art in Late Antique times, and a mature one at that, is proved by the frescoes found in the synagogue at Dura Europos. The date of these frescoes has been put at 245–56 since

dedicatory inscriptions with the year 244–5 were found on the ceiling tiles.

Egyptian Biblical Illustrations

It is an accepted fact that the first Biblical Old Testament illustrations came from Egypt, and that these were drawn upon papyrus rolls. These early Biblical picture rolls were to have a determining influence upon the schemes in which the stories of the Old Testament were cast in the following centuries. Their manner survived due to the fact that illuminated manuscripts were a great preservative of iconography and style, for every manuscript, if it was of an important text such as the Bible, was a copy of an earlier one. Thus the mould formed by the earliest manuscripts was continually re-used: artists were not encouraged to create a whole new repertory of art forms when there were extant examples of their subjects to hand. As the Late Antique period moved into the Early Middle Ages, experimentation with style and iconographical schemes were to be the great contributions of those centuries. The museum and library of Alexandria, founded by Ptolemy Philadelphus (285–47 BC), became famous and attracted scholars and artists from Greece and all over the Eastern world, who drew upon its vast sources of material. For the benefit of the Hellenic section, Ptolemy had the first five books of the Old Testament translated from Hebrew into Greek, and this translation earned the name of the Septuagint. The books translated were Genesis, Exodus, Leviticus, Numbers, Deuteronomy and the Apocrypha, six books in all, and the name of septuagint arises from the fact that 72 translators were involved. Illustrated Hebrew Bibles (of Old Testament books only) already existed; the Septuagint text was illustrated similarly; and it was in this way that the beginning of Biblical imagery emerged in northern Egypt.

The earliest form of the book, in northern Egypt, was the papyrus roll. This format gradually gave way to the codex form, a book made up from pages gathered and bound within a cover. Perhaps, since the root of the word codex stems from the word for a tablet, the idea of the codex form had some symbolic linkage back to the tablets of stone upon which God conveyed his law to Moses. The text of the Bible began to be written upon flat pages, like the earlier tablets. The Bible is a narrative story, written over a thousand years or more; because of this protracted time span it displays a varied and sectional character. The earliest Christian art, which naturally relied on the Bible as its source material, reflected this diversity. But the strength and power of the narrative caused Christian art to emerge first and foremost as an art of the book. The Christian preference for the codex over the papyrus roll form of book resulted in the modification of the layout of the more antique narrative style. The most ancient extant Christian illustrated manuscript dates from the fourth or fifth

century, and is in the codex, rather than the *rotolus* (roll) form. Thus the first Christian illuminations in a book are at least a hundred years later than the first Christian wall paintings found in the baptistry at Dura Europos. Nevertheless, the illuminated book probably contributed more to wall painting than it received. Manuscripts provide a wealth of imagery in a compact form and are portable. They can circulate freely, even over great distances, and sometimes by unexpected routes, whereas wall painting, by its very nature, is a permanent fixture. The illuminated Christian manuscript, besides functioning as a pattern book and a model for the transmission of images of deliverance and faith, primarily served as an embodiment of Holy Writ, and as such deserved to be treated with reverence. It was heavily decorated, often with precious gems, and had its place upon the altar, the throne and the lectern, where it was revered for the authority of its message. Wall paintings and mosaics are often referred to as 'poor men's bibles', a phrase which itself confirms the priority of the manuscript.

Dura Europos Murals

PLATE IV Both the mural scheme of the Dura synagogue and that of the Dura baptistry display a haphazard layout. The synagogue, a larger room, has its decoration composed in three registers. The scenes on the east wall have been destroyed, and the south and north walls are incomplete, although panels of incidents from the lives of Jacob, Elijah and Ezekiel have been identified. The west wall, the best preserved, has three registers of panels, with scenes from the life of Moses and Aaron, Elijah, David, Mordecai and Esther. These are mingled with eschatological scenes, such as the Heavenly Temple and The Ark of the Covenant in the land of the Philistines, which serve to emphasise the doctrines of heaven and hell, judgement and deliverance. Not all is imbued with the divine message, since some of the incidents which make up the Biblical scenes are taken from Jewish Biblical commentaries, exegeses which often combine a mixture of additional stories, legendary material and details taken straight from everyday life. In the panel of the finding of Moses in the bullrushes, two midwives stand on either side of Pharaoh's daughter.

The Alexandrian Septuagint contained the Apocrypha – a book not originally written in Hebrew, nor counted as a genuine part of the Biblical narrative. The intrusion of extra-Biblical elements so early in the codification of its illustration brings to mind the famous letter of St Bernard of Clairvaux, written early in the twelfth century, which denounced the fantastic sculptured capitals of the cloisters of Cluny as completely devoid of religious significance. There is much in Romanesque art that does not appear to be an illustration of a sacred text, or could be construed as symbolic of things religious. It thus appears that this tradition begins early, and is already established by the middle of the third century. It would appear that

since Biblical illustrations originated in the Eastern Mediterranean, the inclusion of anecdotal material from legend and pseudo-evangelical writings followed shortly after, and in the same area.

The *Proto-evangelium* of St James, an apocryphal gospel written in Syria during the last half of the second century, has provided several anecdotal, domestic touches which supplement the Biblical account and find their way into Christian art within its first few centuries. When, in an Annunciation scene, the Virgin is portrayed spinning purple wool for the Temple, or gathering water in a pitcher, these details are taken straight from the text of the *Proto-evangelium* of St James.

A comparison of the murals of the Dura synagogue and the Dura baptistry reveals that the synagogue has the more complex, developed decorative scheme. Since Jewish art predates Christian art, there is a chronological priority of Old Testament over New Testament imagery. The scenes of the Dura synagogue do not follow the narrative sequence of the Bible, and because the scheme of the murals is unclear, even allowing for the loss of the decoration on the east wall, it is thought that Dura's murals, being situated in a provincial frontier town, were inspired by those of an unknown painted synagogue in a more cosmopolitan centre, executed by better artists and with a clearer theological plan. Thus, Jewish Septuagint illustration seems to have existed in a well-developed state prior to PLATE IV 245. The style of these wall paintings is an Eastern version of Hellenism, with a strong thread of Parthian (Persian) influence. The figures adopt frontal poses, and, as we have already said, they lack three-dimensionality and an awareness of their relationship to one another. The relative sizes of the component parts of the compositions are distorted in order to point up more clearly the meaning. Below the three registers of figurative panels, the mural artists painted a decorative border made up of three repeated units – a PLATE V wild animal seen in profile view, a panel of false marbling, and a panel in which a portrait head or a reclining animal or bird is placed within a roundel. This decorative border contains the seeds which were to germinate in many Romanesque schemes of mural decoration. PLATE IV Equally the band of pattern which divides the figurative panels from one another, composed as it is from an undulating line with attendant clusters of small dots, reappears throughout Mediaeval art.

The wall paintings in the baptistry at Dura, dated c.240, are less extensive in conception and less well preserved. Their significance lies in the fact that they are the first representations of New Testament scenes in the history of art. The scenes identified are those of Christ healing the paralytic, Christ and Peter walking on the water, and the Women at the Tomb, incidents from the gospels of Matthew and Mark. Christ is shown wearing a long-sleeved *chiton* and *himation*, and he is bearded with a mass of thick hair. Again, the panels are divided by strong decorative bands with a central undulating line, and the lowest register, which has not survived, and which is too narrow for figural scenes, must have been a decorative border. The

PLATE IV

two small columns which flank the niche are painted with decorative bands, just as the two small columns of the niche in the synagogue bore decorative false marbling. A distant echo of this occurs in the decoration of the columns in the late eleventh-century frescoes in the

PLATE VI

church of Saint-Savin sur Gartempe, in central France.

Fifth to Sixth Century Illuminated Manuscripts

The advanced Christian style of the Cotton Genesis is evident from its almost total neglect of classical personifications, which was a great characteristic of Alexandrian art. As far as it is possible to ascertain, from the meagre remains of the Cotton Genesis, there is not a single personification which would suggest any conscious effort to preserve such a pagan element. This would suggest that the artists of the Cotton Genesis were intent on illustrating the contents in a thoroughly Christian manner, with as few reminiscences of the classical past as possible. The only instances of Alexandrian personification are the winged angels representing the Days in the Creation scenes, and the psyche in Adam's animation, but these have assumed a sort of Christian meaning. In style the figures are squarish, dumpy, rather two-dimensional, and the surface of their drapery is covered with a system of abstract golden highlights. The backgrounds are almost geometric, with sharply separated strips of dark blue, light blue and pink, tending to eliminate all spatial effect. The Cotton Genesis is the only existing Biblical manuscript which has a just claim to being a genuine Alexandrian product. It combines traces of a Graeco-Roman heritage, seen in the sensitive and refined designs of its composition, with the two-dimensional linear style of its Coptic origin.

66 The oldest known illustrated Gospel book, although containing only the texts of Matthew and Mark, is the sixth-century book in the cathedral library of Rossano, known as the Rossano Gospels. Its place of production is believed to be Syria, and it is a handsome, even opulent manuscript with gold and silver uncials written on purple-stained vellum. The illustrations do not follow the text of the Bible, and they seem to be liturgical in character. It has been proposed that they are copied from a cycle of monumental paintings which reflected liturgical practice. Their arched frames and symmetry resemble apse compositions and they could have been copied from fifth-century mosaics or frescoes in Jerusalem. The gospel of St Mark is preceded by an Evangelist portrait, the sole example which survives from the pre-iconoclastic period. Evangelist portraits were the usual features of Gospel books from this date onwards. They derive from the Hellenistic practice of including author portraits in illustrated books. The illuminations in the book are painted with refinement and economy. Each gesture is chosen so that it makes its most telling point. Classical Hellenistic naturalism begins to give way to expression and pattern.

Contemporary with the Rossano Gospels, and from the same area, is the Vienna Genesis, of the sixth century, with a provenance traced to Syria or Palestine. The manuscript is even more sumptuous than the Rossano Gospels, with silver uncials on purple-stained vellum and illuminations occupying the whole of the lower half of the pages. The illuminations illustrate an abbreviated Septuagint text, but elaborate upon it, going outside the text of the Bible for their source. Indeed, scholars have proposed that its illustrations could have been copied from a Jewish paraphrase of the Bible. In the illuminations, great emphasis is placed upon realistic, narrative detail, and upon the psychological state of the figures. Also from the same area and the same date are the Rabbula Gospels dated 586 and signed with the name of the scribe, Rabbula. They were produced in the monastery of St John at Beth Sagba, in northern Mesopotamia, and the decoration comprises eight full-page miniatures and a set of canon tables.

The Rabbula Gospels have great iconographic significance, since they contain the first known painting of the crucified Christ as one of the miniatures, and another with the first known illustration of the scene of the Ascension of Christ. The page with the Ascension of Christ has its literary source (since there was no immediate visual source) in the vision of Ezekiel, which was read on Ascension day in Eastern Syria. Christ stands in a *mandorla*, with angels holding its edge. Under his feet are cherubim, the four Evangelists' symbols and the four-wheeled chariot. Below stand the Virgin and the Apostles as witnesses to the scene. The zoned symmetrical composition has monumentality, energy and drama and communicates its meaning with clarity. The miniature has a strong geometrical border, with small coloured squares creating an overall chevron design, a decorative device often used in Romanesque art. The composition was taken up and appears frequently, for example in apse paintings in chapels in Bawit, Egypt, from the sixth to eighth centuries, in biblical illustrations in Carolingian times, and with particular fervour in Romanesque murals and carved *tympana*, as at Angoulême, Moissac, over the Prior's door at Ely, and on the west portal at Chartres, among others.

66 Rossano Gospels (6th century); Evangelist
portrait placed before the Gospel of Saint
Mark

67 Rabbula Gospels (dated 586); Ascension
of Christ

Missionaries

By the sixth century, monasticism was firmly established in Ireland, and it became a land of *scriptoria*, producing decorated manuscripts of Christian texts before there were any in England. Ireland has an important place in the development of early Mediaeval art since it acted as a transfer station. It received many cultural influences from Egypt and the Near East in the early Christian centuries, which it fed into England in the seventh and eighth centuries, and these then passed to the European continent, serving as a basis for Carolingian and Ottonian art. The Irish Church, being monastic in outlook placed a great emphasis on evangelical missions. One of those was led by St Columban, who set out from Bangor with a group of companions for the Merovingian kingdom in France. He established his first monastery at Luxeuil in the Irish rite, but opposition eventually forced him to move southwards. One of his monks, Gallus, was prevented by illness from journeying with the rest, and he founded his own hermitage. In 720 this developed into a monastic community, St Gall in Switzerland, which became famed for its school, its *scriptoria* and its learning. Columban, having left Gallus behind, travelled to the south side of the Alps and founded a monastery at Bobbio in 613. This also became an important centre for scholarship, with a large *scriptorium* and library, retaining Irish traditions.

The earliest missionary was St Columba, who left Ireland in 563 to convert the Picts in northern Scotland. As a result of this mission, Columba founded the monastery of Iona in 565, and this was to become the dominant monastic centre in the British Isles. Columba died in 597, the year in which St Augustine arrived in Kent to convert the pagan Anglo-Saxons. In 635 the Northumbrian King Oswald, having become a Christian while in exile in Ireland, received a group of monks led by Aidan – a mission sent by the monastery at Iona, to restore the Christian faith in his area. He provided them with the island of Lindisfarne off the coast of Northumbria as the site to found their monastery. Lindisfarne was founded in the Irish tradition, but the Roman tradition had found its way there also, on a route from Canterbury. Northumbrian scholarship was a mix of Irish-Columban traditions, with a new influx from the Anglo-Saxon world. This new influence, although from Rome, was to have strong Near Eastern contacts. Archbishop Theodore of Tarsus (Turkey) was sent by Pope Vitellian to found an ecclesiastical school at Canterbury, which he did in 671, along the lines of educational institutions in Rome, but both Pope Vitellian and Theodore were Near Eastern by birth, and it seems probable that Theodore kept close links with his cultural origins, which he transmitted to his new country of residence by way of precious portable religious objects, ivories and manuscripts. A style common in certain respects to both Ireland and Northumbria, and christened Hiberno-Saxon, emerged around the middle of the seventh century. It was primarily confined

to book illumination, and by its concentration on the decoration of Christian texts it succeeded in enriching the concept of the illuminated book, a concept which was to prove most fruitful during the remaining early Mediaeval period. Hiberno-Saxon books were not just means of communicating religious texts, they were also to be seen as objects of veneration in their own right.

Irish Insular Art

Prior to the seventh century Irish illumination had been simple, using mainly spiral abstract decorative motifs. But in the middle of the seventh century, a new kind of ornament entered its vocabulary. It was not indigenous to the country but Irish illuminators were to develop it with astonishing dexterity and make it something peculiarly and especially Hiberno-Saxon. The new ornament was interlace. This motif is commonly believed to have been imported directly from Egypt, because some of its most systematic and characteristic forms are to be found in Coptic art, though similar designs can be found in Byzantine and Italian art. Whatever its ultimate source, the Irish soon surpassed other artists in the handling of interlace. The Book of Durrow, written and decorated c.680 in a monastery at Durrow founded by St Columba, is the earliest fully decorated Gospel book, with Canon Tables, carpet pages and full-page pictures of the Evangelist symbols, many of which are surrounded by a border of interlace. The new and sudden adoption, in an Irish book, of carpet pages and full-page pictures of the Evangelist symbols, has to be explained by the intervention of an outside, foreign source, since both items are not Insular inventions, but Oriental in origin.

PLATE VII

Adamnan, abbot of the monastery of Iona, wrote a book called *De Locis Sanctis* which is devoted to descriptions of the early Christian sanctuaries in the Near East, Palestine and Syria, and illustrated with ground plans of these important religious monuments. Adamnan was able to produce this book because of the presence on Iona of a pilgrim recently arrived from the Near East. This was Arculf, a French bishop. While returning from the Holy Land, he was driven by storms away from the coast of France on to the coast of Scotland, where he found a sympathetic shelter on Iona. Arculf had made sketches of the Near-Eastern monuments on a wax tablet which he made available to Adamnan. Since the adoption in the Book of Durrow of carpet pages and Evangelist symbols without wings and haloes appears to coincide with Arculf's visit to Iona, it seems not unlikely that this pilgrim from the Near East brought with him an illuminated manuscript which contained such motifs. They established the style of Insular book illumination, but are themselves quite foreign. A sixteenth-century Persian copy of the 'Gospel Harmony' or *Diatessaron* of Tatian, a Mesopotamian theologian of the second century, opens like the Book of Durrow with a carpet

PLATE VIII

PLATE IX

page into which is embedded a cross. A common Near-Eastern archetype must lie behind both pages. Another frontispiece miniature in the *Diatessaron* copy is a composition of the four Evangelists' symbols shown full length. This is closely paralleled in the Durrow Book. The symbols – a man, a lion, a bull and an eagle – serve to remind us that, beside the curvilinear and interlace patterns of ornament in Insular Hiberno-Saxon book illumination, there was the recent introduction of animal and human motifs. Such material was introduced since it was ultimately necessary to illuminate the Bible stories with human and animal participators, yet the Insular love of complicated and abstract decoration led the painters to devise contorted, acrobatic postures for these living beings. Classical art had placed its emphasis upon the depiction of human and animal figures, giving them a dignity and a presence which was enhanced by attempts at providing an illusion of three-dimensionality. In classical art, the figures dominate the rest of the composition and are usually its focal point. When Insular artists began to introduce figures, the figures were made to fit in with the rest of the composition, which was always highly decorative, and mapped out so as to form a superb pattern upon the page. The humans and the animals become entangled with the interlace and have to assume odd, grotesque or whimsical postures. This often appears to prevent them from fulfilling their spiritual rôle, and causes them to be seen in a secular light. This droll and whimsical aspect, which seems to have been invented by Insular artists, was one which they gave to the rest of Europe, and it was to be re-adopted in Romanesque (and Gothic) times with abundant enthusiasm. Indeed, Insular art quickly gained a foothold on the Continent, due to the evangelical efforts of Willibrord (658–739). He was educated at Ripon and in Ireland, and in 670 he set off with a group of compatriots to work in Friesland. He was consecrated archbishop of the Friesians in 695 and established his episcopal chair in Utrecht. In 700 he founded a second monastery at Echternach. These two centres, peopled by the Anglo-Saxons, were to be potent influences in continental Europe in the next century. They exerted a fertilising influence upon the revival of arts under Charlemagne's cultural policy, and this influence was to be felt all over Europe into the early Romanesque period.

PLATE X

The Lindisfarne Gospels take their name from the monastery in which and for which they were written. The manuscript has a *colophon* which states that it was written and decorated by Eadfrith, Bishop of Lindisfarne, c.698. Eadfrith was obviously trained in the Hiberno-Saxon tradition, but we can see the appearance of a fresh stimulus – most apparent in the figures of the Evangelists, here presented as men accompanied by their symbols, not just by their symbols alone, as in the Book of Durrow. The desire to portray the human figure with a new physical presence must have been prompted by some stimulus from contemporary Mediterranean art. This could well have arrived with the papal emissary, Theodore of

Tarsus, who, in his rôle as Archbishop of Canterbury, is known to have consecrated the church of Lindisfarne some time before his death in 690. Carl Nordenfalk draws a comparison between the Evangelist figures of the Lindisfarne Gospels and figures carved on a contemporary group of Byzantine ivories of Near-Eastern origin which once decorated an episcopal throne believed to have been that of St Mark of Alexandria (now in Sforza Castle, Milan). Byzantine art, although hieratic, stylised and intensely spiritual, still retained some links with its classical Greek heritage. Although Byzantine art was a religious, theological art, and Greek art glorified man and his nature above all else, they do occasionally share a common approach to the humanity and dignity of figures, and isolated examples of antique elements appear in, for example, Byzantine manuscripts. Insular art, prior to the Lindisfarne Gospels, when it had attempted to portray man, had depicted him with a flat body overwhelmed by drapery, dislocated limbs and a fixed and hypnotic gaze – a manner quite opposite to that of the classical canons of beauty. The page – fol 25 v – with the Evangelist portrait of St Matthew reveals its Greek model in two further ways: the name of the Evangelist is preceded by the Greek O *Agios*, the Holy, and the inclusion of another human figure half-hidden behind the curtain to the right betrays a knowledge of Greek two-figure Evangelist iconography.

Both the date of execution and the *scriptorium* which produced the Book of Kells, an Insular manuscript nearly contemporary with the Lindisfarne Gospels, are unknown. The most likely place is the monastery of Iona, rather than Lindisfarne: there are differences of text and style between the two books, that of the Kells being flatter, and less monumental in figure scale. The date is believed to be the very end of the seventh century. (Iona was overrun by the Vikings in 807.) The Book of Kells has 10 pages of decorated canon tables. It has Evangelists' portraits, a portrait of Christ, a page of the Virgin and Child, quite possibly the first representation of this scene in a Western manuscript, and two pages of the Arrest and the Temptation of Christ. The decorative inventiveness apparent on every page, indeed in every decorated initial, is overwhelming, unique and inexhaustible. However, although these traits are strongly Insular, the Book of Kells also displays evidence of influence from Mediterranean models.

68 The representation of the Virgin and Child in the Book of Kells is similar to the same subject group engraved into the side of the wooden reliquary of St Cuthbert, probably decorated at Lindisfarne at the end of the seventh century. A feature which they both share is the way the Christ child is seated on his mother's lap – not facing the 69 onlooker, but placed across the lap in a much more casual way. Kitzinger proposed that both were influenced by an Eastern model which was more familiar than hieratic in its presentation of this subject. A suitable model has been more recently discovered – a seventh-century icon from Mount Sinai – which shows the Christ child seated in this manner. The use of this figuration as a model

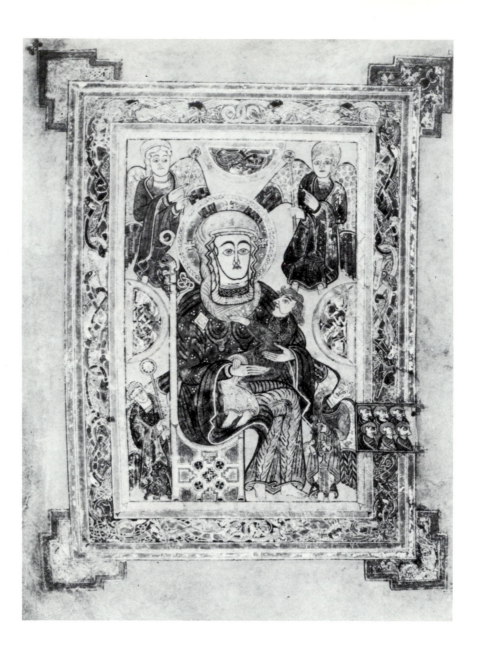

suggests that it was more commonly used in Eastern icon painting than might be supposed from the surviving examples. Similarities can also be found with the Virgin and Child scene in the frescoes at Saqqarah in Egypt. When the whole composition is considered, not just the central motif of mother and child, other Eastern prototypes suggest themselves. Two have been proposed by Françoise Henry. A carved block of stone from Thalin, in Armenia, datable to the seventh century, and a page from a Coptic manuscript, dated 893 (Codex M612, fol. 1v) show similar compositions.

The Hiberno-Saxon tradition survived into the ninth century, but during that period England suffered many barbarian raids and her *scriptoria* were often pillaged. The introduction of Hiberno-Saxon influence, initiated on the Continent in the previous century, was

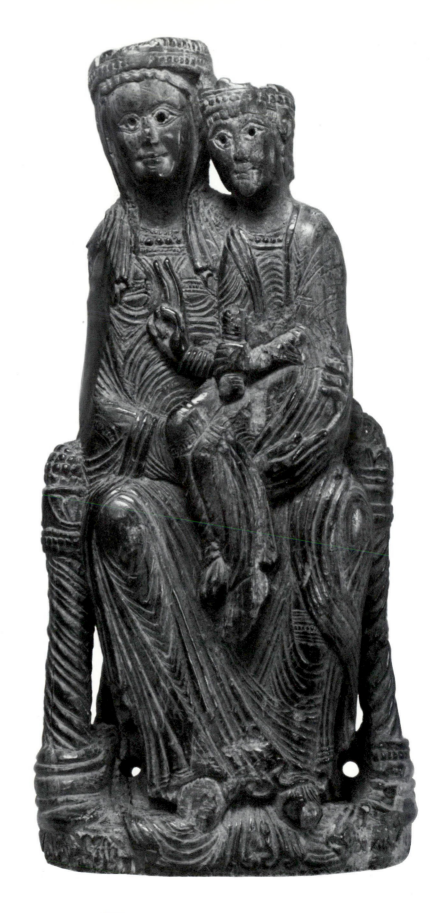

69 English ivory group (mid 12th century);
the Virgin and Child

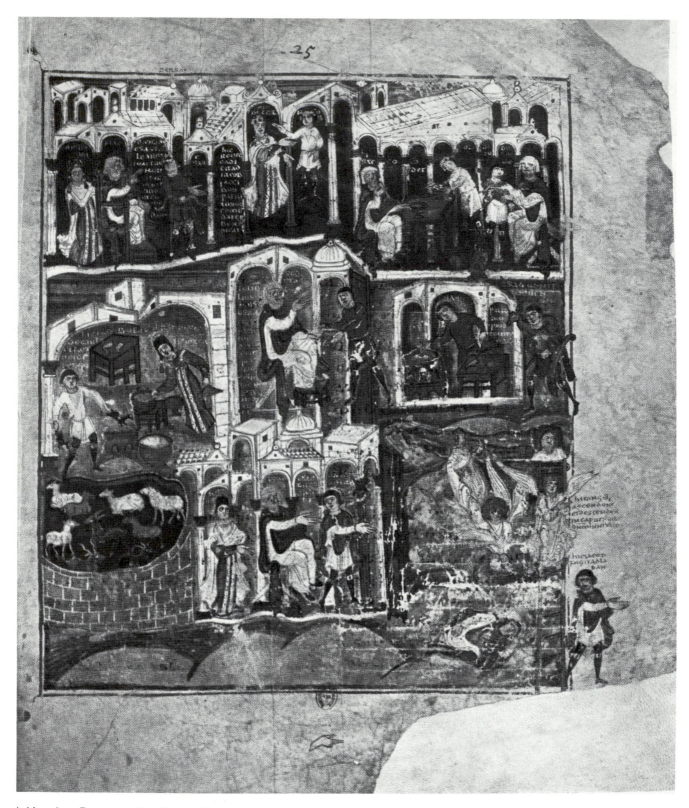

70 Ashburnham Pentateuch (late 6th or early
7th century); the story of Jacob and Esau

given its greatest impact by the figure of Alcuin of York. Alcuin met Charlemagne in Pavia in 781 and was invited to his court at Aix in 782 to be his minister of education and to be responsible for the revision of the Latin text of the Bible, a task in which he was assisted by Near-Eastern scholars. He also organised the development of the cathedral and monastic schools, encouraging the *scriptoria*. The Carolingian Renaissance is largely based on influences derived from antique, Byzantine and Insular sources – on works of art and ideas which reached back through many centuries.

70 The Ashburnham Pentateuch was held until 1842 in the library at Tours. It stands outside the Hiberno-Saxon tradition, but like many of those manuscripts, it displays sundry Eastern influences. It is generally attributed to a *scriptorium* in either Spain or North Africa, and dated to the late sixth or early seventh centuries. It has 68 miniatures, with 19 full-page illuminations of episodes from the first four books of the Bible, the section for Deuteronomy being lost. The most striking aspects of the illuminations are their strong colours – red, purple and green – and the fantastic architectural backgrounds. It can be taken that the illuminators had a knowledge of Oriental things; there are parallels to be found with the paintings of the Dura synagogue, and the plants and animals in the illuminations are native to the Near East – date palms, camels and scorpions. The style is lively and there is already a Mediaeval feel to much of the work; strong means are applied to represent the emotions of the figures – the mourners at Jacob's burial contort their faces and bare their teeth. There is too a great play on the expressiveness of the hands to increase the emotional and narrative points; the hands are often too large and adumbrate many that will be found later in the art of the Romanesque. Although the *scriptorium* is probably Spanish or North African, there are factors which point also to an execution in Europe. The lost leaves were replaced by an Italian artist in the eighth century and the paleography of the rubrics is of a type close to Carolingian.

Carolingian Art

Carolingian art is a term which covers the period from the reign of Charlemagne, who crowned himself Emperor in 800, until about 900. Charlemagne's intention was a *renovatio* of classical culture, embracing literature, theology and the arts. His artists had to turn to older models for inspiration, but in their drive to create a culture like that of ancient Rome, had recourse to material which was not classical. The Oriental tendencies of the minor arts, as well as the Hiberno-Saxon tradition of illumination, can be found in most works. Indeed a variety of foreign influences are often apparent in

71 one and the same work. The Godescalc Sacramentary, dated to 781, indicates the way Carolingian artists began; it contains a page (fol. 3) with an illumination of the *Fons Vitae* – the Well of Life – which

derives from Byzantine prototypes, whilst the writing betrays the influence of Hiberno-Saxon interlace. Carolingian manuscripts contain a high proportion of ornamental decoration, basically curling leaves, fish and animals. Some animals are very realistic and expressive, others are symbolic and are in the Byzantine tradition. The realistic or expressive ones are usually wild beasts, such as lions, snakes and dragons, which display ferocious characteristics. These are the invention of the Germanic tribes, and they constitute prototypes or forerunners of the expressive wild beasts in Romanesque art. The Germanic art which was flourishing in the seventh century under the Merovingian kings was superseded in France and Germany by Carolingian art. However, it survived in Spain, and re-emerged in southern France at the end of the tenth century, ready to enrich the emergent Romanesque art with lively animal motifs.

71 Godescalc Sacramentary (dated 781); the Well of Life

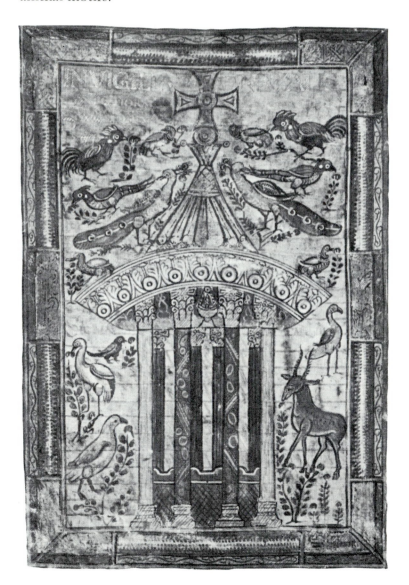

Iconographic novelties were not the speciality of the Carolingian artists of the ninth century, even though it was one of the most spectacular centuries for the illustrated book. The great value of Carolingian book illumination lies in its amalgamation of the two hitherto distinct traditions of abstract and figurative art. Both traditions were seen to be equally valuable, and the juxtaposition of both brought about their enrichment. Romanesque art depends upon this concord for its religious and metaphysical significance; the abstract decoration on a Romanesque capital or around the edge of a Romanesque *tympanum* is an invigorating partner for a scene from the Gospels or the programmed display of Christ judging the peoples of the world; the combination stresses the cosmic nature of the art. The figurative scene speaks to the mind and heart, whilst the abstract part delights the eye, and even empathetically on certain occasions, the tactile sense.

Carolingian artists concentrated mostly upon the Old Testament and the Psalter. The important *scriptorium* founded at the abbey of Saint-Martin at Tours produced the Moutier-Grandval Bible and the Vivian Bible, the first Bible of Charles the Bald. From an examination of their iconography, it is obvious that a fifth- or sixth-century model was preserved at Tours. The library there would have been of great importance, since it was at Tours that Alcuin organised the revision of the Vulgate. A third important Carolingian Bible, that of San Callisto, now at the monastery of San Paolo fuori le mura in Rome, is a couple of decades later than the two Tours Bibles, and its artist, Ingobert, must have had access to a larger range of models than the Tours artists, since his Bible shows certain similarities to the Ashburnham Pentateuch.

Of Carolingian psalters, by far the most important is the Utrecht Psalter, written at Hautvilliers, near Reims, c.832. It is illustrated throughout with narrative scenes, executed in ink, not in full colour, and displays the most idiosyncratic, remarkable style. The content of the narrative scenes is not that of the ninth century, and can be traced back to the fifth century; the text, with its layout and paleographical characteristics can be traced to a seventh-century model, but the lively drawings are unprecedented. Far from the static sumptuous calm of the luxurious Carolingian Bibles, the vigorous animation of **72,73** the Utrecht Psalter illustrations look forward to Romanesque art. The actual composition of the narrative scenes has been traced to manuscripts produced in the eastern half of the Mediterranean in the fifth and sixth century, where the landscape convention can be found. Since the buildings are quite similar to some seen in the Ashburnham Pentateuch, it seems reasonable to suppose that both manuscripts derive from an antique Hebrew source. The immediate appeal of the narrative, found in this Psalter, was one which would be most welcome in Western European culture, whose predilection was for story-telling, for the facts of everyday and religious life are presented in a lively fashion.

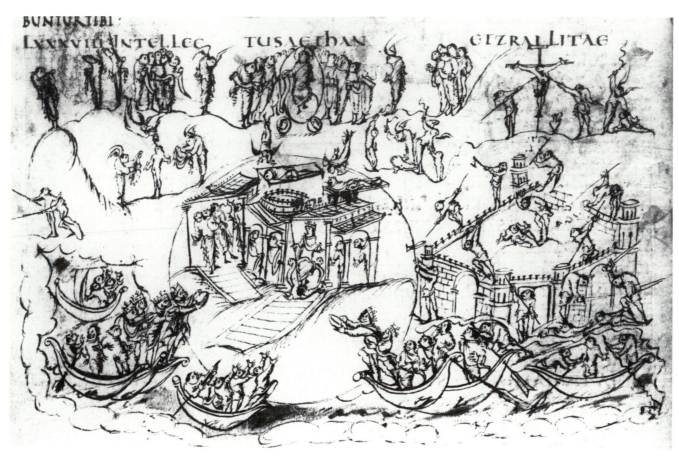

72 Utrecht Psalter (c.832); illustration to
 Psalm 89

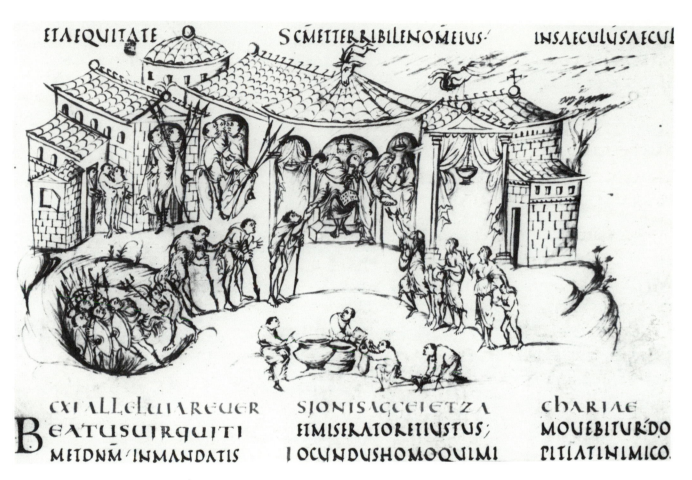

ETAEQUITATE SCMETTERRIBILENOMEIUS· INSAECULUSAECUI

CXIALLELUIAREUER SIONISACCCIETZA CHARIAE
BEATUSUIRQUITI ETMISERATORETIUSTUS; MOUEBITURIDO
METDNM·INMANDATIS IOCUNDUSHOMOQUIMI PITIATINIMICO.

73 Utrecht Psalter (c.832); illustration to
Psalm 112

But concurrent with the racy realistic style of the Utrecht Psalter were the richly decorated Carolingian Bibles, whose narrative aspects were overwhelmed by scenes of a hieratic, symbolic nature. Figurative art had thus two streams, one given over to the recital of commonplace facts, and the other which concentrated on the solemn hierarchy of sacred persons and earthly rulers. Both streams appear to have originated in the Eastern Christian Empire. The realistic narrative style, which is already found in Western Europe by the fourth and fifth centuries, may well have come from Syro-Palestine sources. The hieratic tradition, which came into East Christian art between 450–550, found its way into both Byzantine and Carolingian art (though its greatest period of influence was to begin with Ottonian art, which succeeded the Carolingian). The hieratic tradition did not originate with Christian art, having a well-established previous existence in Persian and Islamic art, in scenes of regal or celestial import.

The courtly circle of the Carolingian Empire appreciated scenes of a hieratic nature. The Moutier-Grandval and Vivian Bibles both have illuminations of Christ enthroned on an almond-shaped **74** *mandorla* (*mandorla* is the Italian word for almond), which first appears in Christian art in the miniature of the Ascension in the **67** Rabbula Gospels. Christ also stands in a *mandorla* for the scene of the Transfiguration, a scene often portrayed in Western art, whose first appearance is in the sixth century, one example being found in the church of the monastery of St Catherine on Mount Sinai.

Charlemagne and his descendants ruled over an area of Europe which comprised Gaul, part of Germany and northern Italy. When the Carolingian era came to an end, at the close of the ninth century, three countries which lay around the periphery of its empire took up much that it had promoted, and developed this material in their own individual and indigenous ways. These three countries were Germany, Spain and England, each of which experienced a flowering of book illumination which paved the way for the Romanesque. Indeed, much of what those three countries produced in the tenth and eleventh centuries adumbrates the Romanesque style. German art had a renaissance which owed a great deal to the Carolingian example, but the flowering was due to religious rather than secular stimulation, particularly in the field of monastic reform. England's development was similar, in that monastic changes paved the way for the burgeoning of Anglo-Saxon art. Spanish art of this period took a somewhat isolated course showed by its willingness to receive artistic influence from the south, from North Africa and the Arab world.

74 Berzé-la-Ville (12th century); apse fresco of Christ in a *mandorla*

Ottonian Art

German art of the tenth and eleventh centuries is termed Ottonian after Otto I the Great (910–72), who was crowned the first Saxon emperor in 962. In 972, Otto II, then aged 16, married a Byzantine princess, Theophano. They were married in St Peter's in Rome, and she journeyed from Byzantium to wed; her father was the Eastern Emperor Romanus II. Thus Ottonian art was quite international, and showed a strong awareness of art from other countries, particularly those of the Byzantine Empire. Otto III, Otto II's son, chose to emphasise the Byzantine rather than the Saxon side of his lineage, preferring the refinement and richness of the Eastern court. Carolingian art had been largely concerned with Old Testament illustration, and this was to change in Ottonian times. Alcuin's project was the revival of letters and the sciences, and he oversaw the

translation of the Vulgate, thus emphasising that the Carolingian era was interested in the conservation of ancient manuscripts and the gathering of new facts to provide a basis for scholarship. The Ottonian era put a greater stress on liturgy than scholarship, and provided illuminated books which could play their part in the church services. The texts which were most needed were the Gospels. Consequently, Ottonian illuminated manuscripts are basically those of the New Testament.

Some of the earliest Ottonian manuscripts originate from Saxony, the area which was the birthplace of the Ottonian emperors. These manuscripts mostly bear abstract decoration based upon patterns copied from Near-Eastern textiles. The major *scriptorium* of the Ottonian world was that of Reichenau, an abbey built on an island in Lake Constance, and it was possibly here that the Gero Codex was illustrated, sometime between 950–70. The Gero Codex marks the transition from Carolingian to Ottonian art. It could well have been made for the Gero who was archbishop of Cologne from 969 to 976, and who was sent by Otto I to Byzantium to escort Theophano from the East to the West.

The early phase of Ottonian art is characterised by much decorative patterning and a striving for expressionistic effects. But when the so-called Master of the Registrum Gregorii came upon the scene, from the *scriptorium* at Trier, Ottonian art entered a new period. The Trier workshop was the place where Ottonian art developed its significant individuality. The Master of the Registrum, named after illuminations in a manuscript of St Gregory's letters, initiated a new style and provided a powerful stimulus for his followers. His inspiration comes from late Classical and early Christian art of the fourth and fifth centuries. His figures are set clearly against their backgrounds, within simple frames and in balanced groups. For his illumination of Christ in Majesty, the artist used a gold ground: this is the first time that this technique appears in Western early Mediaeval art, and indicates some influence from Byzantium. Contemporary Byzantine manuscript illumination was itself turning for inspiration to late Classical and early Christian sources, and it could be that the Master of the Registrum was influenced in his choice of models by a knowledge of the outlook of the Eastern Empire.

Byzantine influences were strong in Cologne for several reasons. Bruno, archbishop there, was the brother of Otto I. He had a working knowledge of Greek and founded the church of St Pantaleon, a rare dedication in the West, since the third-century martyr came from Bithynia, where his church was rebuilt by Emperor Justinian. Empress Theophano often visited Cologne to see her uncle, Archbishop Bruno. She was in fact buried in St Pantaleon, and before her death she presented an important Eastern hanging to the Cologne monastery of St Maria. Another archbishop of Cologne, Heribert, was in close touch with Greek ascetics, who were to have a great influence over Otto III towards the end of his

75

PLATE I

75 Manuscript of the Registrum Gregorii
 (11th century); the Emperor Otto receives
 homage from his empire

life. Greek merchants were often to be found in Cologne, perhaps bringing with them tenth- and eleventh-century Byzantine manuscripts, with which the artists of the Cologne school were undoubtedly familiar.

Influences from Spain

If Ottonian art drew its early support from Carolingian art, Spanish art most certainly did not. Spain had remained outside the Carolingian Empire and had received a cultural experience quite different from that of the rest of Europe, due to Islamic invasion and occupation. Spain was first overrun by the Visigoths in the fifth

117

century; these barbarian invaders were themselves ousted by an Arab invasion of Spain from North Africa in the eighth century. The Arabs adopted a very tolerant attitude towards the Christian culture they found in their new land and did not undertake religious persecutions. A Christian stronghold was concentrated in monasteries in the Asturian mountains in the north, with smaller centres in Catalonia and Navarre. The art of these Christians produced under Arab domination has been called Mozarabic, but the term should be used with caution since the Moslem strain in Spanish art was not necessarily the dominant one; the art of Spanish painting probably kept to the same path it was pursuing before the Arab conquest.

PLATE XI

In the third quarter of the eighth century, a monk from Liebana in northern Spain, Beatus by name, wrote a commentary on the Book of Revelation (the Apocalypse) and the Book of Daniel. His commentary was not original, but derived from a patchwork of earlier church expositions; it was however decorated with a large number of illustrations. Although Beatus's original manuscript is no longer extant, it is known to us through later copies, and a particularly close version is believed to be the mid eleventh-century Saint-Sever Apocalypse (Bibliothèque nationale lat 8878). The illustrations in this manuscript show a similarity with those of the Ashburnham Pentateuch in colouring and style, and both no doubt owe an allegiance to an early Christian model. But the later manuscript is evidence also of the extraordinary popularity which Beatus's commentary enjoyed. Over 20 illustrated copies of his volume are extant, and they can only represent a small proportion of what was produced. The text of the Book of Revelation held an inordinate fascination for the Spanish imagination from the eighth to the twelfth centuries, and must have reflected the depth of feeling caused by domination by an alien creed. Beatus wrote that before the Day of Judgement the world would be ruled by Anti-Christ, who would bring tribulation to the populace and to the Church, but on the Day of Judgement, the Church would emerge triumphant and Christians would be delivered from their suffering. The Anti-Christ could easily have been identified with the Moslem infidel.

Illuminated Spanish Apocalypse manuscripts were, as we shall see, to have a powerful influence upon the emergence of Romanesque sculpture in Languedoc.

CHAPTER 4 SCULPTURE: FOURTH TO TWELFTH CENTURIES

The Decline of Classical Sculpture

Greek and Roman statues made in the centuries immediately before the birth of Jesus stressed the outward grace and beauty of the human figure and laid much emphasis on a presentation of mass and volume. Although the ideals and technical expertise of this classical heritage were never entirely lost, the immense influence of Graeco-Roman sculpture waned with the decay of the pagan world and the growth of Christianity. With the emergence and acceptance of the new Oriental faith, there arose an antipathy to highly finished three-dimensional images of ideal beauty. Christian artists wished instead to concentrate upon the representation of the inner state of the human figure, or even to turn away from the making of a three-dimensional image of man altogether. By the fifth century, sculpture in the round had virtually ceased to exist, and in the Eastern Mediterranean lands – in the Christian Empire during the period of Iconoclasm (726–843), and in territories under the rule of Islam – there was a total suppression of figural sculpture. Sculpture at that time and under those regimes consisted of ornamental decorations in low relief in stone, wood, stucco and precious metals. It almost lost its three-dimensionality, relying instead mainly on line and contour, and on the pattern made by interlaced silhouettes.

Near Eastern Centres of Influence

The Roman Empire was a single state until 395, the year of the death of Theodosius, when it was divided into an Eastern and a Western Empire. The Eastern lasted until 1453; the Western gradually dissolved under the repeated attacks of barbarians and the Arab invasions and was formally brought to an end by Odoacer in 476. Thus in contrast to the decay of civilisation experienced by most of Western Europe, there was an area of relative peace, security and culture round the eastern shores of the Mediterranean, and this political and social peace provided the conditions within which a new Christian art could develop. From the fourth century onwards, sculpture in the West was influenced by portable carved objects in ivory, wood and precious metals, brought from the Near East.

The Christian art of the Near East had two distinct strands from the fourth to the sixth centuries. These two strands stemmed from

two different geographical areas, both of which are encompassed within the term Near Eastern. The Greek cities of the Mediterranean coastline – Alexandria, Antioch and Ephesus – were treasuries of classical Greek culture and they turned the Hellenistic spirit of antiquity into service for the new religion. The Christ of these cities was a beardless youth, semi-naked, with a gentle and welcoming aura. The other strand of the Christian art of the Near East – the Syro-Palestinian strand – was that of the Holy Land itself. This extended beyond Palestine and Syria to Mesopotamia, Armenia and Cappadocia. Since the Holy Land was the cradle of Christianity, and the art of the significant sites was that of commemoration of a life actually lived and sacrificed there, it had the rude stamp of authority and authenticity. This is not to say that it was an art of naturalistic representation. Christ here was a stern majestic figure with a full beard, long hair and a long robe. He was presented more with formality and ceremonial than with the fluent idealism of the Hellenistic artists. Both geographical areas – the Greek cities of the Mediterranean coastline and the Holy Land – were of course part of the Roman Empire and thus were affected by elements of Roman art and culture. However, the position of Rome in the early Christian centuries was that more of a receiver than of a generator. Several Greek and Syrian clerics became Popes and brought with them their retinues and their culture. Christian burial in underground decorated chambers, for example, was not a particularly Roman procedure: there were decorated catacombs in both Antioch and Alexandria, though comparatively little is known about them because they are no longer extant, while those of Rome are famous and are still being discovered.

Egypt occupies a most interesting place in the development of Christian art. Alexandria, in the Nile Basin, was a major centre of Hellenistic art in the first Christian centuries, and from 313, when Christianity was officially recognised in Egypt, it took on a rôle as the propagation centre of Christianity. It played a major part in the early development of manuscript illumination and was a great centre of ivory carving. Coptic Art – that of Egypt in the fourth to seventh centuries – is made from elements of the art of ancient Egypt and of Alexandrian Hellenism. But there is a third ingredient, which gives Coptic art a sense of strength and vigour, and that is the Syrian element. Well-established trade routes existed between Syria and Egypt, and the Syrian influence in Egypt brought about an intermingling there of the two Near Eastern strands in early Christian art. At the same time, there must have been a Hellenic influence spreading out from the city of Antioch into its Syrian hinterland. However, by the sixth century in Egypt, the Syro-Palestinian strand of art began to supplant the Hellenistic art of Alexandria. Sixth-century works of art in which the two strands have begun to merge display a fascinating amalgam of elegance and strength all put to the service of a rich and developing Christian iconography. One such work is the ivory throne known as the throne

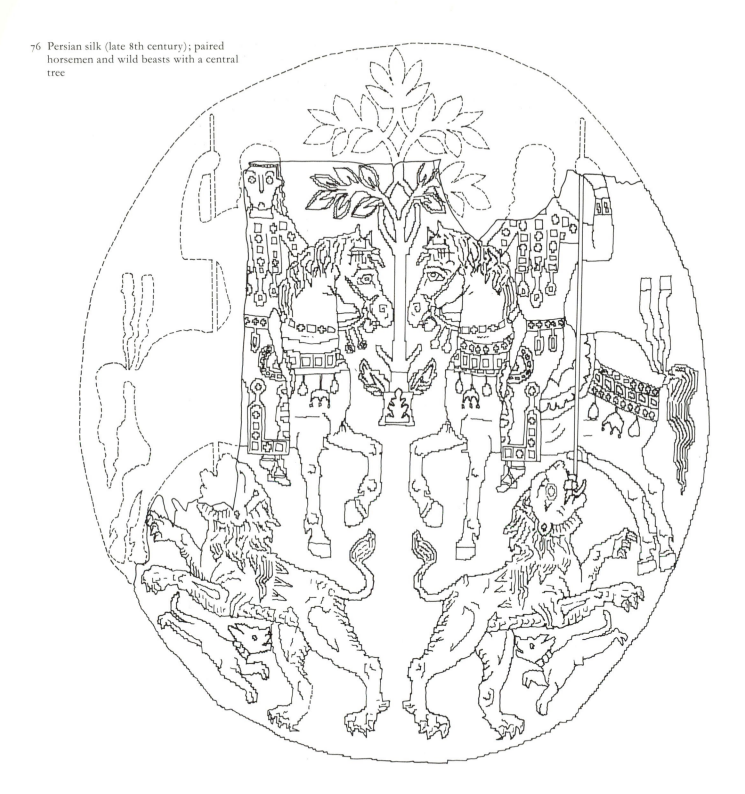

PLATE XII of Archbishop Maximian, mentioned below.

The Coptic world was a melting pot for these powerful artistic influences and was responsible for a significant share of the subsequent character of Mediaeval art. It is quite probable that the popular Christian theme of the Virgin Mary suckling the infant

Jesus – the *Virgo lactans* pose – comes directly from a transposition of the pagan theme of Isis suckling Horus. The most important art form of the Coptic world for the development of Mediaeval art was that of textiles – silks, embroideries and tapestries. The silk trade routes were, in the early Christian centuries, one of the main contributors to the contacts between Western Europe and the Orient. Eastern lands which received visitors from the West even included India and China, and the reason for this travel was the sumptuous nature of Oriental silks. Oriental, especially Persian, silks reached the Western world through copies made in Syria and Coptic Egypt and the flavour of these two countries would have been added to the original designs. Favourite motifs for silks were confronted beasts and birds, horsemen in pairs and fantastic animals in interlaced poses. These features became characteristic elements in Romanesque sculptural programmes: by the twelfth century, any series of carved capitals in Western Europe would embody a number of such motifs.

The Rôle of Ivories

The extent to which forms and motifs are borrowed from another culture can be assessed with hindsight by an examination of the works of art which remain. The large number of extant Christian carved and decorated ivories are of great value in the piecing together of the jigsaw puzzle necessary for an assessment of the sources of Romanesque art. They help to bridge the gap between the demise of large scale sculptural projects of the classical era in the first Christian centuries and the revival of monumental sculpture of the Romanesque period in the second half of the eleventh century. There were no doubt important three-dimensional works in wood and stucco as well as ivory, but ivory is more durable than either and has

78 Coptic stone lintel from Sohag (8th–9th century); St Victor and St Pakene on horseback

survived in much greater quantities. The earliest definitely Christian ivories were made at Antioch from the middle of the fourth century onwards. Alexandria was another important centre for ivory carving, and one in which pagan traditions and iconography remained strong. It was the custom to make up carved ivory panels into small boxes or consular diptychs, both items of a pagan nature, and the form of these secular objects was taken over and pressed into service for Christian use. Consular diptychs were issued between the years 408 and 541 by Eastern and Western Roman Emperors on assuming their title and, since they are securely dated, provide a valuable calendar of artistic change. In the course of the fifth century, Rome was forced to concede a break with its classical tradition, occasioned by the conquests of Goths and Vandals in 410 and 455, which flooded the city with barbarian and Near-Eastern works of art. Indeed, around 500 Western Roman diptychs appear to be mere copies of Eastern Roman models. The Roman tradition had given way to Near-Eastern traditions even before Byzantine generals began the reconquest of Italy in 535 and the foundation of Greek churches and monasteries in Rome. In the fifth and sixth centuries Roman art reflected the unsettled times and these powerful foreign influences. A typical example is provided by the wooden doors of the church of Santa Sabina, dated c.430. These are a pair of carved cedar-wood doors which originally comprised 28 panels of scriptural narrative. Only 18 panels are still extant, and their original arrangement has been changed. The smaller panels bear scenes of the

81

79 Panel from wooden doors of
Sant'Ambrogio, Milan (late 4th century);
scenes from the Life of David. A pair of
Italian wooden doors similar to those of
Santa Sabina (compare with Fig. 81)

80 Parts of shaft of monumental cross at Easby (early 9th century); vine scrolls inhabited by birds and animals

79

80

Passion and Resurrection of Christ, whilst the larger ones have more complex scenes of episodes in both the New and Old Testaments, with their compositions divided into several superimposed strips. Stylistic elements throughout the doors point to both Near-Eastern and Western sources, but Near-Eastern elements dominate. The reliefs show such strong resemblances to Syrian art that it is legitimate to suppose that they may have been made in Syria or, more probably, by Syrian artists living in Rome. The carved decorative surround to all the figurative door panels consists of undulating vine tendrils and leaves with bunches of grapes. A decorative edging made up from a vine scroll was common in Roman art, but the combination of vine foliage with grapes was a device which originated in the Near East. It became a standard for the border of an illuminated page or the sides of a carved cross throughout Western Europe in the following centuries.

The Doors of Santa Sabina

From the early Near-Eastern ivory-carving workshops in Antioch and Alexandria, with their emphasis on the transmutation of pagan motifs, the sphere of influence in the fifth century appears to have

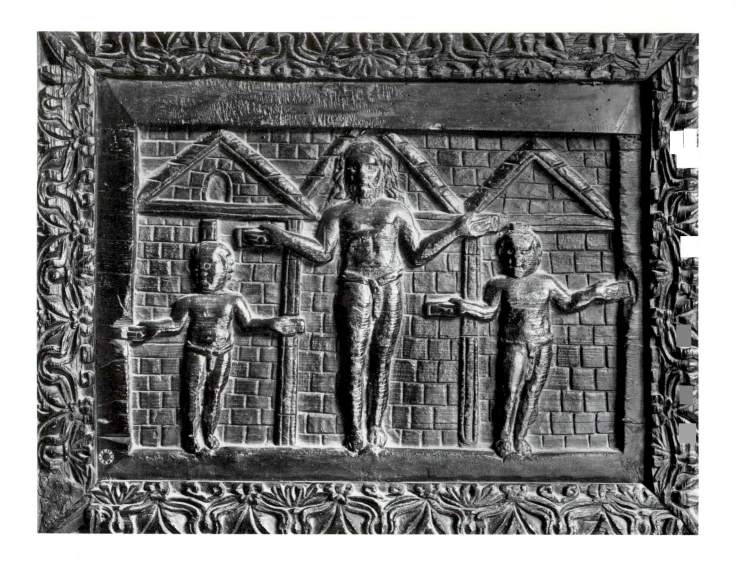

81 Panel from wooden doors of Santa Sabina, Rome (c.432); the Crucifixion

moved to Syro-Palestine, with its sacred sites, churches of Imperial foundation and crowds of pilgrims. Syro-Palestine brought into Christian art a new richness of iconography: extra scenes from the apocryphal Gospels were added to the central scriptural stories, and episodes from the Gospels were depicted in new ways. One of the scenes on the doors of Santa Sabina is of the Crucifixion; it is one of the earliest examples of a depiction of this scene. In the early centuries of the Christian Church, the empty cross as an object of veneration was represented in glory, usually bedecked with jewels: an early fifth-century mosaic in the apse of Santa Pudenziana in Rome depicts it lavishly decorated and set against a cloud-streaked sky. The theological impetus which brought about the change from an empty cross to one which bore the suffering body of the crucified Christ is believed to have stemmed from Syrian liturgical practice and from a desire to express in visual form the pathos of Good Friday laments chanted in Syrian churches. The crucified Christ nailed to the cross in Santa Sabina's carved panel has a full beard, a flowing mane of hair

81

and strong staring eyes, and is naked except for a loincloth. This image of Christ is a compound of two cultural traditions: a beardless figure with long hair and clothed only in a loincloth is the type of Christ created by the Greek cities of Asia Minor, whereas Syrian representations, though also depicting him with long hair, show him with a long beard and with a long tunic – the *colobium* – which reaches from neck to feet.

This search for a new expression of Christian themes often brought with it consternation and dislike of the portrayal of certain scenes. The great effort to establish an international unity in theological thought and therefore visual representation is revealed in the attempts by the many church councils to define and impose dogma. The very first ecumenical church council was held at Nicaea, a city in Bithyinia, Asia Minor, from May to July 325; it was convened by Constantine and it condemned the beliefs of Arius, a cleric of Alexandria, who declared that Father and Son are the same, and it fixed the date of Easter. It was attended by about 220 bishops, only four or five of whom came from the Latin West. The growing importance of Christian theological thought was attended by many disputes. Everyone, from the Emperor down to the common man, would discuss the great issues of the day. St Gregory of Nyssa, on a visit to Constantinople in the fifth century, described them. 'The clothes merchants, money changers and grocers', he wrote, 'are filled with people discussing unintelligible questions. If you ask someone how many obols you have to pay, he philosophizes about the Begotten and Unbegotten, if I wish to know the price of bread, the salesman answers that the Father is greater than the Son . . .'. The major result of these ecumenical church councils was the development of an elaborate system of doctrine, which supported an ever-elaborating system of Christian imagery. New scenes were frequently being created which often not only depicted a religious event but also illustrated a theological idea.

The Rôle of Ravenna

In 410, after the sack of Rome, Ravenna became the official residence of the Western Roman Emperor. After the fall of the Western Roman Empire, the Ostrogoth kings made Ravenna their capital with Odoacer styling himself 'King' of Italy; the Ostrogoths originally came from the borders of the Black Sea and their art had its origins in the Near East. When the town was captured by the Byzantines in 539, it became the seat of Byzantine exarchs. It surpassed Rome in importance. Ravenna was near the sea, had its own port, and established close links with the Eastern Roman Empire and the Near East. To this connection it owed its importance and its prosperity. Many sculptured works still in Ravenna were imported directly from workshops in Constantinople. Several marble sarcophagi were made from stone from quarries in the

39

Eastern Empire – in the Proconnesus Islands in the sea of Marmara and in Greece, and others were made in Asia Minor, Antioch and Palestine.

PLATE XII The carved ivory throne of Archbishop Maximian (515–56) is a major work of art still kept in Ravenna, which clearly reveals its Near-Eastern origins. No one has satisfactorily established its provenance, the claims of Alexandria, Antioch and Constantinople being equally valid. This throne, constructed not as a seat for the archbishop but to house and display a large Bible, is made up of several carved ivory panels representing scenes from the Old and New Testaments, in the manner of the fifth-century Santa Sabina doors. The throne is the work of at least four hands and is in several different styles. It has been reconstructed many times and its original iconographical programme has in consequence been disturbed. Of the five panels on the front, one depicts St John the Baptist and the four Evangelists. The backrest has scenes from the New Testament, and the side panels illustrate events from the life of Joseph and Jacob. The borders of the panels are all of scrollwork, incorporating birds, vines and little animals. The scene of the Nativity on the backrest shows Mary attended by a midwife. The Near-Eastern provenance of such a domestic detail, added to an important scriptural event, has been referred to earlier; Near-Eastern artists led the way in iconographic development, and their iconography was to play a central part in the development of art in the West.

The Development of Liturgy and Missionary Activity

In these early Christian centuries, the Near East was highly instrumental in the development of theological matters and in the enrichment of ecclesiastical liturgy. The addition of narrative details to important scenes from the life of Christ and the Virgin imparted a liveliness and vigour which was not to be seen again with the same intensity until the early twelfth century in Western Europe. The great and powerful monastery of Cluny, in Burgundy, which by the end of the eleventh century had a church building equal in size to that of St Peter's in Rome, was to some extent, as has already been mentioned, responsible for the flowering of pictorial and sculptural narrative. It was the nerve centre of an influential ecclesiastical organisation, ruling over two thousand smaller monasteries spread throughout Europe, and through this position initiated a revival of arts and letters, particularly in the fields of music, liturgical drama and church decoration.

Christian art became, in its early centuries, an art which crossed and transcended all national and cultural boundaries, growing ever richer as it did so. Its liturgical message had its origins in the pioneering missionary venture of the apostle Paul, who travelled extensively through Syria, Macedonia and Greece, finally dying in Rome. As is noted in the Introduction, the Christian movement of

monasticism, founded in Egypt in the third century, was largely instrumental in the encouragement of an artistic dialogue between the Near East and the West. The two early evangelisers in Western Europe were St Martin of Tours (315–97), who founded monasticism in Gaul (modern France), and St Patrick (385–461), who trained for the priesthood in Gaul and then as bishop at Armagh and who was responsible for the rise of monasticism in Ireland. Pope Gregory (540–604) was a tireless worker in the missionary field. For a few years prior to his elevation to the Papacy he was the papal agent in Constantinople and was able in this position to assess the status of the Roman see in the East. On his return to Rome, he set about the elevation of the Papacy and conducted peaceful negotiations with the Lombards and Visigoths who ruled in Northern Italy. He was not unaware of the missionary activities of the Irish at this time: St Columban, of the Celtic Church, converting part of Gaul in 585. (Later, in 615, St Columban founded a monastery at Bobbio with the assistance of the Lombards.)

In 596 Pope Gregory sent a mission to Britain to begin its conversion to Christianity and to bring it under the rule of Rome. The mission consisted of St Augustine and forty monks. They landed at Thanet in Kent in 597, were received by Ethelbert, King of Kent, and quickly began to propagate their religion. From Kent, Christianity spread northwards. In 627, Edwin, King of Northumberland, was converted and baptised in York. But in 635 Aidan of Iona established a monastery on Lindisfarne. He belonged to the Celtic Church, which was completely independent of Rome. So from the 630s until the 660s, when the dispute was finally and irrevocably resolved, the Christian conversion of Northumberland took the form of an ideological battle, with each of the rival factions offering its own particular programme.

The Celtic Church had its base in Ireland, where its many monasteries were centres of civilisation and artistic patronage. Ireland had been spared all the conquests and catastrophies which had swept across Western Europe from the time of the Roman invasion of England and had by the fifth century become a society which was essentially Christian. Western Europe was dotted with monasteries whose origins, directly or indirectly, went back to Irish missionaries or pilgrims; these helped greatly to spread the fame of Irish erudition. Where did this erudition stem from? There is much evidence of Irish links with the Eastern Mediterranean, and indeed monasticism itself, as we have already mentioned, originated in the Near East. Direct sea trade between Ireland and the Near East is proved by archaeological finds, and where *amphorae* and domestic items could travel to and from the Holy Land, so could pilgrims, books and ideas. Three Irish monks lived in Carthage in the second quarter of the seventh century. Statements in two Irish litanies point to further contact in the same century: it appears that Armenians visited Ireland, and that Egyptian monks were buried there.

Celtic Christianity encountered Roman Christianity in

Northumbria in the 630s and 650s, and in 664 a Synod was held at Whitby to decide which system should prevail. The Roman Church won over the Celtic Church and thus England moved further under the domination of the Papacy. A message was sent to Rome from Northumberland and Kent with a request for an archbishop for England. Pope Gregory chose Theodore of Tarsus, and he arrived with his retinue in 668; he was Archbishop of Canterbury from 668 to 690. So just when the Roman Church appeared to dominate, the person who came to represent it was a native of the Near East. He is known to have arrived with Oriental ideas and artefacts, and shortly after his reign there was a surprising outburst of native sculpture which seems to have had no antecedents nor immediate progeny.

The Ruthwell Cross

PLATE XIV

PLATE XV

This late seventh-century sculpture had two significant features: the format in which it appeared was that of a high stone cross; and the figures are simplified, schematised and very deeply carved, presenting a strong sense of plasticity. The most important and noble of these English crosses is the Ruthwell Cross, Dumfries-shire, which is still in a state of fair preservation. It stands 18 feet high and is a tapering cross shaft of red sandstone. Its ornament consists of figure subjects in a series of superimposed, closely-set panels on two faces, and full-length vine scrolls containing birds, fruit and animals on the other two faces. The iconography is very strange, and appears piecemeal. The correct identification of all the scenes is probably not possible, but Meyer Schapiro has shown that its general theme relates to the ideals and ideas of the Egyptian desert fathers which were assimilated and promoted by the Celtic Church. Both its style and subject-matter are reminiscent of Eastern Mediterranean culture. On the remaining fragments of the head of the cross (it was broken in the seventeenth century) are panels representing St John and St Matthew with their symbols, and also a perched eagle and a half figure of an archer. On one face are St John the Baptist with the Lamb, Christ in Majesty treading on animals, St Paul and St Anthony, the Flight into Egypt, and a panel now destroyed; on the opposite face are the Visitation, Mary Magdalene wiping Christ's feet with her hair, the Healing of the Blind Man, the Annunciation and the Crucifixion. Nearly all the iconographic choices can be traced back to the Near East. The Annunciation with Mary standing is the Syro-Palestinian type. St Paul and St Anthony – the latter the founder of monasticism in Egypt – were probably copied from Alexandrian ivories. The Visitation relates stylistically to the golden medallions from Adana, near Constantinople. St John the Baptist with the Lamb is of a type seen on the sixth-century ivory throne of Maximian at Ravenna. The Crucifixion, a lightly clad Christ, belongs to the same category as that on the Santa Sabina doors. The origin of this form of cross – tall and in stone – is thought (by Strzygowski and

Baldwin Brown) to be found in the Near East; there are only a few earlier examples now extant, but all of them are in Armenia.

The Jouarre Sarcophagi

Of similar date as this isolated example of sculpture on the borders of England and Scotland is an equally rare example in northern France. The abbey of Jouarre in the Marne valley was founded c.630 by the Irish monk St Columban. It was one of seven abbeys established by the Irish in that region. Excavations have revealed that, besides the monastic buildings, there were three churches, one dedicated to the hermit Paul. Three seventh-century stone sarcophagi have been preserved in the crypt of one of the churches, and the magnificence of their decorative carving testifies to this remarkable but brief renaissance of religious stone sculpture. One of the sarcophagi can be identified from its carved inscription as the tomb of Abbess Theodechilde, the first abbess of that monastery. According to an ancient local tradition, another sarcophagus, with a scene of the Last Judgement on one of the long sides and one of Christ enthroned and surrounded by the four Evangelists' symbols on one of the short sides, is reputed to be the tomb of Agilbert. Agilbert undertook theological studies for ten years in a monastery in Ireland, became a bishop in England, and in 667 was made Bishop of Paris. He spent his last years at Jouarre Abbey. Bede records the closeness of the ties between the British Isles and the abbeys founded by St Columban in the Marne region. The carved scene of the Last

82 Judgement is one without parallel in Western European seventh-century art; at its centre God is shown, enthroned as the Judge, holding an open scroll and extending his hand and surrounded by ranks of standing figures, frontally posed, rapt in admiration and in the *orans* position. *Orans* figures can be found on Coptic *stelae* of the same date but the expressive mood of the scene is unique. The nationality of the sculptor or workshop responsible has been proposed as Coptic; the carved relief from the end of the

83 sarcophagus with the scene of Christ surrounded by the Evangelists' symbols provides a clue; the Evangelists' symbols turn outwards, away from Christ, rather than inwards in adoration, and this iconographic peculiarity occurs elsewhere only in an early Christian mosaic at Salonica in Greece, and in the paintings in Egyptian and Cappadocian basilicas. Thus it has been suggested that the Jouarre sculptor was trained in a Coptic workshop and fled to France when the Arabs invaded Egypt in the 640s. Several painted versions of Christ surrounded by the symbols of the four Evangelists remain on the apse walls of seventh-century churches in Bawit, but no sculpted version is extant in the Coptic world. There is, however, an earlier sculptural precedent for the Jouarre Christ with the four symbols, and that is to be found carved as one of the panels on the Santa Sabina doors. These, as we have said, are thought stylistically to be of Syrian

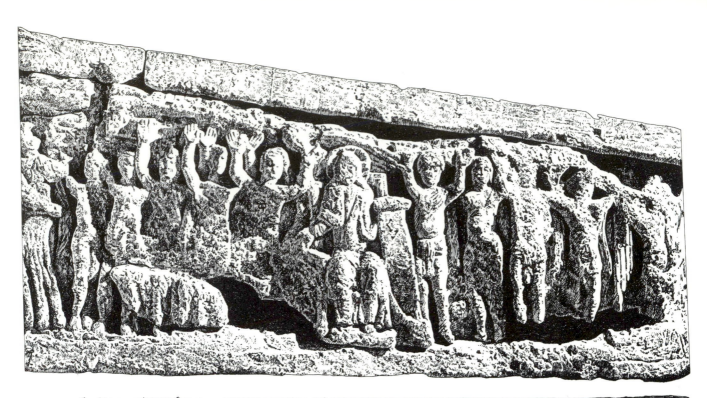

origin. The textual origin of the theme of Christ seated in glory upon a throne within a mandorla around which are arrayed the four winged symbols of the four Evangelists, a man, a lion, an ox and an eagle, comes from the first vision of the prophet Ezekiel (1, v 10, 11, 26–28). A fourth-century Syrian theologian, Ephraem of Nisibis (306–73), wrote biblical commentaries, paying attention to the themes of Ezekiel's visions and the Last Judgement. His works were influential, being treated to early translations, and it could be that his commentaries assisted in the development of this imagery. The composition of Christ in glory surrounded by the four symbols of the Evangelists fills the Jouarre sarcophagus slab, leaving no area undecorated. Even the spaces left between the wings of the four creatures are carved with stems, leaves and rosette flower-heads. Very similar rosettes are to be found floating in the blue background of the painted scene of the same theme at Bawît, in Egypt. The painted version at Bawît was set above another scene, that of the Virgin and child enthroned and surrounded by the apostles. This layout, with the scene of Christ enthroned with the four symbols placed directly above the Virgin also similarly enthroned, was to undergo a most successful transformation from fresco into stone. It was an iconographic formula applied to many French Romanesque tympana, with Christ in glory in the semi-circle and the Virgin enthroned carved in the lintel below. Besides a reliance upon iconographic models, the Last Judgement and the Christ with the four Evangelists' symbols panels of the Jouarre sarcophagus display one of the stylistic traits of Near Eastern relief sculpture, and that is *horror vacui* – a great distaste for empty spaces left in compositions.

Poitiers

In the northern Aquitaine region of France, at Poitiers, further evidence of artistic influence stemming from the Near East is found, in the form of a wooden object of the sixth century and a series of architectural sculptural reliefs of the seventh century. In the abbey of **84** Sainte-Croix there is preserved a wooden reading desk or lectern believed to have belonged to Queen St Radegund (518–87). In 555 St Radegund entered the monastery of Our Lady at Poitiers, built by her husband Clotaire; and in 569 the foundation was renamed Sainte-Croix (Holy Cross) when Radegund was given a piece of the True Cross by Emperor Justin II. The style of the carving of her lectern, on which the sacred lamb is surrounded by the symbols of the Evangelists in decorative roundels, is similar to that of the **85** decoration of the lintels of fifth-century Syrian churches.

After a prosperous period during late Roman times, the Aquitaine region of Gaul flourished again from the second half of the sixth century. Marble carving was reintroduced and the old quarries were reopened. The capitals carved in the sixth and seventh centuries derive from classical models, but their ornamentation, in which a

84 Wooden reading desk of Queen Saint Radegund (6th century); the lamb surrounded by the symbols of the Evangelists and pairs of opposed birds

direct study of nature can often be detected, shows a variety, an elegance and an inventive faculty which rivals the virtuoso carving of the workshops of Romanesque sculptors. The Aquitanian sarcophagi are very different from those of other Christian lands, and their technique is much closer to Syro-Egyptian art of the sixth or seventh century than to classical art. Gaul followed a sculptural evolution very similar to that of the workshops of the eastern Mediterranean. There are several examples of similarities between small low-relief panels of seventh-century Gaul and similar work of

Dana.

Moudjeleia.

ΧΜΓ

M. de Vogüé et E. Duthoit. Echelle de o. 10 p.m. Léon Gaucherel sc.

85 Syrian decorated stone lintels from Dana and Moudjeleia (6th century); foliage, flowers and a pair of opposed birds

86

the sixth century in North Africa – similarities which are striking but are hard to account for.

A small sepulchral crypt chapel, built in Poitiers in the seventh century by Abbot Mellebaude as his future tomb and excavated at the end of the nineteenth century, contains three carved reliefs, set as steps, and carrying a decoration of intertwined vines, snakes, fishes and ivy tendrils. As in Aquitaine, the origin of this decoration lies in the eastern Mediterranean, and it could be that itinerant sculptors from a centre such as Syria were responsible, both for the style of carving and the iconography.

86 Carved stone reliefs from the crypt of
Abbot Mellebaude, Poitiers (7th century)

Lombard Art

The sixth and seventh centuries were times of great change in Gaul
and Italy. In Gaul, little sculpture was produced and it varied greatly
in quality. In Italy, the Lombard invasions were taking place, and
there figural sculpture was practically non-existent, the main output
being low reliefs of an ornamental nature. The Kingdom of the
Lombards (or Langobards) lasted from 568 to 774 and their capital
was at Ticinum (Pavia) in the north. Latin Rome and Greek Ravenna
remained autonomous and exerted considerable influences on the
new rulers of Italy. In 680 a Lombard-Byzantine peace treaty was
signed, and this allowed the introduction into the Italian peninsula of
fresh Eastern influences. The Arab invasion of the eastern provinces
of the Byzantine Empire, and the triumph of iconoclasm in the

capital, Constantinople, led Eastern artists and clerics to seek sanctuary in Western Europe in increasing numbers. To this migration we may attribute the sudden appearance in Western European art, after 700, of Oriental animal ornamentation. In place of the tamer animals depicted up to that time, such as the deer, the lamb and the dove, there appeared wild animals and fabulous creatures such as the lion, the griffin, the eagle and the sea serpent.

The choice of fantastic beasts used as part of architectural decoration has a long history in Near Eastern art. In Assyrian art, for example, columns often utilised an animal for their bases, such as a sturdy lion or a winged bull. This form of architectural sculpture did not find its way into the classical world of Greece or Rome, but the idea first reappears in Christian times in Syrian manuscripts of the sixth and seventh centuries. The pages of Canon Tables in the Rabbula Gospels, a Syrian manuscript dated 586, show the textual concordances between the four gospels set in decorated arcades with slender columns resting on animal bases. The Lombards who came into Italy from the north showed a great predilection for decorative and lively ornamental art. Fantastic animals appear in their art, particularly in decorated capitals and as animal column bases. This outlook was to play its part in the development of Romanesque architectural sculpture. Modena was one of the towns – others were Piacenza, Pavia and Milan – which lay in the middle of the Lombard kingdom. Wiligelmo, the sculptor responsible for the decoration of the Romanesque cathedral of Modena, carved lions as the supports for the columns of the cathedral porches. This idea was taken up by a sculptor known as Nicoló, who carved the portals of the cathedral and the church of San Zeno, both in Verona, again using eastern-looking beasts as column bases. Fabulous animals, freed from their somewhat constricted rôle as a support member, cavort their way across many a Romanesque carved portal. They are to be found, knotted and twisted and pulsating with vigour, forming the in-

87 credible *trumeau* of the south portal of the church at Moissac in France, dated 1130–35, and as a proud ring of prancing monsters making up the fourth row of voussoirs on the portal of Saint-Pierre at Aulnay, France, of 1150–1200.

By the eighth century the Roman classical tradition had all but disappeared under the influence of the Merovingians and Visigoths in the north, and the Byzantine world in the east. The Byzantine world itself had drawn upon the art of the Sassanians and of Mesopotamia and the Orient. By the time that Charlemagne attempted to revive the 'Holy Roman Empire' and to go back to a purely Roman art, the heritage of antiquity had been much obscured by the later accretions of Oriental art. Eastern influences made themselves felt in Charlemagne's Empire in other ways also: the barbarian tradition with its interlaced ornamental patterns and symmetrically opposed monsters reaches back through Germanic and Celtic art to Mesopotamia, having absorbed Persian influences as it travelled westward. At one point Charlemagne considered

87 Saint-Pierre, Moissac (c.1130–35); stone
trumeau with intertwined animals

marrying the Byzantine Empress Irene. He received from the Emperor in Constantinople and from Moslem Caliphs gifts of precious Oriental textiles and of carved ivories, often studded with precious jewels. These sumptuous artefacts from the Near East exercised a profound influence on the style and iconography of local artists and craftsmen. Because, as has already been noted, of the decline of classical Roman influence and the corresponding advance in barbarian and Eastern modes, large-scale volumetric sculptural projects were no longer undertaken; the rendering of the human figure in its plasticity and humanity had given way to linear interlaced abstract patterns and fantastic and imaginary animal ornamentation, bequeathed to Europe by the barbarian tribes, and Byzantine artists, who were required by the ideology of iconoclasm to eschew depictions of the human form. Under Charlemagne, a kind of compromise was reached between this tradition and the Roman aspiration of his new Empire: small-scale sculptural figurative scenes in metal or ivory were bounded and enriched by floral and faunal interlaced decoration, worked with their material in a way that was contradictory to a desire for plasticity. Usually a flat sheet of metal was covered with ornament which made itself one with the surface and the material, stressing its planar qualities. The plane and relief, or the pierced decorative marble panels – the *transenna* so beloved of Lombard sculptors – were the prevailing features of sculpture in the seventh to ninth centuries. The withering away of volume, which had been the main feature of classical sculpture, can be seen in the carving of capitals, which in this epoch accentuated the linear and the decorative. In San Vitale in Ravenna, for example, the mid sixth-century basket capitals are cubiform, the stress being placed on four planes rather than an overall and non-planar naturalistic rendering of acanthus leaves; the ornamentation is cut with the drill and the plane is pierced until it becomes like a lace sheath instead of being carved with a chisel into an illusionistic volumetric rendering of naturalistic plant elements.

88 Stone sarcophagus of Theodota (c.720–30); panel with central tree and opposed winged sea serpents

89 Stone altar for church of San Giovanni, Cividale (c.740); the Adoration of the Magi

88

PLATE XV

Lombard sculptors continued this trend, producing decorative ornamental works in marble for ecclesiastical purposes – capitals, balustrades, sarcophagi, altars and small pulpits (*ambos*). The panel from the sarcophagus of Theodota is a typical early eighth-century Lombard work. It dates to c.720–30 and was part of a sarcophagus which commemorated the Lombard princess Theodota who was Abbess of Santa Maria della Pustella until her death in 720. This relief shows much evidence of influence from the East: the broad border made up of rosettes surrounded by foliage alternating with vines and grapes (recalling the Ruthwell Cross) had found its way to Northumbria in the seventh century, being carved on to the sides of

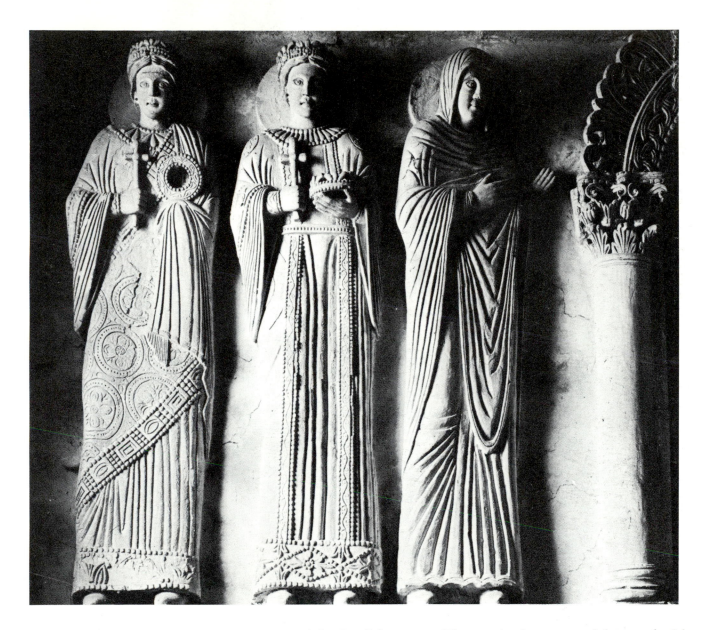

90 Stucco figures at Santa Maria in Valle, Cividale (9th century)

some of the English crosses. The tree in the centre of the panel with winged sea serpents in attendance on either side is most definitely Eastern in origin.

A work with more narrative emphasis is the altar of Duke Ratchis. He was the Lombard Duke of Friuli from 737–44, and commissioned the altar for the church of San Giovanni at Cividale in Friuli (c.740). It has three carved relief panels – the front one portraying Christ in Majesty, one side panel with the Visitation and the other side panel with the Adoration of the Magi. This last scene is particularly striking. The Magi, with their trousered legs and diadem headdresses, approach a hieratic group of the Madonna and Child, seated on a realistically rendered turned wooden chair with a cane seat. The narrative content is strong but there is equally a powerful formalism. The rosettes which form the undulating border of the

89

panel, the stars which fill the sky and the semi-circular patterned ornaments at the base of the panel indicating a journey, will all be found again in the work of Gislebertus at Autun in the twelfth century.

107

The Carolingian Period

Sculptors and masons having lost the knowledge of working stone in the manner of classical artists, the techniques of the goldsmith and the metalworker dominate three-dimensional art of this period. Much that would in antiquity have been carved in stone was, in Carolingian times, modelled in stucco. In the palace oratory in the chapel of Santa Maria in Valle at Cividale in Friuli, there are substantial remains of a decorative scheme in stucco. Six large female saints stand high upon the nave wall, in two groups of three, on either side of an arched recess. Above and below them lies a frieze of rosettes, and the central arch is decorated with palm leaves and interlaced foliage. More interlace decoration is found around the window arch, and the motif shows a similarity with interlace patterning found in murals at Bawit in Egypt. Strzygowski has indicated that decorative sculptural schemes in stucco existed in Egypt, Syria and Persia, but plaster is a less durable material than stone and no really significant examples remain there. The stucco figures at Cividale are some of the most impressive plaster sculptures extant (a fine series of prophets in stucco adorn the window level of the fifth-century cathedral baptistry at Ravenna), and because of their technical accomplishment and maturity various dates have been ascribed to them. However, since other Carolingian decorative work in stucco which is more securely dated to the late eighth and early ninth centuries displays similar characteristics, the Cividale figures have been assigned a ninth-century date also.

90

91

Stucco panels frame the windows and cover the apse walls of the Oratory of Theodulph in Germigny-des-Prés and these, datable to 818, show Sassanian influence. The motif of the standing female figures of Cividale appears in the mosaics of the dome of Charlemagne's Palatine Chapel at Aachen and in other mosaics of the ninth century; these mosaics had their antecedents in the sixth-century mosaics on the nave walls of Sant' Apollinare Nuova in Ravenna, and their prototypes in Palmyra, in Syria. Whether the sculptor of Cividale was an Italian or a traveller from the Near East can probably never be determined, but resemblances to hieratic Near-Eastern sculptures of earlier centuries and to contemporary Byzantine work are strong.

The Carolingian Empire began to break up during the last two decades of the ninth century, but Charlemagne's ideas of a restoration of classical ideals were continued into the Ottonian period. Ottonian art also followed Charlemagne by trying to effect a more strenuous revival of classical and late antique art, but this was

91 Baptistery of the Orthodox, Ravenna (5th century); stucco figures of prophets at window level

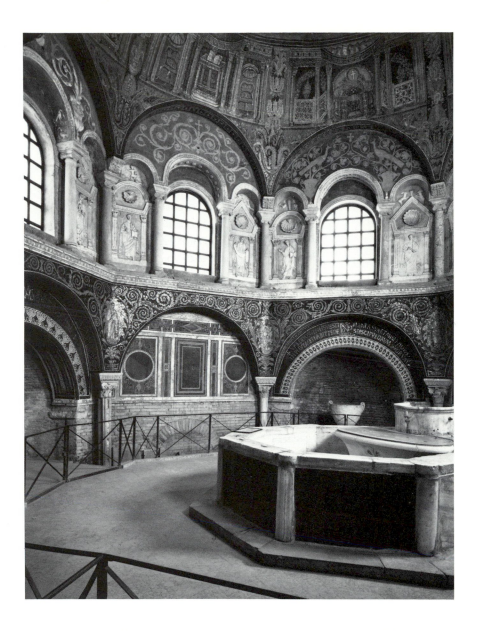

tempered by closer contacts with the Byzantine world than in Carolingian times. The Byzantine influence was predominant during Otto II's reign (955–83) because of his marriage to Theophano, a Byzantine Empress, and this influence continued well into Otto III's reign (983–1002). Sculptural activity continued along the same path as in the previous century. Work was rarely carved in stone; instead it was in metal and ivory. Stucco was still used. Because of the predominant techniques of metal workers and ivory carvers and of the attendant training which accompanied them, large-scale sculptural works undertaken in the Ottonian period often look like scaled-up versions of the minor arts. Some scholars have seen Ottonian art as a direct precursor of Romanesque art, sharing the same spirit, but in the category of architectural sculpture this relationship cannot be supported. Ottonian sculpture adorned

the building to which it was applied; the verb adorn is most suitable since it implies an additive principle, a beautifying with ornamentation, an aesthetic deeply rooted in the minor arts. Romanesque sculpture, by contrast, was to be less an addition to a building, and more an organised constituent part of the whole. Ottonian sculpture tends to lead an isolated life whereas Romanesque sculpture is part of a larger whole.

Armenian Sculpture

Armenian sculpture of the tenth and eleventh centuries can be seen as a precursor to Romanesque in this respect. Sculptural cycles are found on religious buildings at Ani and on the island of Aght'amar in Lake Van. The most extensive can be found on the Church of the Holy Cross, erected by King Gagik Artsrum at Aght'amar in Lake Van between 914 and 921. Armenia was the first Christian state; after King Trdat's conversion by St Gregory between 301 and 314 he proclaimed Christianity to be the official state religion. This just predates Constantine's decree of 313. The Armenian Church broke away in the sixth century from the theological development of neighbouring countries and thus preserved an individual identity. Armenia also developed its own form of sculptural decoration which differed from other Near-Eastern countries. As a country it was well-supplied with good building stone and this permitted the establishment of a tradition of sound stone buildings, the façades of many of which carried relief sculpture. Carved free-standing stone crosses were also a feature of Armenian religious sculptural practice. Over 70 are still extant, scattered throughout the country, and seeming to date stylistically from the sixth and seventh centuries. These stone crosses, carved on their four faces with scenes from the Old and New Testament relieved by panels of floral and geometric decoration strangely resemble Northumbrian and some Irish crosses of the seventh and eighth centuries. Scholars have had to record this similarity but have found difficulty in accounting for it. These crosses were adorned with both figurative and ornamental reliefs as were the decorated façades of Armenian churches. Armenian sculptural decoration may be distinguished from work executed contemporaneously in other Near-Eastern countries; in Syria, also a country with plentiful workable stone, the carvings on the capitals and façades of the churches are primarily ornamental, and the same can be said of the Byzantine world and Coptic Egypt.

The Church of the Holy Cross at Aght'amar has the most abundantly decorated exterior of all Armenian churches, and its iconography must have been drawn from a wider catchment area than just sculpture: paintings, mosaics, textiles and other two-dimensional works could well have provided some inspiration, exactly as they were to do when Romanesque sculptors began to decorate church exteriors. Every exterior wall at Aght'amar is

92

92 Exterior of the church of the Holy Cross at
 Aght'amar (914–21); carved reliefs of
 foliage, bands of animals, a vine scroll
 inhabited by animals and figures and a
 central roundel of a seated king,
 dominated by the full-length figure of St
 John the Evangelist

covered with sculpture. The north and south walls have figures both from the Old Testament and the New: Adam, Daniel, David and Goliath and Jonah are portrayed along with Jesus, the Virgin Mary, saints and prophets. King Gagik with a model of the church stands before Christ on the west façade, whilst Apostles and saints, especially St Gregory, appear on the east. All figures appear in frontal or three-quarter view and they are carved in high yet flattened relief which puts a stress upon the crisply cut profiles of the shapes. The figures are in formal poses and indeed a little stiff, but the intense, expressive gaze of each one holds the spectator's attention. No other church had such a richly carved exterior as Aght'amar, and it appears to have been an isolated example. It spawned no progeny in Armenia itself, but influences from Armenia are discernible in some eleventh- and twelfth-century Italian and French sculpture, notably in Pavia and in the Angoulême, middle Loire and Limousin regions of France. Pavian sculpture developed out of the preceding phases of Lombard sculpture and the north of Italy was an area of sculptural activity in the tenth and eleventh centuries.

PLATE II

93,97

The architectural sculpture of some French and Italian churches of the early twelfth century display similarities to that of Armenian churches of the tenth and eleventh centuries. It is not possible to prove concrete links between Armenia and either France or Italy although many travels are recorded; Bishop Géraud in 1112 planned his new cathedral at Cahors with domes after a long fact-finding tour in the Near East, copying the recent architecture of eastern Armenia. The church of San Michele at Pavia, c. 1130, and the church of Notre-Dame-la-Grande at Poitiers of about the same date (1100–50) both have decorated façades with figures under arcades and a carpet-like profusion of ornamental relief sculpture. The work at Pavia has a slightly cruder feel and a greater sense of mass than its French counterpart, and this gives it a superficially more obvious link with Armenian sculpture, which stresses the same characteristics.

PLATE XIII

The Sources of Romanesque Sculpture

Rome was a barren centre with no major artistic activity occurring from the mid-ninth century until 1000. The new artistic, cultural and socio-political power in Western Christendom lay with the monasteries. Following a reform of the Benedictine order, the order of Cluny was founded in 930 by St Odo, who was first appointed second abbot there in 927 by Cluny's founder, Duke William of Aquitaine. The revival of sculpture in Romanesque times is attributable partly to knowledge of Near-Eastern work gained from pilgrimages, and partly to the widespread use of sculpture in the many and increasingly powerful monasteries. There was, in Romanesque sculpture, a plethora of regional styles, all developing simultaneously, but nearly all stemming from these two sources. There have been several theories which proposed the source of

93 Saint-Pierre, Aulnay de Santonge (12th
 century); sculptural decoration around an
 apse window

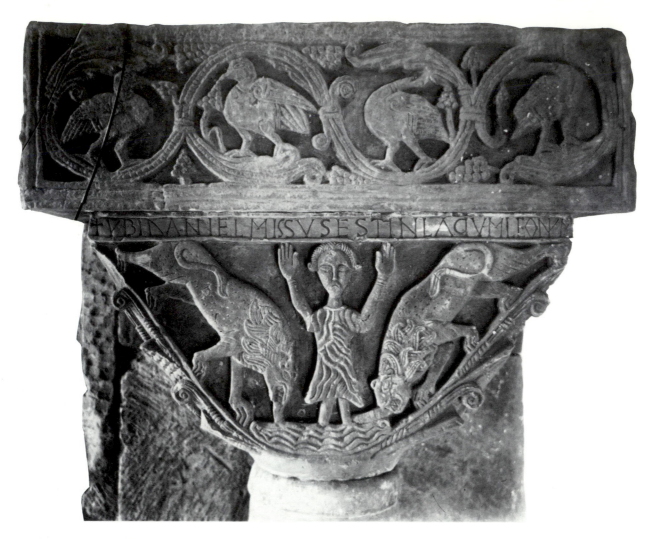

94 San Pedro de la Nave, Zamora (late 7th
century); capital with Daniel in the lions'
den

Romanesque sculpture – some in the Leon region of northern Spain,
and some, with equal conviction, in the Pyrenees; certainly both
areas witnessed a resurgence of stone sculpture. The church of San
94 Pedro de la Nave in the province of Zamora, in Spain, had been
provided with decorated stone capitals as early as the last decade of
the seventh century. A few remain, and they are datable to the 690s.
They have figurative scenes carved on their three visible faces; one of
the capitals bears a scene of Daniel in the lion's den, and another
portrays the Sacrifice of Isaac. In these scenes of deliverance, the
iconography harks back to early Christian models, and the sculptural
technique shows more interest in effects of light and shade than in
plasticity, much as Byzantine basket capitals do. However, these
capitals merit their place in the history of Romanesque sculpture,
since they are delightful precursors of much that was to follow in the
great rebirth of architectural sculpture in the eleventh century.

A conspicuous feature of eleventh- and twelfth-century archi-
tectural sculpture is an organic tension between the function of the

95 Moudjeleia and El Barah, Syria (5th–6th century); decorated *tympana*

architectural member and the subject-matter which is carved upon it. Henri Focillon believed that the single most important aspect of Romanesque sculpture was its overwhelming observance of the law of the frame – that the composition of the carving was conditioned by the confines of the block from which it was carved. This somewhat formalistic approach tended to underplay questions of subject-matter and purpose. But there is no doubt that a new relationship between architecture and sculpture emerged at the beginning of the eleventh century, and one of the areas where this began, as we have mentioned, was the Pyrenees. The church of Saint-Genis at Saint-Genis-des-Fontaines has a carved marble lintel set above the entrance door to the church. The carving was originally executed as an altar table with an inscription which dates it to 1019–20. The subject is Christ in Majesty enthroned in a mandorla supported by angels with three Apostles on either side. Although the sculptural technique owes much to Carolingian metal altar frontals, many aspects of the panel – such as the horseshoe arcading and the detailing of the draperies – may be attributed to the proximity of Mozarabic Spain and reflect, like many works of art in this area, the decorative qualities of the art of the Arab civilisation. Another altar table was re-used as a lintel in the church of Saint-André de Sorede. The re-use of carved reliefs to enrich portals was an early manifestation of the new feeling for architectural sculpture. Soon, new works were commissioned expressly for new buildings – like the carved *tympanum*.

Early Christian Syrian stone churches often had elaborately sculpted exteriors. The artists paid special attention to the decoration of the west façade and its system of doorways, with figural and ornamental sculpture, sometimes in stucco and sometimes in stone. Other areas of the architecture also received decoration – pilasters, window surrounds, door lintels and marvellously eccentric string-courses. The sculptural decoration of *tympana* was rarer but examples do exist. One from the religious building at Si, in Syria, dates from c.33–13 BC and consists of a central figure in an orans position

96

95

149

accompanied by a horse with rider on either side. Comparisons have
been drawn between the majestic west front of the fifth-century
19 Syrian church of Qal'at Si'man with its arched bays and the arched
portals of the west front of the eleventh-century French church of
Saint Gilles, but no inferences can be drawn from the fact that these
two façades look similar because of the gap of time between them.
There is no doubt, however, that the idea of a sculpted doorway and
97 a carved *tympanum* does stem from the Near East. Examples of both
can be found in Syrian and Coptic buildings, but some scholars have
even surmised that the original idea arose in India. There is no great
body of Syrian stone *tympana*, not surprisingly in view of the ruinous
nature of most early Christian Syrian churches, but there is a good
body of decorated *tympana* to be found in Syrian illuminated manu-
scripts. Equally the chevron or zigzag motif, which was to play such
an ubiquitous rôle in the decoration of church doorways in the
Romanesque period, makes an early appearance as a painted archi-
tectural feature, in the pages of the Rabbula Gospels, a Syrian
manuscript of the late sixth century. It then makes an appearance in
stone on the portal of the cathedral of St George at Ani in Armenia.
Coptic churches have carved stone *tympana* dating from the seventh
century which seem to take as their models the painted versions of
Syrian manuscripts from the previous century. The Coptic *tympana*
are not usually on a large scale and their figural content is relatively
uncomplicated, but they contain the germ from which sprang the
awesome carved *tympana* of Romanesque Europe.

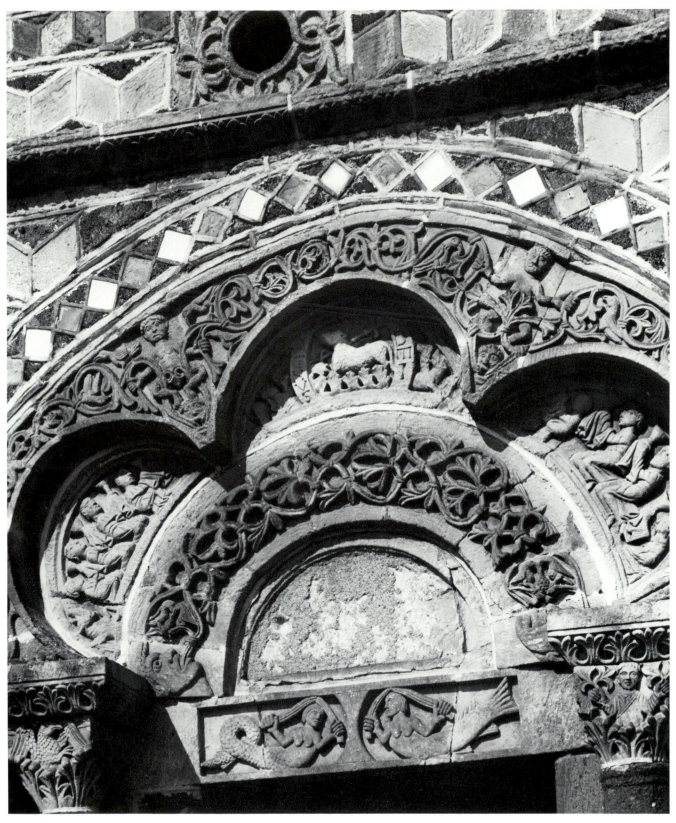

97 Saint-Michel, Le Puy (12th century);
decorated doorway

Plan du Temple, à 0.025.

Details, à 0.05 p.e mètre

Colonne A, à 0.05 p.e mètre

98 Soueideh, Syria (5th–6th century); details
of decorated capitals and bases with faces
and figures among the foliage

The Sculptural Treatment of Capitals

Another feature of the resurgence of architectural sculpture was a
new interest in the eleventh century in carved capitals. It has been
said that the sculptured capital is to the compound pier what the fruit
is to the tree. Often, the use of carved capitals accompanied an
experimental step in building techniques, for example, advances in
stone vaulting. Two of the first Romanesque churches are the abbeys
of Saint-Philibert at Tournus, and Saint-Bénigne at Dijon. Of the
latter building only the crypt survives today, where some of the
earliest and most interesting of Romanesque carved capitals are to be
found. These capitals bear figural decoration, and their application
to the shape of the capital heralds the new inventiveness of the
Romanesque sculptors. Kenneth Clark, in his television series
'Civilization', likened the brotherhood of Romanesque sculptors
to a school of dolphins, experiencing intense self-delight in their
vigorous and almost playful leaps and adventures into the carving
of capitals and relief slabs. Each regional school fed off the

152

99 Saulieu (12th century); decorated capital
with faces among the foliage

achievements of the others, and much of the impetus came from such
a triggering.

Of the three classical orders of capital design – Doric, Ionic and
Corinthian – the Corinthian was the most complicated and many
early Romanesque capitals can be seen as a variant on this classical
order. The Corinthian capital had three rows of acanthus leaves
topped by paired volutes, with two volutes meeting at the four top
corners and jutting out diagonally. Syrian sculptors of the fourth and

153

100 Saint-Bénigne, Dijon (early 11th century);
capital with palmate leaf decoration

fifth centuries changed the classical acanthus leaf into a variety of palmate and pinnate leaves, which were more decorative, more solid and less realistic than the naturalistic antique ones. Perhaps Syrian sculptors selected the Corinthian capital because, of all classical capitals, it was the only one ever to bear any kind of figural decoration: faces and half-figures were to be found mingling with the leaves. This tradition was revived in the eleventh century and was greatly developed and enriched by Romanesque sculptors. Some of the early capitals at Saint-Bénigne provide a witty variation on such a

98

99
100

101 Saint-Bénigne, Dijon (early 11th century); capital with bearded figure in *orans* position

theme; each of the four cubic faces of the capital is carved with a solemn bearded figure in the *orans* position, and the raised hands of each figure meet diagonally back to back at the four top corners of the capital, amusingly aping the classical volutes. Equally, some attempt is made to provide the capital with two layers of simple palmate leaves, and these shapes are balanced and countered by the splendid beards of these praying figures, which with their central scored dividing line can be read as the equivalent for an upturned leaf. The sculptural decoration of these capitals is in low relief, with

101

155

only a small sense of volume evoked. The strength of these figures is conveyed through the intensity with which the pose is maintained, with the open frontal gaze and the arms flung heavenward. A sculptural predecessor in Europe can be found in the seventh-century tomb of Bishop Agilbert in the crypt of Jouarre Abbey. The classical world has no hold upon such works as these.

82

Bishop Agilbert's tomb of the seventh century had, as its main carved scene, the theme of the Last Judgement. The Last Judgement, and the Apocalyptic Vision of Christ surrounded by the four beasts was to prove enormously popular for Romanesque sculptors, adorning numerous *tympana*. It is thought that this tremendous idea was inspired by Spanish Apocalypses of the tenth and eleventh centuries with which Southern France had cultural affinity, but Spain did not itself produce any versions in stone before the French sculptors did. In fact, one of the first *tympana* to be carved with the subject of the Last Judgement was that originally set on the west front of Abbot Adalbert's church at Bremen.

The Sculptural Programmes of Cluny, Moissac, Souillac, Autun and Vézelay

It is generally agreed that the rebirth of monumental sculpture occurred in south-west France. When a survey of the examples is taken, the importance of Cluny as a vigorous impetus for the promotion of Romanesque sculpture is revealed. The Cluniac abbeys of Languedoc – notably Moissac, Beaulieu and Souillac, have some of the earliest examples of monumental sculptural decoration. In the region of Burgundy came a second generation of churches with sculptural programmes – notably those at Vézelay, Charlieu and Saint-Benoît-sur-Loire. Autun was not a Cluniac priory, but it was undoubtedly influenced by the example of Cluny. Why was Cluny so important? Monastic learning and the ideal of monasticism reached

102

an apogee at Cluny; it was a centre of learning but also a centre which saw itself as the guardian of treasured traditions. The series of abbots who reigned at Cluny believed in the interchange and propagation of ideas. (Cluny was the first abbey library to translate the Koran). They believed not only in the power and influence of abstract thought, but also in the power of that thought translated into image. Art was seen as a didactic and spiritual messenger whereby the simple and hope-fully faithful populace could be impressed, terrified and uplifted when they entered a decorated church. The west doorway of the third abbey church of Cluny had a carved *tympanum* showing Christ in Majesty in

103

a mandorla, borne aloft by a pair of angels standing on clouds and adored by the four beasts – bull, lion, man and eagle, the four Christian symbols for the four Evangelists. It is the virtuoso carving of *tympana* which is the great achievement of Romanesque sculpture, and the theological and aesthetic planning of these *tympana* must have been masterminded by clerics and artists working in collaboration.

102 Cluny (late 11th–early 12th century); apse
 capital with one of the tones of plain-chant

103 Cluny (early 12th century); reconstruction of the *tympanum* of the west doorway of the third abbey church, Christ in Majesty with angels and the symbols of the Evangelists **104**

The complicated iconography of such scenes was developed in small-scale works – in miniatures and ivories – before it was taken up by sculptors. One of the earliest carved *tympana* is to be found at the abbey church of Saint-Pierre at Moissac. Several schools of sculptors worked at Moissac at the end of the eleventh and the beginning of the twelfth centuries. The cloister was restored c.1080 to 1100 and was supplied with elaborately carved capitals and panels of figures in shallow relief upon solid piers. The *tympanum* of the south portal at Moissac has the scene of the Apocalyptic vision of Christ as he appeared to St John, an elaboration of the vision which appeared before Ezekiel; the text is found in the book of Revelation (4, v 1–11). St John saw a vision of Christ in Majesty, surrounded and adored by the four beasts and the 24 elders, who all wear crowns and carry chalices or musical instruments. The lintel which supports the *tympanum* is carved with rosettes composed of decorative leaves, and the edges of the doorways of the south portal have scalloped sides. John Beckwith has described the *tympanum* at Moissac as a *diwan* of Divinity, Christ holding court like an Umayyad prince, crowned like a Spanish king, and surrounded by the Elders playing lutes and viols, themselves derived from illustrations of Islamic musicians. The connections drawn above between the art of Spain, Islam and the Moissac doorway are not hypothetical; investigations have proved definite influences from Hispano-Arabic art. The commentary on the

PLATE XI Apocalypse, by Beatus, was copied again and again from the tenth to

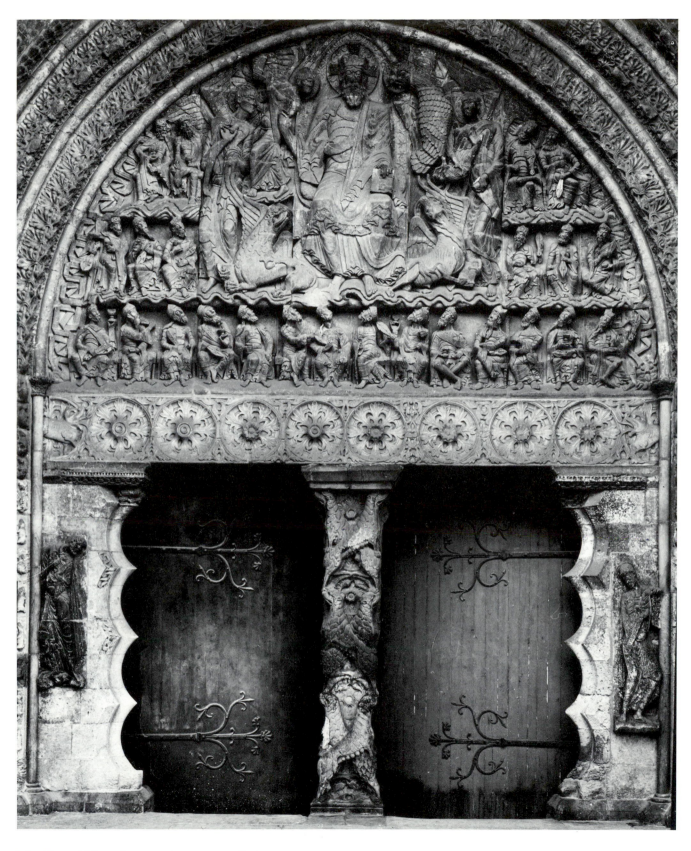

104 Saint-Pierre, Moissac (c.1130–35); *tympanum* of
the south portal, Apocalyptic Vision of Christ

the thirteenth centuries. The versions produced in Spain show strong Islamic influence in their illustrations. The Apocalypse produced at the Abbey of Saint-Sever, France, in the middle of the eleventh century was copied from a Spanish model, and the abbot who probably instigated this was a Spaniard himself, Gregory of Montana. The abbey of Moissac produced a decorated manuscript of the Apocalypse, closely resembling the one at Saint-Sever, and the Moissac manuscript no doubt served as the model for the sculptors of the *tympanum*. A Beatus manuscript of the Apocalypse was also used as the model for the carving of the capitals in the cloisters at Moissac.

The word apocalypse is a transliteration of the Greek word for revelation. Thus the *tympanum* at Moissac offered a vision in stone of things hitherto hidden, which also carried implications of prophesy. The manual and visionary powers of the sculptors are as portentous for the future as the subject-matter they portrayed.

Souillac, like Moissac, had a *tympanum* carved in low relief. It was carved at about the same time and displays many stylistic similarities, but the subject-matter was quite different. The *tympanum* was destroyed, but fragments of it have been preserved in the interior of the church; these show that the subject was the story of Theophilus, an early Faust-like character, and his delivery from the power of Satan through the intervention of the Virgin. Souillac's *tympanum* was the first work in the twelfth century to stress the importance of the Virgin. The early churches of the Near East had included scenes from the life of the Virgin in their iconographical programmes, and apocryphal writings were used to supplement the narrative of the Bible. But the popularity of her story assumed less importance in the West as the centuries passed. Then, with the Souillac relief, the cult of the Virgin began anew in Western Europe; the stimulus at that point in time must have come from the Eastern, Byzantine world.

Two other Languedoc churches with carved *tympana* are at Beaulieu and Conques. Both are decorated with the scene of the Last Judgement. In the *tympanum* at Conques, the resurrected are shown arising on Christ's left, whilst the damned are dragged down on the right. Once this theme arrived within the domain of sculpture from that of manuscript illumination, it proved to be the most popular subject for twelfth-century *tympana*. At Conques, directly below the feet of Christ, St Michael holds a pair of scales for weighing the good and evil. This is the first time this scene appeared in such a central position, though it had already been carved on many capitals and the side of a portal. Its origin is to be sought in the Near East, and its transmission effected through illuminated manuscripts. A Cappadocian fresco at Yilanli Kilise of the eighth century shows an angel with a pair of scales in a Last Judgement context, and this example in some way harks back to the iconography of Christian Egypt, where a creature judging the good or evil qualities with a pair of scales was borrowed from frescoes produced in the centuries of the Pharaohs.

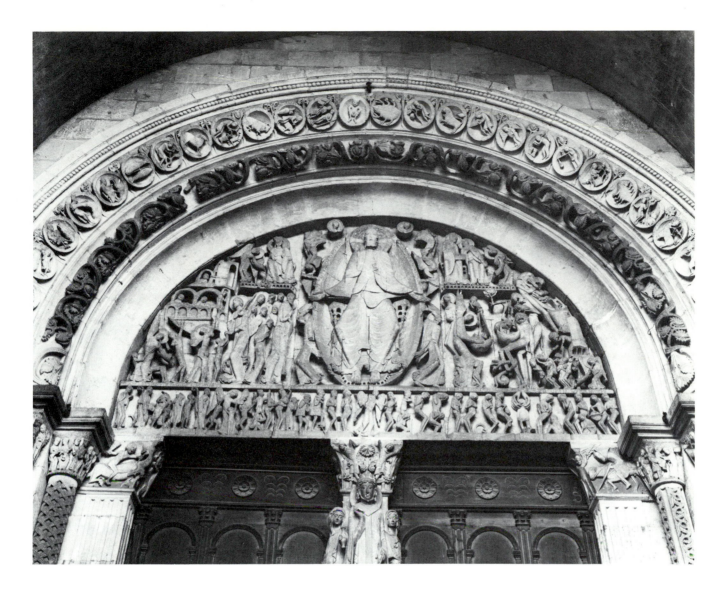

105

106,107

108

In Burgundy, a Last Judgement *tympanum* has survived of which
we know the name of the sculptor. His name was Gislebertus and he
carved the portal of the cathedral of Saint-Lazare at Autun between
1120 and 1135. Gislebertus's style is eccentric and his iconographical
programme is unique. Autun is the work of an artist whose vision
was emotional and isolated. Gislebertus did however rely upon
models, and several of the nave capitals, for example those of the
Nativity and of Jacob wrestling with the angel, derive from
Byzantine manuscripts, which themselves go back to earlier Near-
Eastern models.

Contemporaneous with Autun is the *tympanum* of the abbey
church of Sainte-Madeleine at Vézelay, carved between c.1125–35.
The theme of Vézelay's *tympanum* was a magical mix of the Ascension
with Pentecost, with the descent of the Holy Spirit. Christ is seated
within a *mandorla* and his hands break out from its frame in order to
release fire on to the heads of the Apostles. At Autun Christ is seated

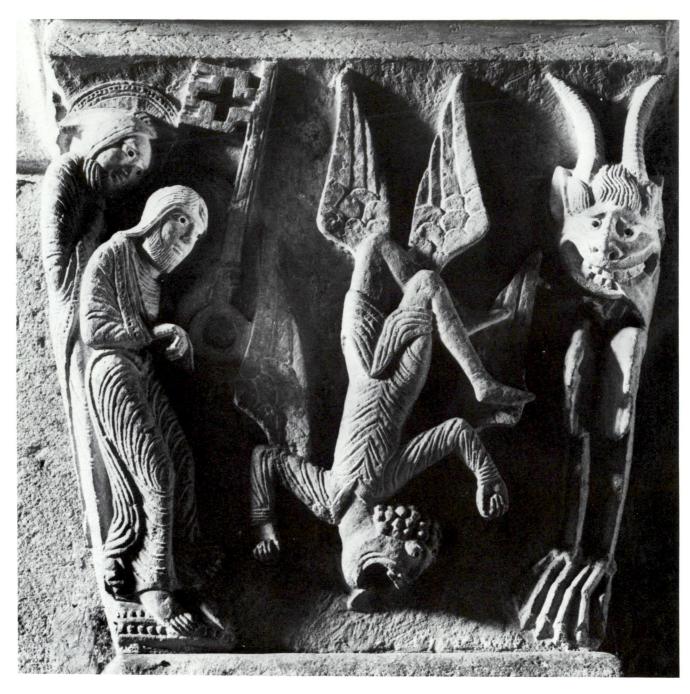

106 Saint-Lazare, Autun (c.1120–35); capital
with the Fall of Simon Magus

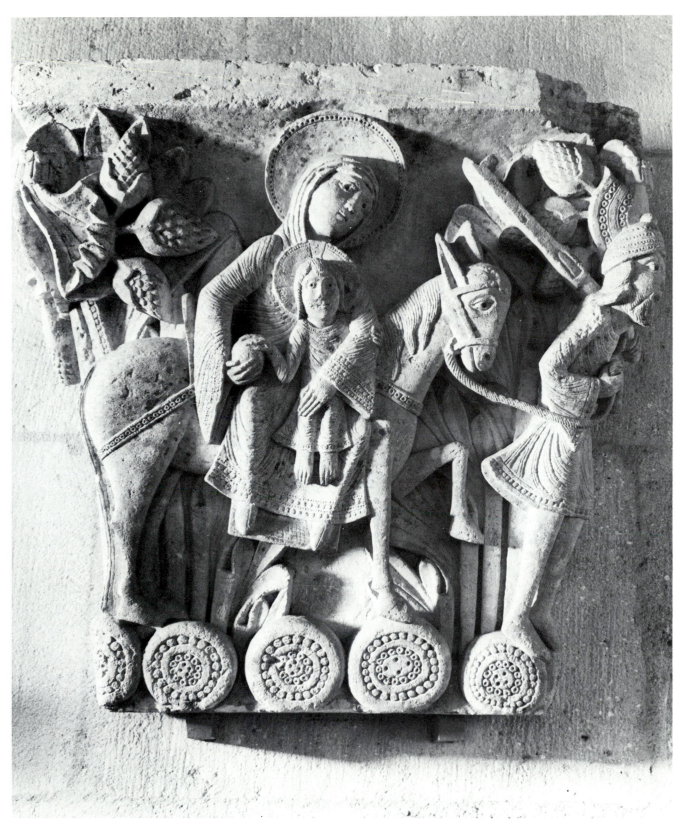

107 Saint-Lazare, Autun (c.1120–35); capital
with the Flight into Egypt

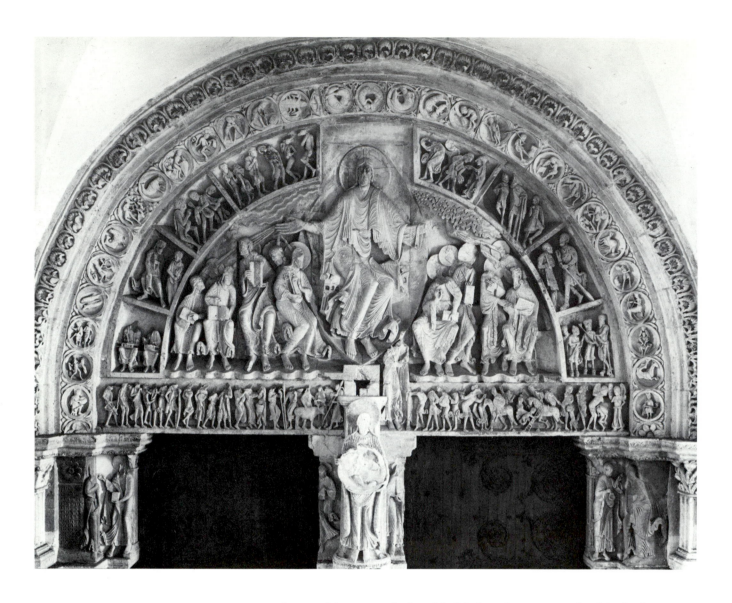

108 Sainte-Madeleine, Vézelay (c.1125–35);
central *tympanum* with the scene of
Ascension and Pentecost conflated

109

enthroned in a *mandorla* with his hands outstretched in judgement, but there he takes up a severe and frontal position, the body arranged around a central vertical axis. This treatment of Christ in an Ascension scene is an Eastern variant where the preference was for symmetry and austere frontality. Although the upper half of Christ's body at Vézelay is frontally positioned, his knees are thrown to the side causing the drapery of his robe to fall into whorls and flutters. This adds emphasis to the tremulous excitement of the scene. The central compartment of the *tympanum* is filled with the twelve Apostles and the large figure of Christ. The outer part contains small compartments, each with a group of figures who communicate with one another in great agitation. A row of assorted creatures traverses the lintel and they too quiver with emotion. The cosmic nature of the scheme is underlined by all these figures who represent the different nations of the earth. The source of such a complex iconographical scheme can be found in Near-Eastern art. From literary sources, the

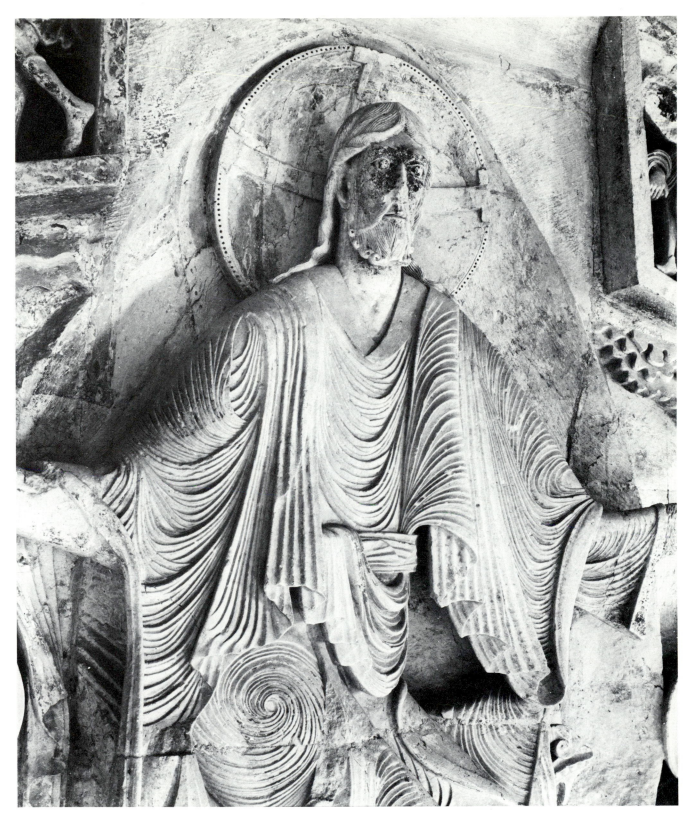

109 Sainte-Madeleine, Vézelay (c.1125–35);
detail of Christ

sixth-century mosaics of the Church of the Holy Apostles at Constantinople are known, and the important scene of Pentecost, having regard to the dedication of the church, showed each of the 12 Apostles preaching to a group of people who represented a different nation. The diffusion of such an idea would have been effected through illuminated manuscripts, and many Byzantine manuscripts contain illustrations of parts of the scene.

At Vézelay in 1146, when the *tympanum* had been in place for about a decade, St Bernard of Clairvaux preached in order to arouse support for the Second Crusade to the Holy Land, and from Vézelay in 1190 the start was made for the Third Crusade. Men went in a missionary fervour, attempting to emulate the rôle of the Apostles carved in stone before them, and they went on a pilgrimage, going back to the fount, the Near East, which was an inexhaustible reservoir for the art of the Romanesque era.

BIBLIOGRAPHY
Selected titles

Aberg, N.: *The Occident and the Orient in the art of the 7th century*, Stockholm 1943

Baldwin Brown, G.: *The Arts in England*, London 1903 ff

Beckwith, J.: *The Art of Constantinople*, London and New York 1961

Beckwith, J.: *Early Medieval Art*, London 1964

Brooke, C.: *The Twelfth Century Renaissance*, London 1969

Busch, H. and B. Lohse (eds): *Pre-Romanesque Art*, London 1966

Butler, H. C.: *Early Churches in Syria, fourth to seventh Centuries*, Princeton 1929

Conant, K. J.: *Carolingian and Romanesque Architecture 800–1200* (Pelican History of Art), London 1959, reprinted 1979

Creswell, K. A. C.: *A Short Account of Early Muslim Architecture* (Pelican History of Art), London 1958

Dalton, O. M.: *East Christian Art*, Oxford 1925

De Vogüé, C. M.: *Syrie centrale: architecture civile et religieuse du Ier au VIIe siècle*, 6 vols, Paris 1865–1877

Der Nersessian, S.: *The Armenians*, London 1967

Focillon, H.: *L'Art des sculpteurs romans*, Paris 1931

Gough, M.: *Ancient Peoples and Places. The Early Christians*, London 1961

Gough, M.: *Origins of Christian Art*, London 1973

Grabar, A. and C. Nordenfalk: *Early Medieval Painting from the Fourth to the Eleventh Century*, London and New York 1957

Grivot, D. and G. Zarnecki: *Gislebertus, Sculptor of Autun*, London and New York 1961

Harvey, J.: *The Mediaeval Architect*, London 1972

Haseloff, A. E. G.: *Pre-Romanesque Sculpture in Italy*, Florence 1930

Hearn, M. F.: *Romanesque Sculpture*, Oxford 1981

Henry, F.: *Irish Art 800–1200 AD*, London 1973

Hinks, R.: *Carolingian Art*, London 1935

Hubert, J., J. Porcher and W. F. Volbach: *Europe in the Dark Ages*, London 1969

Jantzen, H.: *Ottonische Kunst*, Munich 1947

Kitzinger, E.: *Early Mediaeval Art in the British Museum*, London 1940, reprinted 1969

Krautheimer, R.: *Early Christian and Byzantine Architecture* (Pelican History of Art), London 1965, reprinted 1981

Levison, W.: *England and the Continent in the 8th Century*, Oxford 1946

Mâle, É.: *Religious Art in France. The Twelfth Century: A Study of the Origins of Medieval Iconography*, Princeton 1978. (Originally published as *L'art religieux du XIIe siècle en France*, Paris 1922)

Moray, C. R.: *Early Christian Art*, Princeton 1942

Puig I Cadafalch, J.: *Le Premier Art Roman*, Paris 1928

Rice, D. Talbot: *Byzantine Art* (Pelican History of Art), London 1968

Rice, D. Talbot: *English Art 871–1100*, Oxford 1952

Rostovtzeff, M. I.: *Dura Europos and its Art*, Yale 1938

Salvini, R.: *Medieval Sculpture*, London 1969

Schapiro, M.: *Late Antique, Early Christian and Medieval Art*, London 1980

Schiller, G.: *Iconography of Christian Art*, vol. 1, London 1971, vol. 2, London 1972

Strzygowski, J.: *Early Church Art in Northern Europe*, London 1928, reprinted 1981

Strzygowski, J.: *Origin of Christian Church Art*, Oxford 1923

Volbach, W. F. and M. Hirmer: *Early Christian Art*, London and New York 1961

Weitzmann, K.: *Illustrations in Roll and Codex*, Princeton 1947

Williams, J. (ed): *Early Spanish Manuscript Illumination*, New York 1977, London 1978

Wolff, P.: *The Awakening of Europe* (Pelican History of Art), London 1968

Zodiaque, St-Léger Vauban (publishers). Series on Romanesque architecture of French regions, by various authors

Zodiaque, *Lexique des Symboles* 1969

INDEX

Compiled by H. K. Bell